RENAISSANCE
ART

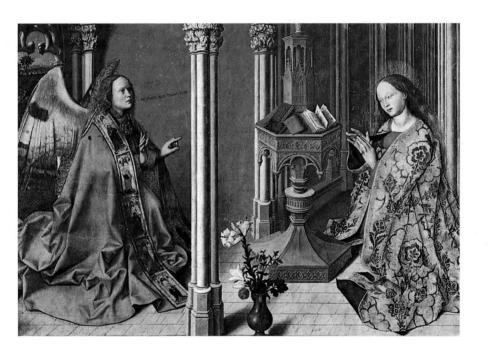

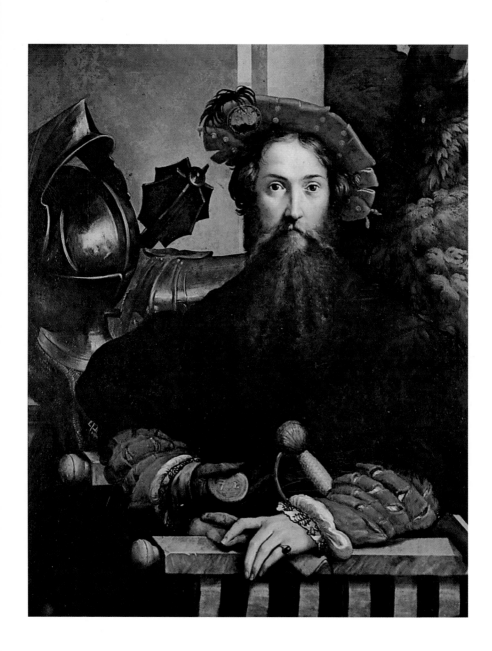

RENAISSANCE ART

Gérard LEGRAND

CHAMBERS

For the English-language edition:

Translator
Gearóid Cronin

Art consultant
Dr Patricia Campbell, University of Edinburgh

Series editor
Patrick White

Editor
Camilla Rockwood

Proofreaders
Stuart Fortey
Camilla Westergaard

Prepress
Vienna Leigh

The editors would also like to acknowledge the contribution of Mr R P Tarr, Senior Lecturer and Specialist in Renaissance Art, to the section on *Theory of Perspective*.

Originally published by Larousse as *L'Art de la Renaissance* by Gérard Legrand

ISBN 0550 10121 7

Cover image: Jan van Eyck, *The Arnolfini Wedding Portrait*, 1434 (London, National Gallery). Photo E Tweedy © Larbor/T.

Page 1: Master of the Aix Annunciation, *Annunciation*, around 1443-1445 (Aix-en-Provence, Ste-Marie-Madeleine). Photo L Joubert © Lauros/Giraudon.

Page 2: Francesco Mazzola, known as Il Parmigianino, *Gian Galeazzo Santivale* (Naples, Museum of Capodimonte). Photo G Tomsich © Photeb/T.

Typeset by Chambers Harrap Publishers Ltd, Edinburgh
Printed in France by MAME

Contents

INTRODUCTION 6

THE EARLY RENAISSANCE 18

THE INTERNATIONAL STYLE AND HUMANISM 27

AT THE CROSSROADS OF THE QUATTROCENTO 36

IN AND AROUND FLORENCE 49
- *The Theory of Perspective (p. 54)*
- *Botticelli (p. 62)*

FROM ROME TO VENICE 68
- *Leonardo da Vinci (p. 72)*
- *Michelangelo (p. 76)*
- *Raphael (p. 80)*
- *Titian (p. 89)*

A EUROPEAN-WIDE MOVEMENT 90
- *Albrecht Dürer (p. 96)*

THE MANNERIST TRADITION 112
- *Fontainebleau (p. 122)*

TWILIGHT AND LEGACY 128
- *The Building of Saint Peter's in Rome (p. 134)*

CHRONOLOGY 137

INDEX 140

BIBLIOGRAPHY 143

INTRODUCTION

The term '18th-century art' refers to a definite period; the term 'art of the Middle Ages' applies to a wider-ranging, less clearly defined period, given its designation retrospectively; and the term 'Baroque art' is linked to controversies which have still not been completely resolved. However, to talk about 'Renaissance art' is to talk first and foremost about the broader cultural phenomenon of the Renaissance itself. Nobody today any longer believes that the Middle Ages was an era entirely steeped in darkness, followed by the radiant dawn of the Renaissance. This view gave way not long ago to an opposing but equally exaggerated view, whereby some commentators argued that the Renaissance amounted in reality to no more than 'the decline of the Middle Ages'. According to this view, the Renaissance in all its manifestations resembled an obscure valley dwarfed by the majestic edifices of medieval scholasticism, if not feudalism, and 'Cartesian rationalism'. This view of the Renaissance, which was applied to scientific advances in particular, was extended (quite inappropriately) to art. This positivist denigration of the Renaissance was echoed by another negative view, this time of puritanical origin, forcefully expressed by the Nazarene painters and the Pre-Raphaelites, and by a critic as eminent as John Ruskin. In fact, the Renaissance was a global phenomenon in the history of ideas and civilization. Its various manifestations constantly interlinked and overlapped, and its key figures consciously promoted this: a huge number of artists, as we shall see, were also writers, engineers or scientists, or practised painting, sculpture and architecture all at the same time.

The Renaissance was also a remarkable feat of self-assertion. This does not mean that a few adventurous thinkers suddenly decided to create or to 'launch' the Renaissance, or that a school of architects announced a revival of ancient practices, but rather that the Renaissance quickly became aware of itself as a revolutionary era. It was even maintained (by André Chastel) that it was the only period in art history that possessed to this degree the sense of its own reality, of its potential, of its 'desire to exist'.

There is ample evidence that this was the case: that supplied by artists is more understated than that of writers, but they shared the same objectives. In around 1455, the scholar Aeneas Silvius Piccolomini (Pope, from 1458 to 1464, under the name Pius II) declared: 'With Petrarch, literature has been resurrected; with Giotto, painting has been revived; we have seen each of these arts reach a state of perfection'. Even the cautious Erasmus, echoing Marsilio Ficino, conjured up the vision of a new golden era: 'What a century I see opening up before me! How I would like to be young again!' Dürer (who took Erasmus to task for other reasons) would always say that his visits to Venice – a city on the edge of a changing world – were the happiest moments of his life.

The terms 'renovation', 'restitution' (Rabelais) and even 'renaissance' were quite commonly used at the time – a fact which alone justifies speaking of the Renaissance as of something other than an illusion (if myth did come into it, it was a defining, vital myth). A clear ambition to be self-sufficient

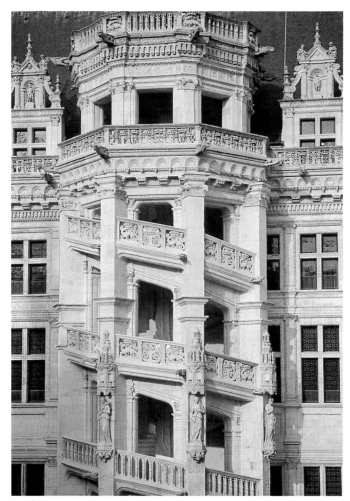

Château de Blois, interior façade of the north wing, 1515–24. Built by an unidentified architect at the beginning of the reign of Francis I, it typifies the era of the first statesman to have grasped the cosmopolitan dimension of the Renaissance. Although the spiral staircase was already a familiar feature in the Middle Ages, its ornamental apertures, the octagonal tower that encases it and the brilliant decorative motifs of the balconies and bays are all of Italian inspiration. *Photo © Wolf Alfred/Hoa Qui*

informed the Renaissance. This self-assertion explains why chroniclers, when talking about an artist, would sometimes attribute heroic qualities to him, just as *virtù* (an untranslatable Italian word) was attributed to statesmen. A similar degree of excellence was expressed by the word 'divine' (already applied to some artists before Michelangelo). Even where such high-flown language was dispensed with, the impression given by these brilliant and multi-talented men was unique: 'Their glory extends through the fields of sculpture, architecture, poetry and science. All modes of expression invite them to show their genius. [...] Their works give us only a vague sense of the lofty heights inhabited by their noble souls' (Berenson). The Renaissance emerged as a phenomenon of self-knowledge and renewal. In less than two centuries, the old theoretical frameworks were demolished. The Christian universe, a strained compromise between Ptolemaic astronomy, Aristotelian cosmology and the 'literal' teachings of the Bible, collapsed. Christian society – criticized and reformulated by some humanists, dismantled during the Reformation after the emergence of city states

INTRODUCTION

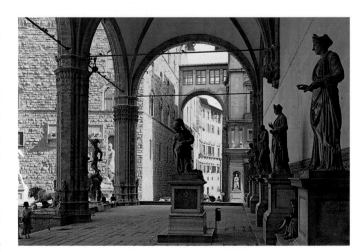

and fledgling modern monarchies – would be rebuilt on new foundations in the aftermath of the Renaissance. But the Renaissance movement constantly sought to know more about itself, and this was especially true in the area of the arts. It gave us the first writings on pure and applied aesthetics, and the first catalogues of works of art. Once the impetus had been given, the battle against 'barbaric' (Gothic) architecture and Byzantine painting developed a sense of solidarity that cut across the generations: thus, a Mannerist in the 1560s would go to the trouble of saving a *Madonna* he believed to be by Giotto. The mindset of the Renaissance has been aptly described by a renowned historian of science (Alexandre Koyré) as one in which 'everything is possible'. This reflected a spirit of curiosity which was constantly active. One of his friends said that Raphael's greatest joy was to 'be taught and to teach', although there is no evidence that Raphael had a formal education.

Wide-ranging in its repercussions, the Renaissance was essentially a unifying phenomenon. The welter of experimentation and individual expression was not chaotic and random, but reflected a quest for clarity and universality. The somewhat paradoxical historians who specialize in the study of those more or less distinct artistic movements designated as 'counter-Renaissance' or 'pseudo-Renaissance' are obliged to admit that these constantly intersected with the main movement. It is through these intersections that we can map out the broad outlines of the Renaissance. Burckhardt's history (*see Bibliography*) remains the essential starting point for any study of this subject. In his principal work he barely speaks about art as such, but he does emphasize its connection with society, outlining the role performed by art in all aspects of social life, from pageants to medallions. His intention is to show aesthetics at work in an area where this was least expected: the creation of the state. And we see how, particularly in the field of urban design, art was reintroduced intensively into the life of Italian towns at a time when they sought to recreate the image of cities of classical antiquity. It has never been possible to seriously refute Burckhardt's

other basic tenet: the recognition during the Renaissance that individual consciousness and energy have an intrinsic value. The description of a man as 'unique' or 'remarkable' was therefore always intended as a term of praise, for artists and humanists alike.

Humanism and the Renaissance are sometimes contrasted with each other. Humanism, which evolved before the Renaissance proper, is seen as a progressive movement whose influence gradually pervaded the scholastic establishment, bringing about – through a more attentive study of ancient texts – a transformation in the fields of philology, medicine and even theology. The Renaissance is seen as a more general cultural phenomenon, pervading private life, customs and the arts, rather than public law and the sciences.

The Renaissance did not simply continue the triumphant development of humanism which followed the decline of scholasticism in the 13th century: it boasted its own highly radical philosophers, who went unrecognized for a very long time. However, their forerunner, Petrarch, was also the most famous of the humanists. He was the first to explicitly put forward the idea of returning to classical antiquity, and the first to realize that this return could only be a new beginning and not simply a matter of blind faith. This kind of double rift explains why neither Charlemagne's schools nor the 12th-century cloisters fostered a 'renaissance': the Middle Ages believed that it was perpetuating an ancient classical tradition that it confused with the Christianized Roman Empire.

From the point of view of art, what is especially interesting about humanist attitudes as they were recast during the Renaissance is the idea of the intrinsic value of poetry, music or painting. The ancient classical world might have been far removed in time, but it chimed with a new sensibility, one which was totally free of dogma. The aesthetic and moral ideas of

Giulio Romano, interior courtyard of the Palazzo del Te, 1524–30 (Mantua). This splendid architectural arrangement represents a continuation of the Florentine style, transposed to Rome at the beginning of the century, and here embellished with the addition of highly Mannerist elements (dropped keystones). However, Guilio Romano's most innovative achievements in architecture were his drawings, with which both Vasari and Vignola were familiar and which they doubtlessly imitated. *Photo © Photo Francastel/T*

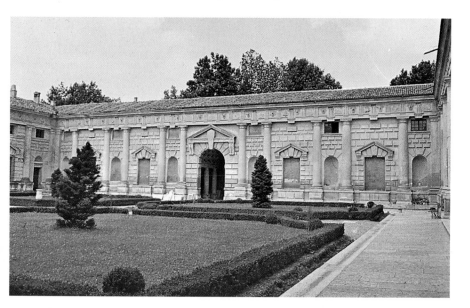

INTRODUCTION

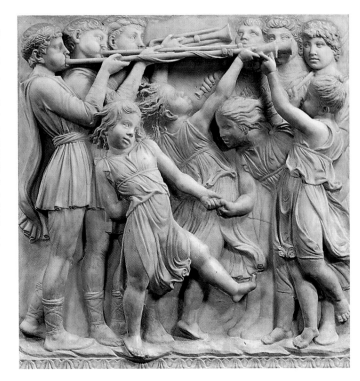

Luca Della Robbia, *Angel Musicians* (relief sculpture on the Cantoria), 1431–8 (Museo dell'Opera di Santa Maria del Fiore, Florence). There is nothing idealized or sentimental about these young children: their faces are those of the street children of Florence, while their poses and clothes are derived from those of the figures on classical sarcophagi. *Photo © Scala Larbor/T*

Right-hand page, bottom: Chalice (?), Venetian Murano blown glass, 15th–16th centuries (Museo Poldi-Pezzoli, Milan). The quest for an aesthetic that was both sober and highly sophisticated, extending into the realm of what we would today call 'the applied arts', corresponded to the new appetite for luxury that characterized the era. *Photo © Scala Larbor/T*

antiquity, which had been popularized by the rediscovery of ancient texts, could restore man to a place in a cosmos that was ordered differently from the Aristotelian cosmos as interpreted by the students and professors at the Sorbonne in Paris (the 'sorbonagres', to use Rabelais's expression). And this was a not insignificant place. The whole of the Renaissance was pervaded by the idea of man as a microcosm, an idea that centred round Pico della Mirandola's famous *Oration on the Dignity of Man*. This was not an immutable dignity: both man and history were envisaged as perfectible. It was far-reaching, underpinning political struggles as much as artistic expression, and the battle against monastic obscurantism as much as the stylistic objectives regarding the imitation of antiquity (an imitation which must not be interpreted as a rigid precept). It was a dignity which, in the domain of ideas, was meant to be all-embracing: Florentine Neoplatonism – Florence was the centre of intellectual life for over three decades (between around 1460 and 1495) – was an essentially synthetic philosophy. The central role given to man in this philosophy was complemented by a freedom which allowed him, in a sense, to dominate time and space. This even extended to the sphere of architecture; for example, the theoretician (and architect) Filarete wrote to Sforza: 'I give you the building in human shape and form.' The two focal points of Renaissance art were to be man, central and endowed with virtually unlimited potential, and the quest for a style (another word that was just coming into existence). This explains why, for a long time during this period, there was a tendency towards the monumental and definitive, sometimes even at the level of the smallest objects.

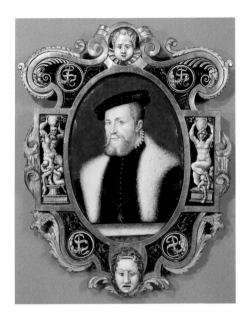

Attention has focused on the degree to which Renaissance art was in tune with the official ideology of the period: Catholicism. Although it is true that there were some eccentric or 'maverick' artists (Piero di Cosimo being one of them, it appears), they did not really cultivate 'paganism' or heresy, unlike various groups of humanists who were sometimes tolerated and indeed protected by the papacy (up until around 1540 at least) in this era remarkable for its conflicting theological viewpoints. There was, however, a pronounced vogue for all things antique: Mantegna, in 1460, organized 'pagan' festivities for his friends, and afterwards gave thanks to the Madonna for having ensured their success.

There are no longer any grounds, in the light of the studies undertaken by Erwin Panofsky

Léonard Limosin, *The Constable Anne de Montmorency,* c.1555 (Musée du Louvre, Paris). Although he also practised engraving and painting, Limosin is most noted for his enamel miniatures which assimilated and adapted the influence of Dürer, Rosso and Niccolò dell'Abbate. The essentially aesthetic rather than allegorical decoration of the frame in this piece is of humanistic inspiration; Montmorency was a cultured patron of the arts. *Photo © Giraudon*

and his disciples, for disputing the view that Renaissance art was extensively fuelled by Neoplatonic philosophy as well as by the models of ancient Rome and Greece, and that it developed over a long period beginning in around 1420 and lasting right up to the middle of the 16th century, with unexpected offshoots in Fontainebleau and in the work of the highly sophisticated Veronese. This art was at the same time that of a Christian society in crisis, but what it reflected was not so much this crisis as a flex-

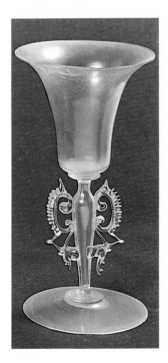

ible religion which was somewhat remote, indeed secularized. It must be remembered that the Platonic humanists dreamed of reconciling with Platonism not only a well-assimilated Aristotelianism, but also the three main religions: Christianity, Judaism and Islam. This is perhaps reflected in the painting by Giorgione known as *The Three Philosophers.* Despite the fall of Constantinople – most eminent Byzantine scholars having already taken refuge in the West – this dream continued to haunt the artistic and intellectual circles of Florence and Rome. This desire for synthesis was also echoed in scientific and political theories: Machiavelli (like so many Copernicans at a later period) kept abreast

INTRODUCTION

of developments in art. 'It was a world of unparalleled humanity and intensity. It is easy to forget just how great was the scope of this era with its poetry, its ability to see things and examine the heart of things beyond surface appearances in order to ascertain the meaning at their root' (E Garin). The capacity for long-term self-education was characteristic of the Renaissance: 'The exchange between the arts and other forms of cultural expression was continuous and vital.'

From this time on, painting – of necessity the major focus in a book dealing with this period – increasingly broke free from religious decoration. The rediscovered understanding of human anatomy derived from Classical Greek and Roman statuary. The application of perspective, no longer a rudimentary affair but 'legitimate' (constructed according to certain laws), led to a reconfiguration of the pictorial space. In narrative representation, the impact of new ideas which led to traditional elements (such as symbols) sometimes being presented in a totally new manner gave artists a new freedom in the way they constructed their paintings. We do not allude here to the 'naturalism' of the Renaissance: it exists, but accounts for only a small part of the Renaissance mindset, and the word is not entirely apt in this context. Even if, as soon happened, painters took great pride in reproducing the third dimension of space and the 'life' of the figures (by representing mass in terms of perspective), this optical realism in relation to the material world – for which there was a corresponding tonal realism with regard to colour – was a means rather than an end in itself.

The interest in drawing shown by almost all the major artists of the Renaissance (and which sometimes was enough to make prestigious artists of lesser figures) is indicative not only of the attention they paid to the real,

Simone Martini, *The Condottiere Guidoriccio da Fogliano*, 1328, detail from a fresco (Palazzo Pubblico, Siena). An entirely secular commemoration of its subject: the confident figure, whose self-assurance is in keeping with the simplicity of the landscape, reflects the determination of the real-life model. A certain effect of depth can also be observed in this painting, in spite of the remarkably luminous, plain background. *Photo Scala © Larbor/T*

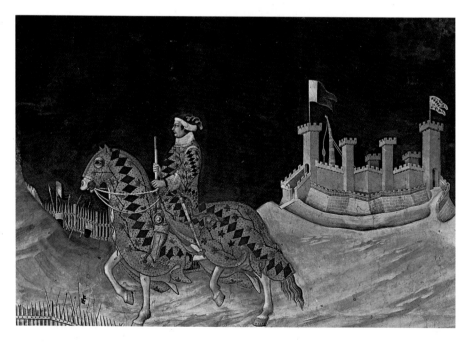

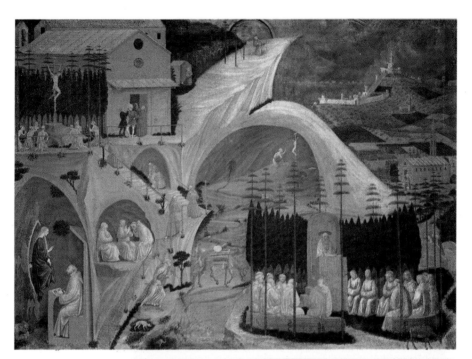

Paolo Uccello, *The Thebaid: Scenes from the Lives of the Hermits*, c.1450 (Galleria dell' Accademia, Florence). The lives of the first Christian monks, as recounted in legends, is enriched with episodes relating to more recent figures (Saint Bernard, Saint Francis). The deliberate multiplicity of perspectival viewpoints seems to echo the theories of Nicholas of Cusa, which were well known in Florence at around this period. ('God is a sphere whose centre is everywhere and whose circumference is nowhere.') Thus, the simplification of forms in the painting does not derive from medieval traditions: Uccello was deeply engaged with Florentine mathematicians who were formulating innovative theories. *Photo © Scala*

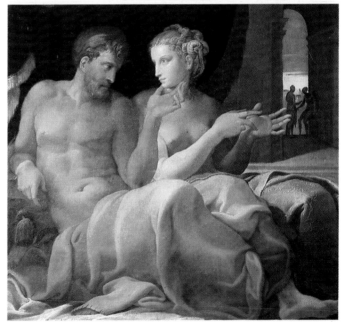

Francesco Primaticcio, *Ulysses and Penelope*, c.1560 (Edward Drummond Libbey Collection, Museum of Art, Toledo). The hero has returned to his faithful wife, who seems to be trying to calculate how long they have been separated. The tiny figures in the background emphasize the remoteness of the world through which Ulysses has travelled. The aristocratic dignity of the poses and the shadowy light irradiated by bright colours combine to create a sense of serenity befitting these mythological beings. *Photo © the Museum/T*

INTRODUCTION

The Ideal City, architectonic perspective (?); painting on wood attributed to **Luciano Laurana**, after 1450 (Palazzo Ducale, Urbino). Among other possible attributions, mention must be made at least of Francesco di Giorgio Martini. The panel is dated sometime between 1440 and 1500. Like the other two panels which are related to it (one in Berlin and the other in Baltimore), this marvellously luminous picture remains an enigma: was it an architect's scale model, a demonstration of perspective, a humanist utopia, or perhaps a model for a stage set? It is a fascinating and enduring mystery. *Photo © Giraudon/T*

but also of their aesthetic concerns. More generally, it was not a matter (especially in Italy) of copying reality as it was, or even of interpreting it 'in terms of a temperament'. Even Leonardo da Vinci, who was always talking about observations and transcriptions, subordinated this essential practice to another objective. The art of the Renaissance sought archetypes not in nature as it had been created, but in nature as a creative force. It was the act of creation, a quasi-divine activity, that the artist had to make his vocation. And so, despite its sophistication, artistic expression (from the *Ideal Cities* of Urbino and elsewhere right through to Primaticcio) often appeared to be preoccupied with the creative principle, or 'the dawn of the world'. Realism, although it did develop during the Renaissance, was not its guiding principle: it was one of its consequences, and did not acquire the status of a specific objective in itself (apart from in the case of some local schools) until much later. With regard to this 'dawn', it should be borne in mind that, thanks to the rediscovery of the cultures of ancient Greece and Rome, the artist knew that classical antiquity was a golden age now far removed in time. This explains a certain melancholy, very different from the 'spleen' of the Romantics. The artist is neither overwhelmed by the spectacle of the beautiful works of the past, nor threatened by the ugliness of everyday life. His anxiety stems from his awareness of the fleeting nature of his existence which makes it impossible for him to create such masterpieces. This made it all the more important for the art lover to move freely between the two worlds: Cyriacus of Ancona, who brought back a large number of inscriptions and drawings from his travels in Greece and Egypt, also waxed lyrical about van der Weyden's *Pietà*, which he saw at the home of Lionello d'Este at Ferrara in 1449.

How did art fit into public life? Even writers of a sociological bent (Francastel) have protested against reductive interpretations in which the flowering of the Renaissance is seen as a semi-automatic consequence of social relationships. Such interpretations put excessive emphasis on the restrictions endured by artists, to the point of ignoring the artist's creativity. These restrictions were indeed real: patronage was not the idyllic relationship between benefactor and protégé as was imagined in the 19th century. However, the fact remains that without the patronage provided by the

three Medicis in the second half of the 15th century and the patronage offered subsequently by so many Italian princelings – or, for example, that given by Pope Sixtus IV after the Holy See was re-established in Rome – the movement would have lacked a vital impetus. We should be wary of too modern a view: a patron was scarcely an employer any more than an artist was his employee. The person commissioning the work of art gave tips and allowances rather than a salary as such, and the artist worked slowly in order to take advantage of as many of these as possible. His growing prestige would help him to earn a livelihood, no doubt on a piecemeal basis, but in an environment that was often congenial. In the cities, which had relatively small populations and were still semi-rural (many artists admitted or concealed the fact on the land register that they owned a plot of land beyond the city walls), easier credit terms for the protégé of a powerful figure must have smoothed over many problems. When things began to change – in the 16th century in the bourgeois urban centres (Venice, Antwerp) – the changes worked to the artist's advantage. The restrictions imposed by the medieval corporations collapsed at exactly this time. As far as ideological constraints were concerned – somewhat less restrictive than those that existed in later absolute monarchies – these amounted essentially to an allegiance to the Christian faith which was taken for granted and which accommodated many ambiguities.

With regard to constraints imposed by a programme of artistic work, in cases where there was no formal agreement between the painter and the scholarly advisor who devised the programme, or between the painter and the patron, it is clear that the artist often resorted to subterfuge (Perugino and Isabella d'Este, for example). The referential code of the paintings was

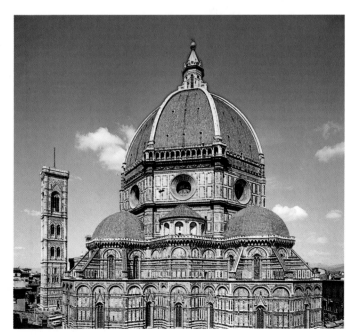

Filippo Brunelleschi, dome of Santa Maria del Fiore, 1420–36 (Florence). The humanist Alberti said of this extraordinary architectural achievement that its structure 'was destined to cover with its shadow all the Tuscan people', thereby endowing it with both a cosmic and a political significance.

INTRODUCTION

no longer really restrictive: even the most minutely detailed allegories no longer constituted a closed system. So what restrictions were there? Those that stipulated the amount of gold or lapis lazuli to be used were the result of ostentation (or avarice) on the part of the client and had little impact on the originality of the artist. Was art a liberal economic activity or a mercantile activity? The debate, which originated during the Renaissance, remains unresolved to this day. In any event, things were now done in an entirely new way as regards working in teams or workshops: unlike the purely practical *capomaestri* of the Middle Ages, Brunelleschi was not only the purveyor of supplies to a team of 200 to 300 men constructing the dome of the Duomo in Florence, he was also the man who designed and built it – not in accordance with purely technical approaches or abstract principles, but with the concrete theory that he had derived from his study of previous buildings and monuments and from his mathematical deliberations.

A painter's studio might be mocked by an individual scholar as a place of 'mechanical life', but other scholars would debate the pre-eminence of painting or sculpture, or would defend these art forms against the exclusive pursuit of literature. The division of labour was not so extensive as to make it possible to identify the work of an apprentice wherever this is suspected. Indeed it is better to attribute to the masters themselves a large proportion of the work referred to as done by their 'workshop', for the masters had sup-

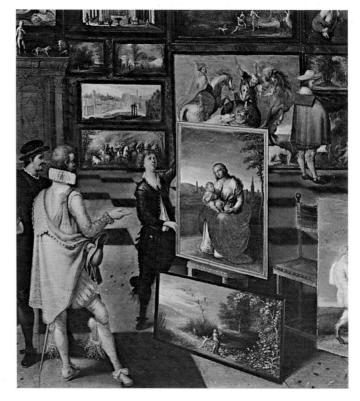

Jérôme II Francken, 1578–1623, *The Picture Shop of Jan Snellinck*, detail (Musées Royaux des Beaux-Arts, Brussels). In its twilight phase, the Renaissance extended the vogue for art to collecting paintings and even to richly detailed representations of art collections in paintings. *Photo Lou © Larbor/T*

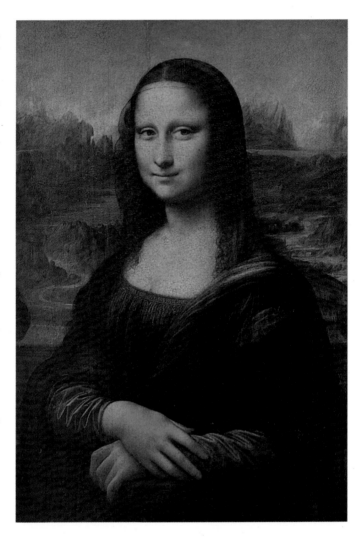

Leonardo da Vinci, *Mona Lisa (The Gioconda)*, 1503–7 (Musée du Louvre, Paris). The model, seated on a terrace, appears sharply foregrounded against a landscape shrouded in mist. This fascinating portrait of an unknown lady has given rise to endless speculation (the name 'Mona Lisa' is as hypothetical as 'the Gioconda'). It has inspired the greatest number of pastiches, caricatures, allusions and commercial uses of any painting in the history of art. Such is the cult that has grown up around this painting that the thick varnish which covers the portrait has – for superstitious reasons – never been cleaned. *Photo J P Vieil © Archives Larbor/T*

plied the idea for the work if not the actual preliminary drawings.

The atmosphere of the Renaissance and the ambitions that informed it must be sought first and foremost in Italy. This is not to diminish in any way the technical contributions of the Flemish and the Dutch or their artistic achievements; nor is it to overlook their Italian contemporaries' appreciation of 'Master Albert' (Dürer) or Vasari's appreciation of Fouquet; nor does it mean that we are forgetting the brilliance and glamour of the French Renaissance. But the fact remains that the Renaissance was Italian when it began, essentially Italian at its height, and still largely Italian in its final phase, which was not so much a disintegration as a final redistribution of its strengths.

THE EARLY RENAISSANCE

The last years of the 13th century and the whole of the 14th century (*trecento* in Italian) were an extremely turbulent period in Europe's history. In 1300, a vast crowd gathered in Rome for the Papal Jubilee; but this triumph of the papacy, which had succeeded in imposing its authority on the Holy Roman Empire, was but a prelude to a complete upheaval in its fortunes (although the emperors were not to gain from this in the short term). Soon after, the popes went into exile at Avignon under the protection of the same French kings who had refused to give in to their demands. This was an extremely complicated state of affairs: the old aristocracy was beginning to lose political power in most Italian city states, where internecine strife was rampant, and there was no clear prospect of a resolution. In Rome there was even a brief resurgence of republican sentiment, its proponents invoking the memory of classical antiquity.

The beginning of the *trecento* nevertheless witnessed an artistic revival of considerable magnitude. This had been initiated a short time before by Cimabue (c.1240 to sometime after 1301), the first Tuscan painter to take advantage of a visit to Rome (in 1273) to produce topographical views of the city. More importantly, he was the first artist to break away from the two dominant movements of the time: the imitation of Byzantine art and the expressionism of Pisan sculpture. We know that Cimabue was also familiar with the frescoes and mosaics of the Roman Pietro Cavallini (died before 1340), although it is unclear whether the influence of the one artist on the other was a one-way or two-way process. In order to assess the importance of this dual inheritance (absorbed

Giotto, *Sermon to the Birds,* c.1302 (Musée du Louvre, Paris). This is a famous fragment of the predella of a signed picture, which the artist executed for the Franciscans in Pisa. The aura of spontaneous intimacy – with the saint portrayed in the presence of birds which are not depicted in the stereotyped manner of medieval art but are individuated – authenticates this panel.
Photo H Josse © Larbor/T

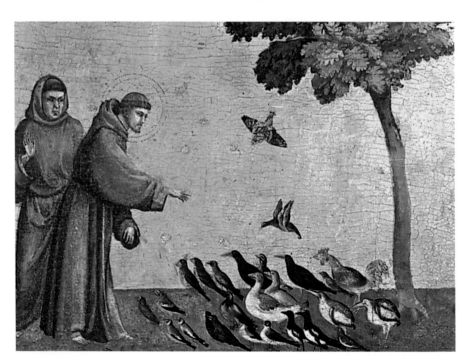

ISTIUM BERNARDI BELLINI BUONARROTI BELLINI ALATI BELTRAFFI... MASSYS BUONLNI RAFAELLI RICCIARDI ROBUSTI VICINI ROSSELLINI SEISENEGGER HEMMESSEN ARCIMBOLDI ANDREA...
VELAZQUEZ NICOLA MAZZOLA CURRADI ARMENINI ANTONISMORA NINI OSBISTI FELTRINI HINA SAENREDAM LUTHERACH GERI MEMBELA COSIMO BOSCO BRUSCO MECCO CHIANLLINI ANDU PIERO...
CHIO ZUCCARI ALBERTI ALEANDRA LORI... BO SPIER AMERIAGLICHE SIMON LAMIGNATI SALNERO OEI... NANCY ALLA GRANCINI ZARO ANTONENTO DA MENZIONARGE...
LO THLRLANDAIO GIORGIONE GIOTTO GIOVANNI PISANO GRUNEWALD HOLBEIN INGRES JEAN DE BOULOGNE LEONARDO DA VINCI LIMBOURG LIPPI LORENZETTI LOTTO I...

Duccio di Buoninsegna, panel of the *Maestà*, *The Holy Women at the Sepulchre*, 1308–11 (Museo dell' Opera Metropolitana, Siena). This is one of the panels of the Maestà which was ceremoniously transferred from the painter's studio to the cathedral in June 1311: an event which anticipated the recognition of the artist's place in society. Without resorting to excessive pathos, Duccio depicts the angel sitting on the tomb, pointing to the simplest, most striking proof that the Resurrection has taken place, allaying the fears of the women, who are said in the Bible to have taken this 'young man in white' for a ghost.
Photo Scala © Larbor/T

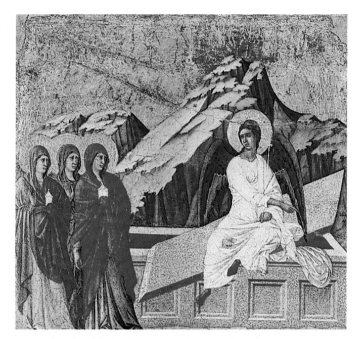

Giotto, *The Betrayal of Christ*, 1305–6 (Scrovegni Chapel, Padua). The positioning of the figures, the understated way in which their facial expressions are dramatized and the treatment of the flesh tones and clothes in a way which suggests the contours of the body show to what extent Giotto had channelled his knowledge of both classical and medieval sculpture into his painting. His Paduan frescoes would have a significant influence on art right up to the middle of the Renaissance period, and not only in northern Italy.
Photo Scala © Larbor/T

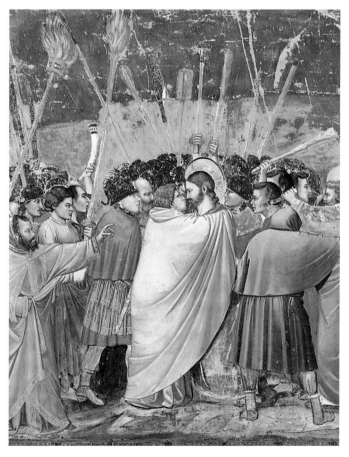

by Giotto) we must focus on the main area in which this watershed was reached, namely architecture.

Gothic architecture had never really taken root in Italy. It was founded essentially on the vertical thrust of a building, whereas Italian architecture (from Tuscany to Sicily) was intrinsically horizontal, even if this horizontality was occasionally breached by campaniles (Siena) and towers (San Gimignano). It only very rarely featured rib vaulting or flamboyant decorative elements (Milan Cathedral). Almost everywhere, it was expressed in the form of cosmetic alterations to earlier buildings (the façade of Orvieto Cathedral, c.1330) or as local styles (for example, the Lombardy-Byzantine style, or the Venetian style with its borrowings from oriental architecture). The characteristic banded marble décor of the churches of central Italy was classified as 'Gothic' for reasons of chronological convenience, as was the civil architecture of the period, which was austerely Gothic in appearance while showing a direct continuity with Romanesque architecture and having embellishments derived from ancient Rome.

This difference in emphasis reflected a difference in terms of mentality. When the greatest Gothic architect, Arnolfo di Cambio, received the commission for Florence Cathedral (1296), this was expressed in terms which exalted the magnificence and 'the honour of the people and the

Ambrogio Lorenzetti, *Allegory of Good Government*, detail, 1337–9 (Palazzo Pubblico, Siena). Lorenzetti's frescoes are the earliest examples of a secular didactic cycle in European art. The traditional work of the medieval miniaturists describing everyday life was reinterpreted and assimilated into a new overall concept of an existence governed by the desire for prosperity, civil peace, clarity and happiness. *Photo Scala © Larbor/T*

MICHELANGELO BELLINI BORGOGNONE BERNINI PERRUGUELE BLOEMAERT BOSCH BOTTICELLI BOTTICINI BOUTS BRAMANTE BROEDERLAM BRUEGEL BRUNELLESCHI B
GIULIANO DONATELLO DUBREUIL GREUZE VAN EYCK FOUQUET GENTILE DA FABRIANO LE PEINTRE GUARDI GOES GIORGIONE GIOTTO GIOVANNI PISANO GRÜNEWALD H
FRA ZUCCARO ALBERTI ALCANIZ ALTDORFER FRA ANGELICO ANTELLO PIETRO ANNAMANTI ANDREA DEL CASTAGNO ANDREA PISANO ANGELICO ANTOCHIO DA MESSINA ARCH
CETHI BANDIAO GIORGIONE GIOTTO DI GIOVANNI PISANO GRÜNEWALD HOLBEIN INGRES JEAN DE BONDEONE LEONARDO DA VINCI LIMBURG LIPPI LORENZETTI LOTTO

Ambrogio Lorenzetti,
*The Presentation at the
Temple* (Uffizi Gallery,
Florence). This painting
is famous as an
example of a still
imperfect 'scientific'
perspective: the lateral
perpendicular lines are
not governed by the
perspective of the
central vanishing point,
and the arcades in
between do not join up
properly. What is
particularly interesting
is the brilliant way the
tiled floor is rendered
and the cleverly
dissymmetrical way in
which the figures are
grouped: Simeon (who
is holding the child)
and Anna, who holds
the scroll bearing the
text about the coming
of the Messiah,
proclaim the truth of
the prophecies before
the respectful family
group – thus having
the effect of eclipsing
the official
'presentation' before
the High Priest
portrayed seated in the
background. In the
upper part of the
picture Lorenzetti has
depicted the outside of
the church for which
the painting was
commissioned.
Photo © Scala

republic of Florence' rather than in terms of religious fervour. In fact, as
in the case of the pagan temples reworked by Early Christian art, the plan
of the Cathedral is that of a public space. It is true that the plan had been
altered substantially by the time the Cathedral precinct was completed
(1376), but the architect designed the octogonal chancel on the aes-
thetic model of the chancel of the Florence Baptistery, a medieval build-
ing whose 'classical' origin is a matter of controversy.

Although painting at this time was mostly stuck in the rut of using tired
old Byzantine motifs, sculpture in the Pisa region benefited from the
emergence of Nicola Pisano, an artist from the southern regions where
Frederick II Hohenstaufen (d.1250) had dreamed of creating a secular,
even pagan-inspired, kingdom. Furthermore, Tuscany was virtually a
cemetery of classical ruins, some of which had been under excavation
since the end of the Barbarian invasions. Both Nicola Pisano and his son

THE EARLY RENAISSANCE

Andrea Pisano, *Saint John the Baptist and the Sinners*, 1330–6 (south door of the Baptistery, Florence). Here, this Pisan sculptor, who worked with Giotto on the Campanile, attempts to suggest an entire landscape behind the figure of the saint. Although the craftsmanship is essentially Gothic, the flowing robes and the expressions suggest a development in the direction of Giotto. *Photo © Titus/T*

Giovanni borrowed extensively from this classical Roman idiom, with the result that the harshness of expression in their work was sometimes toned down. Giotto was also to become familiar with this Gothic sculpture.

The importance of Cimabue is as a seminal figure. He took Byzantine painting techniques (the arrangement of angels around the Madonna) to the point of no return, and liberated others (painted crucifixes) from the convention of pathos. Painting at Assisi, he introduced the model of the 'ancient classical city', corresponding with what was known at the time about Roman architecture. His workshop included two disciples who would surpass his own achievements: the Sienese artist Duccio and the Florentine artist Giotto. In the work of Duccio (c.1260–1318/9), traces of Byzantine influence became increasingly rare (*Maestà Ruccellai*, c.1285, Uffizi Gallery, Florence). He finally established the refined delicacy of emotion and sense of the arabesque that were to be the distinctive features of Sienese art (*Maestà*, Siena Cathedral, 1300–10), whose influence was soon to spread throughout the world. However, attractive though his work may be, Duccio would be overshadowed in history by Giotto (whose influence he had absorbed).

Built in the Gothic style after the death of the future Saint Francis, the double church of Assisi (13th century, though the last additions to it were built in 1499) was effectively transformed during its construction into a huge painting site which vividly summed up the evolution of art

GIULIANO DONATELLO DÜRER EL GRECO FRA ANELICO OLTAT GENTILE DA FABRIANO GHILRI EL GHIRLANDAIO GIORGIONE GIOTTO GIOVANNI PISANO GRÜNEWALD HOLBEIN GELO NICCOLÒ PISANO DA CHIRI IZ MILLO ANSO ARTINI TRANQUI PLENINO PIERO DELLA FRANCEX ARTERO DI COSIMO ANTONIO CO IQUE ENIOITO TOSI AIOTI CHIO ROLOSIMO MIBRI ERMANZE B QUENO ANNY PERMOF ERONS MELS ERAN MARO ESURA NAMIO MARO MELSI ROM SURAO TO LOENL QUEMINE EL GHIRLANDAIO GIORGIONE GIOTTO GIOVANNI PISANO GRÜNEWALD HOLBEIN INGRES JEAN DE BOULOGNE LEONARDO DA VINCI LIMBOURG LIPPI LORENZETTI LOTTO LUC

at the dawn of the *trecento*. Cimabue and his workshop (around 1280 and with the possible involvement of Duccio) succeeded and sometimes worked in a diametrically different manner from the anonymous master known as 'di San Francesco' who partially decorated the Lower Church with 'Gothic' or 'realist' frescoes. Although now greatly damaged, their work shows the expressive distortion that Cimabue brought to the Byzantine hieratic style (a distortion prefigured in the work of the mosaicists of the Florence Bapistery, where he worked at the beginning of his career). After him, Giotto and his team took over the Upper Church until around 1300, and in the Lower Church until 1310-20: this was the period when the Lorenzetti brothers and Simone Martini made their own magnificent contributions.

The vital role of Giotto in Assisi obviously stems from the fact that he was the artist entrusted with the task of illustrating Saint Francis's life. This he did in an ingenious compromise between the everyday world and

Andrea Orcagna, *The Damned Cast into Hell*, detail from *The Last Judgement*, c.1360 (Museo dell'Opera di Santa Croce, Florence). The end of the *trecento* seems to have been overshadowed by a general and spectacular decline in artistic and intellectual life: this is reflected in Orcagna's style, at once rigidly stereotyped and staccato, with a stiff, lifeless quality, as if the lessons of Giotto had been completely forgotten.
Photo © Scala/T

spirituality, which enabled him to glorify Franciscan mysticism while at the same time making it accessible to the ordinary people who were the main target for the preacher's message (and by using an iconographical scheme which had the effect of rehabilitating the somewhat subversive 'Poverello' in the established Church). But it would be wrong to confine Giotto to Assisi: his work had an impact throughout the whole of Italy.

A native of the area around Florence, Giotto (1266/7–1337) rapidly became famous in that city, which was at the time going through a period of intense cultural and commercial development. He started working in Assisi after spending an initial period in Rome (in around 1290) – a visit which allowed him to become familiar with certain classical sculptures – and became the most famous of all Tuscan artists. He was invited in turn to Rimini, Milan, Naples and Rome (where he painted *Boniface VIII Proclaiming the Jubilee*, 1299, Saint John Lateran) by various illustrious figures, though he never lost touch with his native region. In Padua he executed the cycle of frescoes for the Scrovegni Chapel, an immense work, in which he depicted Halley's Comet (seen in 1301) no longer as a medieval omen of catastrophe, but in the guise of the mysterious star of Bethlehem. Back in Florence, he oversaw the cycles of frescoes for the chapels of Santa Croce (in around 1320), where his personal involvement is evident from the firm smoothness of the drawing and the way the buildings are perfectly integrated into the landscape. Just before his death, he appeared to be increasingly preoccupied with architecture (for example, the plan of the Campanile in Florence), and with references which are already humanistic in tenor (exemplified by the drawings for the sculpted medallions which were to adorn the Campanile). A sceptical modern school of thought has tried to minimize the vital role played by Giotto, especially in the case of the frescoes executed for the Upper Church at Assisi, castigating the 'patriotism' of Vasari, for whom the father of a renewal of painting could only conceivably be a Tuscan. But history endorses the intuitive opinions expressed by contemporary commentators on Giotto. The reason Vasari tells us that when Cimabue discovered Giotto he was a simple shepherd boy is to highlight his direct relationship with nature; indeed, nature was his teacher (he rejected the endless repetition of Byzantine conventions).

The legend that Giotto drew, freehand, a perfect circle for the papal envoy in order to display his expertise symbolizes the admiration the Renaissance held for 'the great master' – a term used by Cennini, author of the oldest manual on the theory and practice of painting that we have (early 15th century). Giotto firmly established the art of draughtsmanship even though he had no grasp of the mathematical science underlying it. The Giottoesque revolution in art, however, should neither be reduced to realism nor limited to a scholastic or abstract monumentalism. The figures are still presented as if in a frieze and they are rarely presented on receding planes, although – and in this Giotto surpassed Cimabue – a sense of depth is always suggested. Sparing in the conven-

GIMBELL ANGELICO BELLINI BORGOGNONE BERNARDI BEAUDUFF LE BLOEMAERT BOSCH DOL BOSCH BOTTICELLI BOTTICINI BOUTS BRAMANTE BRONZIN·LAM BRUEGEL BRUN LLEN CH
GHLANANCO DONATELLO DURER·FRANCESCO PIERI FRANCILQUEL CENTILE RA GABRIELI CHIRLEL CHIRIANO AUG GIORGIONE GIOTTO GIOVANNI PISANO·GRUNEWALD HOLBEL
CHELO NICOLO AMBROGIO LORENZETTI ROBERTI AUVERNO AUER DEL FINO EL ARMANNI FRANCESCA EL CASTAGNO ANDREA MILANO DA CLUEN CASTOPINTO DA MESSINA·MARC
GHIRLANDAIO GIORGIONE GIOTTO E GIOVANNI PISANO GRUNEWALD HOLBEIN INGRES JEAN DE BOULOGNE LEONARDO DA VINCI LIMBOURG LIPPI LORENZETTI H

tional use of gold haloes, Giotto was interested in the different contours and reliefs of the face and delineated these; he introduced the variety of everyday life into tragic or fantastical scenes – in short, the subject is not so much the codified legend as the actual life of the legendary beings depicted. The artist paid attention to the setting (whether urban or rural), the ground, and the flowing robes which emphasized or contradicted the expressions. The purpose was no longer to educate or to elicit an emotional response from the faithful, but to make them participate, through their own personal experiences, in a reconfiguration of sacred history.

Giotto's influence was both major and sudden. The famous (and perhaps ambiguous) praise given by Dante, who was personally acquainted with Cimabue and the young Giotto, does not do it full justice. The influence of Giotto, the first 'modern' artist – in contrast to the veteran Cimabue who was still heavily influenced by the 'Greek' style – was felt on sculpture (Andrea Pisano, Ghiberti, etc) as well as on painting (Cimabue in his later works, the Lorenzetti brothers and also the newly established schools in Bologna, under Tommaso da Modena, and in Lombardy, under Giovanni da Milano). The Tuscan painters who are specifically referred to as 'Giottoesque' did not constitute a homogeneous group. Overall, they took from Giotto his narrative coherence and some basic principles, which they skilfully applied – sometimes in the depiction of pleasant anecdotes (Bernardo Daddi), sometimes in more original experimental treatments of space and light (Maso di Banco, Stefano Fiorentino and especially Taddeo Gaddi) – without however always managing to avoid a certain dryness or, conversely, excessive sentimentality. Several of these

Enguerrand Quarton, *Pietà*, c.1454 (Musée du Louvre, Paris). It was only in 1939 that the identity of the painter of the *Coronation of the Virgin* and this *Pietà* was discovered. There is the same aura of majesty through simplicity, the same restrained emotion: the modelling of the faces, hands and rocks, the cool colours (the chiaroscuro is due to age), and the way in which Christ is depicted are identical in the two paintings. It would appear that Quarton's paintings, recreated from the illuminations he did for manuscripts, were well known throughout southern Europe, and may have influenced Antonello da Messina. *Photo © R G Ojeda/RMN*

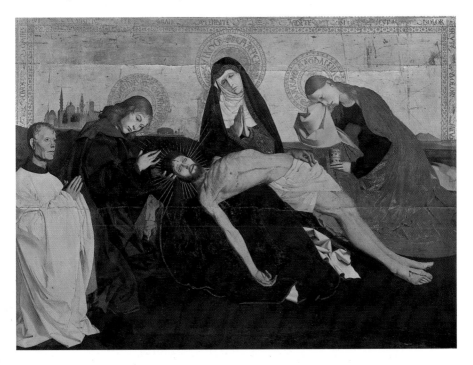

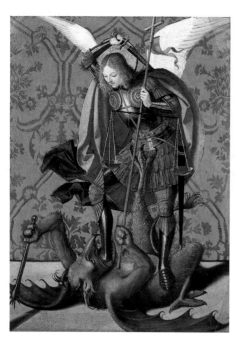

Josse Lieferinxe, *Saint Michael Slaying the Dragon*, c.1500 (Musée du Petit Palais, Avignon). A native of Hainaut, this artist was one of the last major figures in Provençal painting. His meticulous technique is northern, but his use of strong light to define stylized forms is in the pure monumental tradition of the Avignon School (which had some links with northern Italian painting) and shows the same restrained sense of drama.
Photo © Giraudon

artists had their own studios where they trained painters who became more eminent than themselves.

Although Florentine painting seems to have gone into a decline after the demise of Giotto, Sienese painting flourished, independently of Duccio and his followers, with the emergence of Lippo Memmi and especially Simone Martini and the Lorenzetti brothers: Pietro, evidence of whose work exists from 1305 onwards, and Ambrogio, evidence of whose work exists from 1319 onwards. The latter two artists sometimes worked together. In their work, the explicit influence of archaeology (then in its infancy) can be observed: in around 1334 Ambrogio drew and incorporated into one of his paintings a Venus excavated near Siena (Giotto had only used details of figures on Christian sarcophagi for inspiration). Whereas in his Assisi frescoes Pietro often shows elements of Gothic intensity – although this tendency in his work was later toned down – Ambrogio, who undertook sophisticated experiments in perspective, was one of the first landscape painters to seek inspiration directly in actual locations (some of which we can still recognize today), and developed a form of stylization in which fantastical elements convey a sense of serenity.

Tradition has it that both brothers died in the same year, 1348. This was a fateful year in history: the year of the Black Death, which, together with a serious economic crisis, ravaged Europe and in particular central Italy. People reacted with horror. Although some painters, most notably the Sienese (for example, Bartolo di Freddi) continued the artistic practices of the past, this horror was reflected in the work of others, such as Andrea Orcagna and Andrea di Firenze in Florence, and Francesco Traini and the painter known as the Master of the Triumph of Death (a significant theme) who might have been an anonymous native of Bologna, or the Florentine Buffalmacco or even Traini himself, at the Campo Santo in Pisa. Scores of visionaries and street preachers made their appearance. The emergence of two rival papal capitals in Rome and Avignon was one of the causes of the Great Western Schism (1378), which saw not just two but three claimants to the papacy vying for power through a series of councils and against a background of intervention by foreign powers. The early humanists' appeals for Italian unity were drowned out in the chaos of sedition. Medieval Christianity collapsed, while modern monarchies had yet to become securely established.

THE INTERNATIONAL STYLE THE
STYLE AND HUMANISM THE
HUMANISM THE INTERNATIONAL
ND HUMANISM THE INTER-
STYLE AND HUMANISM THE
HUMANISM THE INTERNA-
ND HUMANISM THE INTER-

THE INTERNATIONAL STYLE AND HUMANISM

The International Style is the term used to designate a rather loose stylistic trend sometimes referred to as 'courtly style' or *style fleuri*, which existed from approximately 1390 to 1425 at the latest, and which prevailed throughout the western Mediterranean region (extending also into continental Europe), in the process clashing or blending with other styles. This was an essentially heterogeneous phenomenon, to such a degree that the term (to which, for the sake of clarity, we will not here add the adjective 'Gothic') is used with reference to an atmosphere created by certain common elements in styles (whether vernacular or personal) which were nevertheless distinct from one another. This atmosphere was indicative of specific concerns within society. Despite its rather random nature, the term enables us to understand more fully a crisis in the art world which originated before the birth of the Renaissance proper and ended after overlapping with the Renaissance at various phases in its development.

A climate of osmosis prevailed in the very last phase of the *trecento*. This was fostered by several events that were politically and socially significant: the establishment of the papacy in Avignon; the (theoretical, at least) suzerainty of the Kings of Aragon over the Balearic Islands, Sardinia, Sicily and, shortly after, over the whole of southern Italy; the claim laid by the House of Anjou to the kingdom of Naples, reinforced by a series of journeys undertaken there by members of that dynasty; and especially the wide-

Claus Sluter, *Moses*, 1395–1405 (detail from the Charterhouse at Champmol, Dijon). The expressiveness of this sculpture is a direct continuation of the medieval tradition, while the relief is robustly stylised. The importance of Burgundian sculpture in the history of art remains a strange phenomenon, for there is little documentary evidence to show how it came to be so influential. It appears to have been more appreciated in Italy than in France itself, where it nevertheless may have contributed to the final flowering of an exaggerated Gothic style.
Photo © Giraudon/T

INTERNATIONAL STYLE AND HUMANISM

ranging influence (from 1380 onwards) of the Duchy of Burgundy, which, stretching from Flanders to the borders of Provence, could claim to be the wealthiest kingdom in western Europe at the time.

In Italy itself, the beginning of the *quattrocento* (15th century) was marked by a new phase in the rise of the bourgeoisie, while in France, the Hundred Years' War increased the power of the great feudatories, of which Burgundy (which was actually an independent sovereign state) was the prime example. The princely courts of France and the smaller courts of the last Italian 'tyrants' were now, bizarrely, fated to exist amidst the already illusory memories of their own splendour, as retranscribed by art, in which the bourgeoisie would see the glorification of an aristocracy which they now sought to emulate. This explains the success of 'precious' artists, whose meticulous imitations of garden flowers or garments adorned with brocade nevertheless eschewed realism. With regard to the spread of the International Style, it is worth noting not only the role played by manuscript illumination but also the growing vogue for portable ivory altarpieces, enriched with reproductions of famous works of art, and the existence of the first art collections, owned by members of the feudal nobility. Individual painted panels, as opposed to medieval frescoes or polyptychs, emerged at this time.

The International Style did not really make its mark in architecture, where Flamboyant Gothic continued to exert a dominant influence, relieved occasionally by a later, more low-key or eclectic phase of the Gothic style. On the other hand, the term 'international' is appropriate for so-called 'Burgundian' sculpture, which grew up suddenly around Claus Sluter, of whom it is known only that he was a stonemason in Haarlem in around 1380. At the Charterhouse of Champmol, this powerful artist liberated statuary from its architectural setting, into which it was nevertheless integrated by matching elements in the spatial environment. We know scarcely much more about Melchior Broederlam (to whom there are references during the period 1381 and 1401), a Flemish painter who also worked at the Charterhouse of Champmol. The perspective that predominates in the architecture of his altarpiece (the only one of his works that has survived, now in the Musée de Dijon) is somewhat idiosyncratic and shows similarities with perspective as used in some Sienese paintings. He achieves a sense of depth by his use of pathways winding between rocky masses towards the horizon in a series of zigzags: this 'coulisse' system of landscape was to be copied by other artists. The flowing drapery and the gracefulness of the Virgin and Child counterbalance the realistic details.

Illumination

Any consistency which the International Style managed to acquire was due to the journeys undertaken by artists (about which we know virtually nothing). It was also due to an art form which spread from the north of France, Burgundy and also the north of Italy: manuscript illumination.

NORELLI STILLE TINTORETTO TITIAN UCCELLO VAN DER WEYDEN VAN EYCK VASARI VERONESE VERROCCHIO ZUCCARO ALBERTI ALCANIZ ALLORI ALTDORFER AMBROGIO
BECCAFUMI BELLANGE BELLINI BONGO GNONE BERNINI BERRUGUETE BEQLEMAERT BONDOL BORTHI BOTTICELLI BOTTICINI ACIOLS BRAMANTE BRUNELLIAM BRUEGHN BRUNELLE
LES ACEHPANO DEVRUSSCO MULIER TANDEGA NANNI ESIRO KALLE PERUGELINO AFFROD2I DEFRANCO AMANDAR GIORGIONI GIORGIO DEL JULHRANSI JUTON UUROLIBROS PONTI ON
DECOCHI CONTANISROVAN EJRTANDEGA NANNI ESIRO KALLE PERUGELINO AFFROD2I DEFRANCO AMANDAR GIORGIONI GIORGIO DEL JULHRANSI JUTON UUROLIBROS PONTI ON
BOTTICELLI BOTTICINI BOULS BRAMANTE BROEDERLAM BRUEGUEL BRUNELLESCHI BUFFALMACCO CAMBIO CAMPAGNOLA CARAVAGGIO CARON CARPACCIO CARRACCI CAVAL

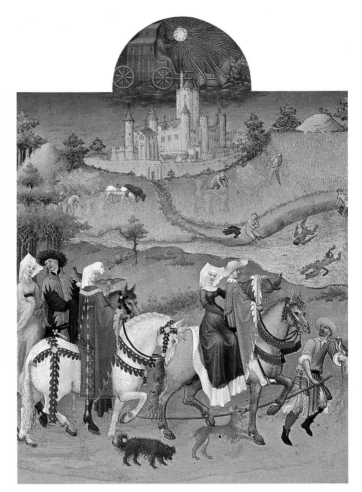

Pol de Limbourg and his brothers, *Les Très Riches Heures du Duc de Berry: August*, 1413–16 (Musée Condé, Chantilly). Scenes of everyday life and the passage of an astrological symbol in the sky are all bathed in a new, refined and tender light. In this way, something noble is made out of the familiar landscape, and the most delightfully realized concrete details in the picture have a dreamlike quality.
Photo © H Josse/T

This venerable art underwent profound changes during the *trecento*. It became a complex mode of expression independent of the illustrated text. A huge amount of trade was done in this field, primarily in Paris, which had been the centre for European commissions since 1250. The renowned French illuminator Jean Pucelle had already (before 1333) reproduced the Palazzo Vecchio in Florence in his work and seemed to be familiar with the work of Duccio. Colouration was transformed by the belated influence of stained-glass windows, but also by fine draughtsmanship and numerous experiments in perspective.

These experiments – of the 'herringbone' or 'doll's house' type – as well as techniques designed to draw the viewer into the picture or involving the placing of figures on different planes within the painting (Jean Bondol, c.1368), would also be familiar to the Franco-Burgundian masters of illumination working at the end of the century, who made their art into a miniaturized version of monumental painting. A single patron, the Duc de Berry, employed in turn André Beauneveu, Jacquemart de Hesdin and Pol de Limbourg and his brothers (before 1416). The Limbourg brothers succeeded in transcending all the conventions of a world in decline, which they

INTERNATIONAL STYLE AND HUMANISM

celebrated in their work: this was Gothic art at its most sublime, even as it was undermining itself. While their conventionally monotonous floral borders are as meticulously executed as they are elegant, references to Giotto and even to Taddeo Gaddi can be discerned in their compositions.

The Boucicaut Master of Hours (Jacques Coene of Bruges?), who is thought to have worked in Italy in around 1403 and who influenced Flemish easel painting, then in its infancy, deserves to be ranked almost alongside the Limbourgs. The other great centre for manuscript illumination was Lombardy: the miniaturists of Gian Galeazzo Visconti inaugurated a style that was meticulous (they worked on encyclopedia-type books which summarized medieval learning) and which featured numerous experiments in chiaroscuro (Giovannino de Grassi). A very fashionable artist, Michelino da Besozzo, contributed to the dissemination in Burgundy and France of the 'ouvrages de Lombardie', as they were called by French artists of the period.

As well as the Burgundian court, another centre for the development and influence of the International Style was the papal court at Avignon. It is worth briefly recapitulating its history at this point. The first exiled

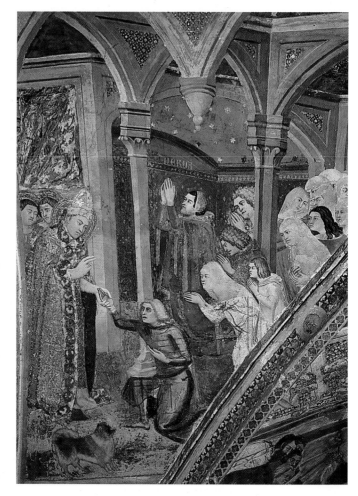

Matteo Giovanetti, *Saint Martial Resurrecting the Son of Nerva,* 1344 –5 (Papal Palace, Avignon). In an attempt to render spatial depth, difficult to appreciate in a fresco, the artist has included a variety of architectural elements – based on the actual architectural environment of Provence – arranged along vertical and horizontal lines. *Photo P Jehan © Larbor/T*

Bernardo Martorell,
*Saint George Killing the
Dragon*, 1438 (Art
Institute, Chicago). This
is a typical theme of
Christian legend, and
was depicted by many
artists of the time.
Martorell's dynamic,
rhythmic style remains
in the tradition of
Catalan Gothic, while
incorporating a formal
unity that echoes
Provençal and perhaps
even Sienese painting.
However, the way in
which the foreground,
middle distance and
background are
interconnected is
clearly lacking in
verisimilitude.
*Photo J Martin ©
Larbor/T*

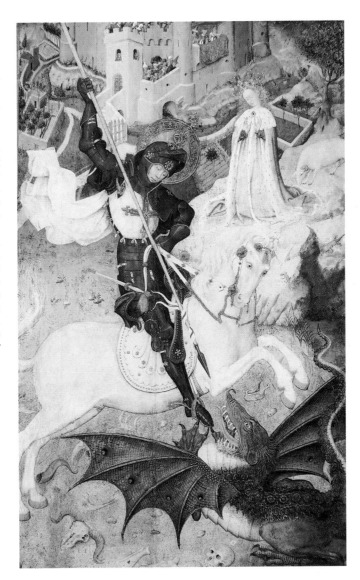

popes were great builders and displayed a zest for lavish splendour and
ceremonial in keeping with their diplomatic functions. Therefore, in
1339, Simone Martini (c.1284–1344) was invited to Avignon. In a career
that spanned 21 years, this Sienese master – who did not so much suc-
ceed Duccio as go against everything he represented – perfected the
expressive use of arabesques (for example, his *Annunciation*, 1333, Uffizi
Gallery, Florence) while developing a more unified and low-key style of
painting which showed he had absorbed the influence of Giotto. He died
in Avignon. Although only a few remarkable *sinopie* (preliminary sketch-
es) for the frescoes that he did for the Church of Notre-Dame-des-Doms
survive, a few panels from the time allow us to assess the role he played
in the emergence of Provençal painting. He was surpassed in this role only
by Matteo Giovanetti, whose art, although less precious and more intimate

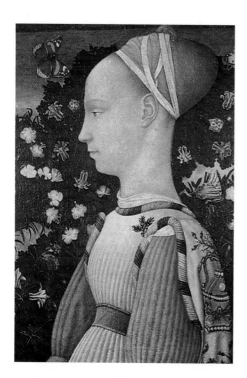

Pisanello (real name Antonio di Puccio di Cerreto), *Portrait of a Princess of the d'Este Family*, c.1438 (Musée du Louvre, Paris). The identity of the model (Ginevra d'Este or, more probably, Margherita Gonzaga) is of little significance. The idealized profile, with its pensive expression, stands out against a luxuriant background which is a blend of nature and tapestry. In the few paintings that he executed, Pisanello remained essentially a medallist. Photo H Josse © Larbor/T

than the art of Martini, was equally marked by the desire to transfigure reality. Giovanetti practised at the Papal Palace and in the surrounding area up until 1367, after which date the return of Pope Urban V to Rome, followed by the Grand Schism, led to a decline of artistic activity in Provence for some years. But the Provence School had been born: today we know that both Tuscan and Catalan artists visited the court at Avignon earlier than was originally supposed.

The first generation of Avignon artists were often anonymous, but they served as a crucial link in the diffusion of Italian art. The art of Avignon explains, despite their relative clumsiness, the appearance of 'southern' frescoes at Karlstejn Castle (Bohemia), the *Passion* by the Master of Trebon (c.1380) and the illuminations in the *Bible of Wenceslas* (1408). The Italianate elements in the work of northern French artists owe perhaps as much to the influence of the art of Avignon as to Italy itself. With regard to Spain, which had links with Avignon from around 1320, mention must be made of Miguel Alcaniz in Valentia and, after 1400, Luis Borrassa and Bernardo Martorell in Barcelona.

In Italy, the International Style was the product of a cross-fertilization between the sophisticated art of the illuminators and goldsmiths of Lombardy and the inheritance from Giotto. A disciple of Michelino da Besozzo, Stefano da Verona, is chiefly famous for having been Pisanello's master: he produced frescoes in Mantua, and he was a painter of animals (one of the first ever) and an energetic draughtsman. He was also a medallist who was to have countless imitators during the Renaissance. His taste for beautiful legends and fairytale landscapes coexisted with a tendency for direct observation (which anticipated Leonardo da Vinci). In other regions (Piedmont, Urbino), the international art of manuscript illumination could not hide the growing interest in realism. In Tuscany, many artists practised a hybrid style, resulting in some outstanding individual achievements. The phenomenon actually came about rather late: in Siena, the marvellous, semi-abstract Sassetta and his entourage (Sani di Pietro) continued to use Florentine perspective without embracing the rationalism that underlined it. However, they belong to the *quattrocento*, like Giovanni di Paolo, whose work is characterized by a harsher, more extensive mysticism. Part of the latter artist's work shows an unexpected curiosity about natural phenomena, and even about cosmology, which was going through a crisis at the time. In Florence, Lorenzo Monaco may be considered the most eminent representative of the International Style

BECCAFUMI BELLANGE BELLINI BORGOGNONE BERNINI BERRUGUETE BLOEMAERT BOISPOT BOSCH BOTTICELLI BOTTICINI BOUTS BRAMANTE BROEDERLAM BRUEGEL BRUNELLE
IRA AVELIJSANO DONATELLO DUBEN EL GRECO FRIARLE FOUQUET GENTILE DA FABRIANO GOTHLRO GUTFRIENDALO CISNEROS ONA GUOTTO GIOVANNI PISANO GIRUS AVAN DE
FRAACHLO BUCCARI VASARI BACANTA ATIO ALI JINDORENA AMERICO ISO HEYFRD IL ROMANCO CAMBIO CAMPAGNOLA CARAVAGGIO CAROSO CARPACCIO SFICO DA SESTA
BOTTICELLI BOTTICINI BOUTS BRAMANTE BROEDERLAM BRUEGEL BRUNELLESCHI IL ROMANCO CAMBIO CAMPAGNOLA CARAVAGGIO CAROSO CARPACCIO SFICO DA SESTA

Giovanni di Paolo, *The Madonna of Humility*, c.1445 (National Art Gallery, Siena). In this treatment of a popular theme of piety, Giovanni di Paolo resorts, as he often does in his work, to a radical simplification of the landscape. Here he reduces the world outside the garden to a patchwork (featuring fields, rocks and villages) suspended beneath the sky. This might appear archaic but, in fact, it reflects the artist's quest for formal purity. The painter deliberately eschews realism here, and this has sometimes been misinterpreted as a 'rejection' of the Renaissance. *Photo © Alinari/ Giraudon*

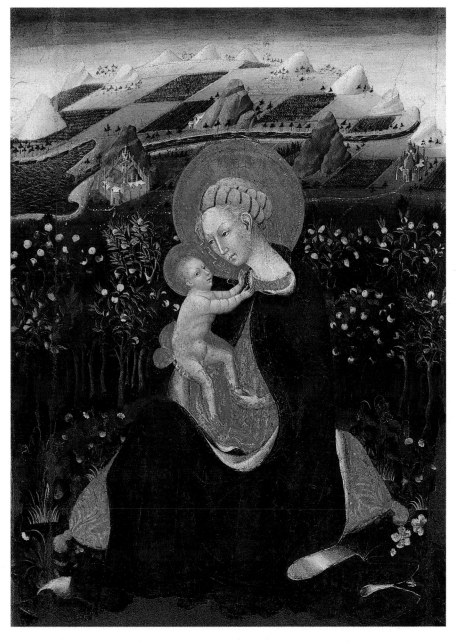

(c.1410–20) in his formalistic tension, his use of vivid colours and his indifference to spatial problems; but the painter who dominated this period not only in Tuscany (of which he was not a native) but also in Rome, Gentile da Fabriano (c.1370–1427), went beyond this style. If we compare his *Adoration of the Magi* to that of Lorenzo Monaco (both works are in the Uffizi Gallery in Florence), we see that the latter gathers his figures together into a frieze, whereas Gentile breaks up the conventional pictorial space of the triptych and includes a winding procession of horsemen. The three scenes featured on the predella are delightfully inventive in their treatment of light, but at the same time attentive to the concrete presence of the legendary world. The saints of the *Quaratesi Polyptych* (1425, today dispersed between London, Florence, the Vatican and Washington) and a few late Madonnas show, in their monumental aspect, that Gentile's alleged archaism is indeed relative.

The process of osmosis referred to earlier in this chapter makes it difficult to form a clear idea of the lives of certain artists, and means that works sometimes have to be attributed on a rather uncertain basis. If the somewhat mediocre painter known as the Master of the Bambino Vispo (who is thought to have trained in Spain) is in fact Gherardo Starnina (who is known to have travelled in Spain), then Starnina cannot be the

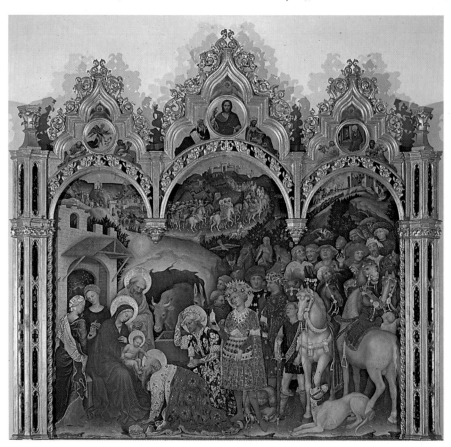

NOKPUT SITTER TINTORETTO TITIAN UCCELLO VAN DER WEYDEN VAN EYCK VASARI VERONESE LEMUL CHU LAYTICINI ALUTS KRAMANTE BRODERLAM BRUEGEL BRUNELLE
ACHAMI BELLANGE BELLINI BORGOGNORE BERNINI BERNINI QUEE BLOEMAERT CABRIOEL CANETTI CHI CHITRANSVALE CIMON RIGGON CLOUET GIORGANNI IMANO CIRUS RAVELLINA
HUANCHO ANGOLO VERROCINO UCCELLO CEITANIN CARACCINI DEREGNO REANI FRANKEL ANDREA ARPEGGIANOS ANONI DEPASCHI CHINO AISA CHINO ISA CHINO ISA
BOTTICELLI BOTTICINI BOUTS BRAMANTE BROEDERLAM BRUEGET BRUNELLESCHI BUFFALMACCO CAMBIO CAMPAGNOLA CARAVAGGIO CARON CARPACCIO CARRACCI CRIVINI

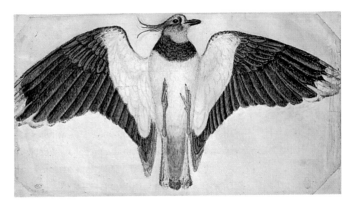

Pisanello, *Study of a Lapwing*, c.1437 (Musée du Louvre, Paris). This drawing, rendered in ink and water-colour, is a reminder that, from the beginning of the Renaissance, interest in scientific observation extended to all areas of nature. *Photo H Josse © Larbor/T.*

painter of the charming *Thebiad* in the Uffizi Gallery (c.1410?), which is traditionally attributed to him – unless we assume a stylistic hiatus which makes it even more difficult to trace the development of a career about which we know all too little as it is.

However, throughout this period there was a non-formal element whose development is evident wherever the International Style is well-documented: illuminated manuscripts display a large number of subjects and ornaments borrowed from secular classical antiquity, and even from paganism. In 1430 Philip the Good created an order of knighthood dedicated to the Golden Fleece (not to a saint), reflecting a mindset that had been widespread for a long time, and not only at the Burgundian court.

The Avignon School was contemporaneous with the birth of Italian humanism, and with Petrarch. The poet, whose *Triumphs* spawned a whole series of paintings (panels, miniatures, etc), was the proud owner of a painting by Giotto. Meeting Simone Martini at Avignon, he asked him to provide illustrations for a Virgil manuscript and suggested a frontispiece (today in Milan) celebrating Virgil not as a medieval sorcerer but as a poet capable of appealing to scholars through his universal vision. We also know that Petrarch commissioned portraits of Laura and of Napoleone Orsini from Master Simone. Unfortunately these paintings, which would make their creator the first painter of individual portraits since classical antiquity, are now lost. Furthermore, according to one attractive theory, Girard d'Orléans, probably the painter of the first known French portrait (*Jean le Bon*, c.1365, Louvre, Paris), is said to have been familiar with the work of Simone Martini. But Petrarch, an avid collector of manuscripts, was not alone in taking an interest in art: his friend Boccaccio heaped lavish praise on Giotto and left anecdotes about the artist's life. Working on the compilation of a dictionary of mythology, he made no secret of the fact that the purpose of his work was to provide poets and artists with a reservoir of imagery. Indeed, Petrarch had described the statues of ancient classical gods in a poem, although he based his descriptions on unreliable medieval texts, whose emphasis he shifted (from naive admiration to intense nostalgia): we shall see what were the consequences of this shift in emphasis.

Gentile da Fabriano, *Adoration of the Magi*, 1423 (Uffizi Gallery, Florence). The luxuriousness of the haloes and ornamentation, requested by the extremely wealthy client who commissioned this painting, is in fact the only 'medieval' element in the picture. The warm colours are toned down, as though enshrouded. The same figures reappear on three different levels, a depiction of space in three different zones that was previously unknown in painting. Discreetly innovative techniques of draughtsmanship link these levels in a single rhythmic perspective, which reinforces the visual impact of the arrival of the procession of admirers in the foreground. *Photo Scala © Archives Larbor/T*

AT THE CROSSROADS OF THE
CENTO AT THE CROSSROADS
OADS OF THE QUATTROCENTO
ENTO AT THE CROSSROADS
FOLLOWTO AT THE CROSSROADS
OADS OF THE QUATTROCENTO
ENTO AT THE CROSSROADS OF
F AT THE CROSSROADS OF THE

AT THE CROSSROADS
OF THE QUATTROCENTO

Donatello, *The
Annunciation,* 1433–5
(bas-relief tabernacle
sculpture, Church of
Santa Croce, Florence).
Most probably
executed after the
sculptor's visit to
Rome, this relief
sculpture of gilded
stone makes lavish use
of motifs from classical
antiquity in the dec-
oration and in the folds
of drapery. The graceful
and restrained pose of
the Virgin was to
inspire numerous
variations in *quattro-
cento* Tuscan painting.
Photo Scala, Florence ©
Larbor/T

In 1404, the construction of Orsanmichele in Florence, one of the
extremely rare examples of Flamboyant Gothic architecture in
Tuscany, finally came to an end. We should not be deceived by the length
of time it took to complete the building (construction work had begun in
1330) into thinking this indicates a sense of continuity. This exact peri-
od coincided with the upheaval that ushered in the Renaissance – an
upheaval which necessarily involved a break with the practices of the
past. Two revolutions would dominate a short phase (roughly 1420–50)
in the history of art, and nothing would ever be the same again. The first
revolution was of a highly ideological nature: a radical return to the
sources of classical antiquity, in an interpretation which, under the influ-
ence of humanism, deliberately promoted a heroic image of man. This
revival of classicism happened first of all in the fields of sculpture and
architecture. At the same time these two art forms were viewed in a pre-
cise theoretical context: that of perspective as the organizing principle
of a homogeneous space. The other revolution was a revolution in terms
of technique: the development and spread of oil painting. Oil painting

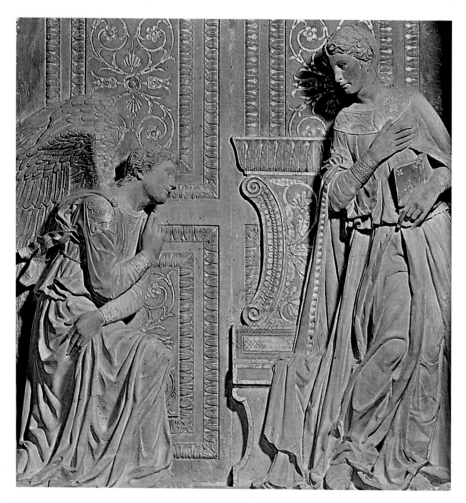

CANALETTO MULLER CANO ORELLU JOHAN CASPER PIRAN LEE SVLVIUS VAN EYK VASARI VERONESE VERROCCHIO CVJACI ALBERTI ALCANIZ RIJOEN ALTDORFER AMBROGIO DE PREDIS PANINI SAN-ACRO CASTELLO HONOR GNORE BERNINI BERNAQUILEI SENEMERI BONRACCORRI BOSCHI BOTTICELLI CIVRIANO NOTICINI ROOTS BRAMANTE BROEDERLAM BRUEGEL BRONZINO BRANCHON NICCOLO CASTELLO OTRISTO PIERO FRANCESCO CASTAGNO ORISTELLO PIERO PIERO PIERO BONO BRUEGEL BRUNELLESCHI BRUTUS ABATI CASTELLO BOTTICINI BOTTICELLI ALBERTI ALCANIZ ALTDORFER AMBROGIO ORIENTE ARCIMBOLDO BRUNELLESCHI BRUTUS MANTEGNA RUBENS CARAVAGGIO CARO CARRACCIO CARRACCIO DA

Donatello, *The Prophet Habakkuk*, 1423–6 (Museo dell'Opera del Duomo, Florence). One of the four statues (two are now lost) that Donatello executed to adorn the Campanile of the Duomo in Florence. Donatello himself nicknamed it 'Zuccone' (pumpkin-head): the expressive, almost coarse intensity of the face, for which Donatello used a life model, contrasts with the bold, simplified sweep of the drapery, which was inspired by Roman statuary. *Photo ©Alinari/ Giraudon*

had been known about since around the 12th century, but had been so little used that doubt had been cast on its very existence prior to the advent of its modern form, which was invented in Flanders and quickly spread throughout the countries around the Mediterranean.

When Salutati, the Chancellor of Florence, proclaimed his native city to be 'The New Rome' in 1403, he was echoing the view of Petrarch at a time when Rome was incapable of carrying on the venerable tradition it had inherited from classical antiquity. The influence of literary human-ism also made its mark in 1401 on the brilliant early career of the sculp-tor Ghiberti (the author of the first autobiography by an artist to have survived into the modern era). He submitted the win-ning entry in a competition for the design of the second door of the Baptistery (the first, by Andrea Pisano, had been inaugurated in 1336). It would take him 20 years to honour his contract, and another 25 years to complete the third door, the commission for which was granted to him following the enthusiasm which greeted the second. This third door (1452) presents for the first time a story whose narrative is con-tinued from one panel to another. Ghiberti proudly included his own portrait (along with those of his assistants) in the door. The background is highly animated, depicting a world of living creatures despite the cramped surface areas: bodies, drapery, buildings, rocks, ani-mals – all are modelled harmoniously. While nothing is really presented in relief, some of the effects give the impres-sion of sculpture in the round. The use of gold heightens the effects resulting from the play of light, but stops short of sheer virtu-osity. The influence exerted by Ghiberti should not be underestimated, although we know that he did not keep pace with artis-tic developments in his old age. He had a considerable impact on painters: both Uccello (who had been his assistant) and Gentile da Fabriano were subject to his influence. He had an even stronger impact on sculptors, and there are obvi-ous similarities between Ghiberti and Donatello (works in Siena, 1417–27).

The early work of Donatello (*David*, 1408, Bargello, Florence) shows affinities with the Burgundian style, but his

Lorenzo Ghiberti, floral decorative motifs, c.1440 (north door of the Baptistery, Florence). This delightful doorframe, as suitable for a palace as for a religious building, was executed by Vittorio Ghiberti, the son (b.1416) of the great sculptor, from his father's design. Typical of the continued development of the *quattrocento* in the direction of the Renaissance, this, or something very like it, might have been created a hundred years later.
Photo Scala © Larbor/T

Saint John the Baptist (Bargello, Florence), completed shortly afterwards, is a work of austere solemnity. He developed under the influence of his friend Brunelleschi. His bas-relief sculpture of *Saint George* (1420) is governed by strict laws of perspective. In collaboration with Michelozzo (who was essentially an architect), he produced major works for Prato Cathedral as well as in Siena and Naples. The influence of Late Romanesque art is evident in his busts and in the cantoria of Florence Cathedral, where his secular versions of *putti* (Cupid figures disguised as cherubs) were an inspiration to sculptors and painters: large numbers of these would feature in art for centuries to come. His bronze *David* (exact date unknown) borrows its sinewy litheness from Hellenic art. In 1443, Donatello erected his first equestrian statue in Padua, the *Gattamelata*: his influence on northern Italian painters (such as Mantegna) and also – through his relief sculptures at Sant'Antonio – on Uccello can be attributed to his long stay in Padua. His last Florentine works developed 'heroic' realism in the direction of a tragic vision that is sometimes over-wrought, while the superb rhetoric of his *Judith* (1455) quickly became popular with the public.

With Filippo de Ser Brunelleschi, we are no longer dealing with a man of the Middle Ages (despite his dates), but with the first of those archetypal multi-faceted geniuses that characterized the Renaissance. Originally a maker of bronzes and a monumental mason, he found himself competing with Ghiberti (1401) for the door of the Baptistery in Florence. His model (which has been preserved) shows him to have favoured a somewhat harsher style. Later, his carved wooden *Crucifix* would win a friendly competition between himself and Donatello. Essentially an architect, he was also an engineer (fortifications, theatres, etc) and would take out an 'industrial patent' for a paddleboat designed for crossing the Arno.

Probably in 1418, he carried out the famous experiments in perspectival painting ('Brunelleschi's peepshow') which, perhaps initially designed as architectural exercises, were nevertheless to have a decisive effect on pictorial theory and art history. These two small panels (which were kept for a long time in the Medici collections) were to be the foundation, either directly or indirectly, for the entire thinking of the Renaissance concerning vision. It was in the same year that Brunelleschi obtained the commission for the completion of the cathedral (the 'Duomo') in Florence, which he would finish in 1436. Judged an impossible task, the dome (minus the lantern which, based on his drawings, was added after his death) was primarily inspired by the Pantheon, despite the somewhat Gothic profile of the double-shell structure and the slight influence of modest Romanesque constructions in a similar vein (Cremona or even Pisa). Brunelleschi went to Rome several times with Donatello: in around 1402, 1417 and 1430 at least. He decided on and oversaw the erection of the dome with unusual speed.

This stupendous achievement, which remains a mystery in many respects, was complemented by other masterpieces: the portico of the Spedale degli Innocenti (1421), whose broad arches are suspended on surprisingly slender columns; the Pazzi Chapel of Santa Croce; the Old Sacristy of San Lorenzo; the design for the Palazzo Pazzi (executed by Giuliano da Maiano in around 1465); the cloister of Santa Maria Novella; the design in the shape of a Latin cross for Santo Spirito; the plan for a rotunda with multiple domes (unfinished, at Santa Maria degli Angeli); and last but not least it was probably Brunelleschi who devised the original design for the Palazzo Pitti.

History offers us few examples of one individual having such an important intellectual influence: Brunelleschi's theories had an immediate impact on the meteoric career of Masaccio (1401–28), the first Florentine painter to have rediscovered the spirit of Giotto in a different context. Working in 1423 with Masolino, a man 20 years his senior – a precious painter still portraying dreamy scenes in the courtly tradition while showing an interest in 'infinitist' perspective – Masaccio magisterially applied, in the frescoes he executed for the Brancacci Chapel of Santa Maria del Carmine in Florence, the lessons he had learned from

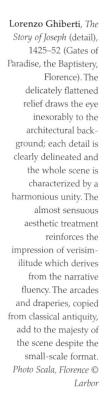

Lorenzo Ghiberti, *The Story of Joseph* (detail), 1425–52 (Gates of Paradise, the Baptistery, Florence). The delicately flattened relief draws the eye inexorably to the architectural background; each detail is clearly delineated and the whole scene is characterized by a harmonious unity. The almost sensuous aesthetic treatment reinforces the impression of verisimilitude which derives from the narrative fluency. The arcades and draperies, copied from classical antiquity, add to the majesty of the scene despite the small-scale format. *Photo Scala, Florence ©Larbor*

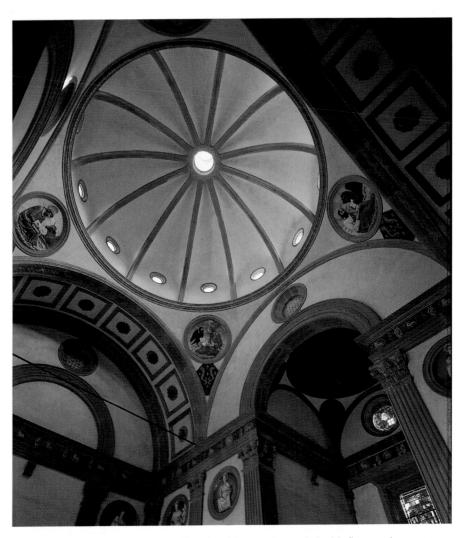

Filippo Brunelleschi, dome of the Pazzi Chapel, 1429–46 (Florence). A masterpiece of architectural harmony, whose modest proportions manage to convey a sense of classical amplitude by virtue of their lightness. Some of the medallions, all of which were executed by Donatello and Luca della Robbia, may have been designed by Brunelleschi.
Photo © Dagli Orti

Brunelleschi. The pictorial space is peopled with figures who are sometimes tragic (*The Expulsion of Adam and Eve*) but who are, above all, always endowed with a forceful dignity: both saints and minor figures from the Bible are put on the same level. These are not ghostly figures, for they have shadows (the definition of living bodies, according to Dante) and 'stand firmly on their feet', as Vasari was to put it. The expressive dimension was subordinated to the dictates of form, which itself was governed by the desire to create a monumental composition that did not exclude the modelling of individual details. The same mastery is evident in the famous *Trinity* in the Church of Santa Maria Novella, a masterpiece whose classicizing elements were inspired by Brunelleschi, and in the *Polyptych* in Pisa. However, Masaccio died at the age of 27 and had hardly any immediate successors. As for Donatello, he did not exert as much influence in the field of sculpture as his lesser followers, Desiderio da Settignano and Mino da Fiesole, whose work was

considered more 'pleasing', but whose gracefulness should not lead us to overlook the vital creative inspiration that Donatello provided time and time again.

As well as these, mention should be made of the Rossellini brothers, who were architects as well as sculptors. As for Luca della Robbia, he did not fulfil the promise he showed early on in his career (around 1435): the discovery of enamelled terracotta and his intense involvement in the family workshop resulted in the creation of a huge number of sentimental religious figures of a very mediocre standard. Then there is the lone, isolated figure of Jacopo della Quercia (d.1438), a Sienese sculptor who worked chiefly in Lucca and Bologna and was distinguished by his bold, robust style.

At around the same time, the end of the Great Schism meant that Rome regained some of its previous importance as a city (1417). Prompted by Pope Martin V, who was a scholar and an archaeologist, Gentile da Fabriano, Pisanello, Masaccio and Masolino all came to work in Rome. Although at first Provence was overrun by marauding bandits, the Avignon School did not lose its vigour entirely (Thouzon altarpiece, 1410), but its centre of gravity shifted. In 1438–41 the Count of Provence, René d'Anjou, who laid claim to the throne of Naples, brought with him to this Italian city the team of artists – of mainly northern European origin (Flemish, Burgundian, or even Parisian) – who had been part of his entourage at Aix. He was an aesthete and a distinguished connoisseur of art (even, according to tradition, a painter), and in Naples his entourage sharpened his appreciation of the southern light. It appears that he also brought to Naples (as part of an intricate web of reciprocal influences) knowledge of the new Netherlandish painting. However, before focusing on the Netherlands, let us briefly summarize the history of the Aix School.

After René d'Anjou's definitive return to Aix, an artist who for a long time remained anonymous painted the masterpiece the *Triptych of the Annunciation*. He has been convincingly identified by modern critics as one Barthélemy d'Eyck, the King's 'page'. The painting reveals traces of the influence of the Neapolitan artist Colantonio, based on the rare surviving works of that master. In 1452-4, Enguerrand Quarton, who had previously worked with Barthélemy, painted *The Coronation of the Virgin* (Villeneuve-lès-Avignon) and that other jewel of Provençal painting known as the *'Avignon' Pietà* (Musée du Louvre, Paris). A profusion of minor works

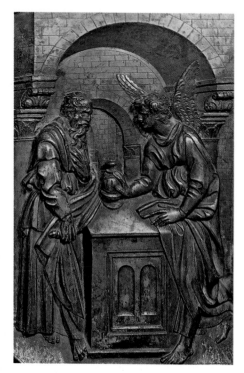

Jacopo della Quercia, *Zacharias in the Temple*, 1417–27 (Baptistery of Saint Giovanni, Siena). This sculptor, a forerunner of Michelangelo and most certainly influenced by Burgundian art, firmly sets his powerful figures against a Roman-style background.
Photo © Scala/T

41

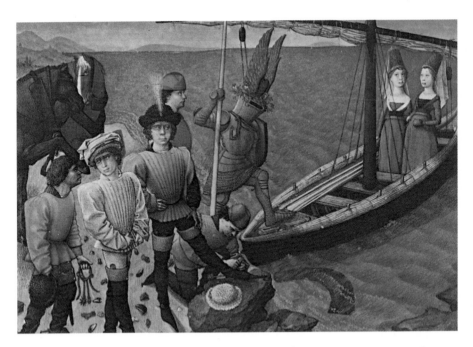

Master of the Cueur
d'Amour Espris,
*Cueur boards a boat,
with Fiance and Entente
already on board,*
c.1465–70
(Österreichische
Nationalbibliothek,
Vienna). Following the
rather verbose text of
the poem (1457), the
figures are based on
medieval allegories.
However, the skilful
way in which the
transparency of the
water and the
luminosity of the
horizon are rendered
and the highly unusual
composition are
indicative of artistic
ambitions alien to the
courtly convention.
Photo © the Library/T

attests to the vitality of the school up to around 1476: Nicolas Froment
(*The Burning Bush*, Aix-en-Provence Cathedral) displays both an exten-
sive knowledge of Italian innovations in painting and a certain overem-
bellishment that can be traced to Flemish influences on his work. A lone
figure, the Master of the Cueur d'Amour Espris (could it be Barthélemy
again?) illustrated the long archaistic poem written by René d'Anjou. The
style he used for this was exquisite: sunlit and moonlit scenes were
depicted in a hitherto unfamiliar manner and imbued with an atmo-
sphere of mystery. With Lieferinxe and, later, Dipre, we come to the end
of the century (and to a 'classicism' that echoes the art of northern
France). The Avignon School also flourished in Nice (with the Bréa broth-
ers, in around 1475), perpetuating a trend that was both popular and
'international'. The more feudal version of this produced the last paint-
ings of the Gothic era on the fringes of Burgundy: the Master of Moulins
(c.1490) would also later be identified as a Dutchman living in France,
Jean Hey.

However, Flemish painting seems to have sprung up spontaneously,
beginning with one of its greatest masters, Jan van Eyck. A manuscript
illuminator, valet de chambre and confidant of Duke Philip the Good, in
whose service he carried out diplomatic missions to foreign countries,
notably to Portugal in 1428, Jan van Eyck (1390/1400–41) began his
career with the spectacular Ghent altarpiece, *Adoration of the Lamb*. He
died relatively young, leaving behind, in particular, portraits of remark-
able intensity.

Oil painting as he had developed it (and which would not really replace
tempera painting techniques for several decades to come) meant that it

BELLINI SELLAER TINTORETTO TITIAN UCCELLO VAN DER WEYDEN VAN EYCK VASARI VERONESE VEROCCHIO OTTO-CARO AELBER DI ALANTE ANTONI ALTDORFER AMBROSIUS DE
CAFFI SELLAER BELLINI BONICO GNONE BERNINI BERRUGUETE BIO CEMARI CARRIANI BORGCH BOTTICELLI BOTTICINI BOUTS BRAMANTE BRONZINI JAN BRUEGHEL BRUNELLESCHI
ANGELO NICOLO MASIO BACHER IAMIGIANINO BATENIR PERINI PERUGINO PIERO DELLA FRANCECCA PIERO DEL COSIMO PINTURICCHIO POLLAIUOLO PONTORMO
TICELLI BOTTICINI BOUTS BRAMANTE BRUEDERIAM BREDEGEL BRUNELLESCHI BUTTALMACCO CAMBIO CAMPAGNOLA CARAVAGGIO CARON CARPACCIO CARRACCI CAVALLIN

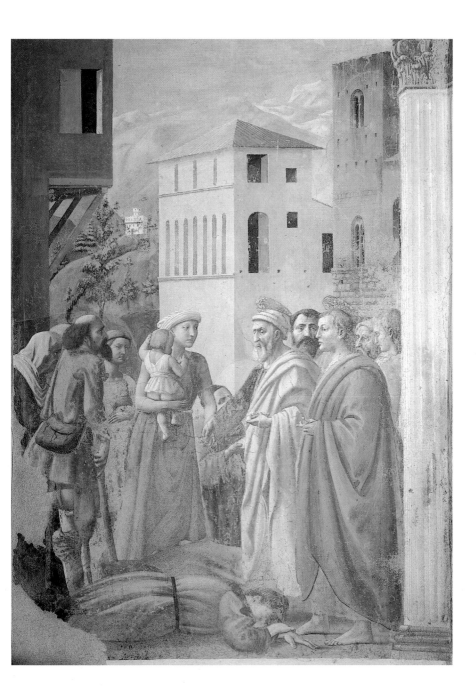

Masaccio, *Saint Peter Distributing Alms and the Death of Ananias*, 1426–8 (fresco in the Brancacci Chapel, Santa Maria del Carmine, Florence). This fresco shows the sudden and decisive emergence of rational architecture into narrative painting, and not only on the level of the setting. The figures are portrayed directly against a background treated 'realistically' (in accordance with perspective) but are not outlined against it: their volume is an integral part of their solemnity. The same stylistic tension pervades the landscape and the figures, who are imbued with a sense of their dignity as human beings (the man lying at the feet of the apostle has in fact just been struck down by divine justice). *Photo © Alinari/Giraudon*

Rogier van der Weyden, central panel, triptych of the *Seven Sacraments: the Crucifixion*, c.1445 (Musée Royal des Beaux-Arts, Antwerp). Known especially for his *Last Judgement* at the Hospital of Beaune, the Flemish painter here shows his skill in the sophistication of the architectural details and in his dramatic depiction of suffering and grief. *Photo Lou © Larbor/T*

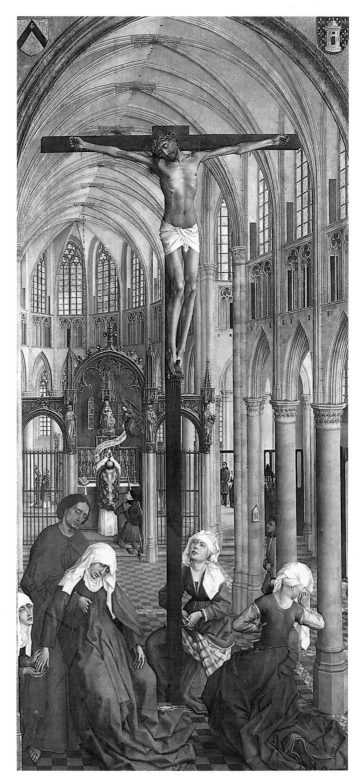

Antonello da Messina, *Christ at the Column*, c.1470 (Musée du Louvre, Paris). A variation on a familiar theme of this artist, whose success was assured by the numerous pastiches made of his work. The extreme delicacy of the execution is complemented by a certain restraint in the expression of pathos. Trompe l'œil details already point towards illusionism, the hallmark of technical accomplishment.
Photo © R G Ojeda/RMN

Antonello da Messina, *Entombment of Christ*, c.1473 (Museo Correr, Venice). Despite the very poor condition of this painting, we can see in it the poetic inventiveness (the angels), the anatomical knowledge and the distinctive luminosity which were characteristic of the great Sicilian painter.
Photo G Tomsich © Larbor/T

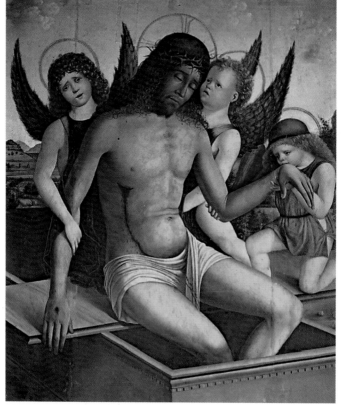

was now possible to achieve hitherto undreamed-of effects of light and chromatic transparency (*The Rolin Madonna*, c.1430, Musée du Louvre). He helped to steer painting towards realistic representation, to make trompe l'œil the hallmark of verisimilitude and to suggest that realism was the ultimate goal in art. But in his work (as in that of his Provençal or Italian imitators) the pure delight taken in the subject matter and the rather rarefied atmosphere are again paramount.

His successors in Flanders – including Petrus Christus, Dierick Bouts, Ouwater, Geertgen tot Sint Jans and Gerard David – all show the same delightful appeal, in differing degrees, but without attaining his excellence. They do not in any way overshadow van Eyck's two immediate rivals, Robert Campin (the Master of Flémalle, 1378/9–1444), whose geometrical manner lends an air of strangeness to everyday details, and Rogier van der Weyden, a dramatic interpreter of the traditional religious repertoire, although the anxiety of the humanist Renaissance is occasionally reflected in his work (*Christ* in the *Braque Triptych*, Musée du Louvre, Paris).

Van Eyck's genius meant that his work was to have a wide-ranging influence, whose precise ramifications are uncertain. Only his influence can explain the emergence of Konrad Witz in Switzerland, or even the emergence of Stephan Lochner (d.1451) in the Rhineland. Gothic craftsmanship both dispersed and renewed itself at various crossroads – which sometimes became the sites of new schools – leaving by the wayside those who could not keep up with its development. Compromise is all too obvious in the work of the German Michael Pacher (d.1498), an admirer of both Donatello and Mantegna.

North of the Loire, mention must be made of one very great artist who, apparently, stood outside the sphere of intense Flemish influence. This was Jean Fouquet (c.1420–77/81), whose career remains obscure. His monumental art – influenced perhaps by his familiarity with the manuscripts of the Limbourg brothers (he was a manuscript illuminator throughout his life) – centres on a journey he made to Rome in 1446; he was at the time a highly regarded court portraitist. Whether in the *Melun Diptych* or in the superb *Nouans Pietà*, the scale of conception, the subtle boldness of the colours and a rigorously geometrical approach show him to be a master. At the beginning of the century, painting in Burgundy and Flanders was often illumination on a larger scale; but Fouquet's illuminations, with their remarkable atmospheric clarity, seem to be miniature pictures, especially the *Antiquities of the Jews* (which dates from before 1475). The large number of works attributed to him – exemplified in the *Hours of Étienne Chevalier* (before 1461) – show an Italian influence; they are also remarkable for their sensitive evocations of the landscapes of Paris and the Touraine region. His works were plundered by his imitators – Bourdichon, Jean Colombe and, later, Perréal – but all that these artists did was to produce pleasing pictures based on his innova-

Jan van Eyck, *The Arnolfini Wedding Portrait*, 1434 (National Gallery, London). A great deal has been written about this painting, much of it beside the point. The young woman is not in fact pregnant, but is lifting her heavy ceremonial gown in a traditional gesture. The small dog symbolizes fidelity. In the mirror at the far end of the room, in the position occupied by the viewer of the picture, we can see two 'witnesses' to the wedding, which the painting commemorates but does not describe. According to one very plausible theory, one of these witnesses is none other than the artist himself, proudly putting his name to his tour de force ('Jan van Eyck was here'). *Photo E Tweedy © Larbor/T*

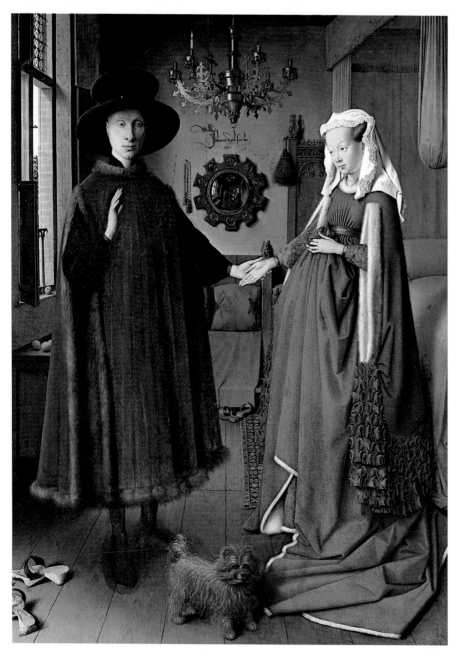

Michael Pacher, *Saint Wolfgang Altarpiece: the Circumcision of Christ*, detail, 1471–81 (Church of Saint Wolfgang, Salzkammergut). Italian perspective, ostentatiously applied, emphasizes the angular folds of the vividly coloured garments in a semi-abstract vision. *Photo © Leonard von Matt/T*

tions. His *Self-Portrait* (Musée du Louvre, Paris) is the first French painting to show signs of influences from beyond the Alps.

Burgundy's centre of gravity had shifted (from 1420 onwards) from Dijon to Bruges. Flemish workshops produced illuminators, weavers and goldsmiths, who travelled far and wide. When painters from Flanders became known in Italy, their realism banished the last vestiges of the courtly style; but this realism was reinterpreted by the Italian artists with the emphasis on clarity and stylization. Antonello da Messina immediately set an example: in his short career, which he began in Naples as a pupil of Colantonio, this great innovator was inspired by Flemish painting with regard to representational technique (he was to introduce Eyckian oil painting to Milan and then to Venice, in around 1470). But he must also have come across Tuscan art (around 1460?): the attention given to the model is complemented in his work by a delicate precision unknown before this time (*Virgin Annunciate*, Palermo); and traditional symbols are arranged in a pictorial space already structured in terms of Renaissance ideas (*Saint Jerome in his Study*, London).

IN AND AROUND
FLORENCE

Fra Angelico, *Coronation of the Virgin,* 1434 (Musée du Louvre, Paris). Only the throne and the haloes are 'Gothic': the composition of this picture is typical of the way paintings were structured during the Renaissance. In a celestial atmosphere, all the elements combine in a paean to the art of pictorial representation itself (the marble décor and rich garments, the variety of facial expressions, etc) which is loosely inspired by the teachings of Thomistic scholasticism.

In around 1450, Florence became the intellectual capital of the West. The city, which had succeeded in eclipsing Genoa, Lucca, Siena and Pisa economically, had been dominated since 1434 by Cosimo de' Medici. Heir to the ancient family business, banker to the Holy See – in 1439 he played host to the ecumenical council which, it was hoped, would reunite the Roman and Greek Orthodox Churches – he set himself up as an arbitrator and peacemaker in Italian affairs. He was dedicated to culture: he had the Convent of San Marco rebuilt (and decorated by Fra Angelico), he was a patron of Filippo Lippi and he sponsored Uccello. Above all, he collected objets d'art (statues, paintings, antique cameos, pieces of gold and silver, etc) and made his collection available to artists. A protector of the humanists (Marsilio Ficino, who translated Plato) and the wave of scholars who had fled Byzantium, Cosimo invented the system of artistic patronage, and was immediately imitated in this by the princes who ruled the small courts throughout northern Italy. His court architect Michelozzo carried on the tradition of Brunelleschi (the Villa Careggio, the Palazzo Medici-Riccardi). Cosimo's son Piero only ruled

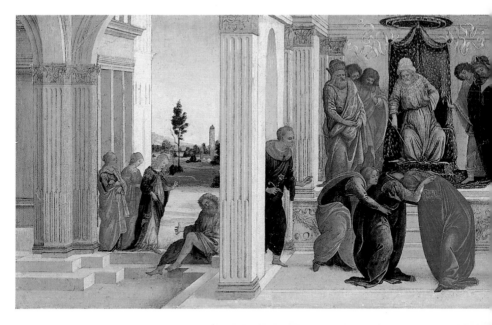

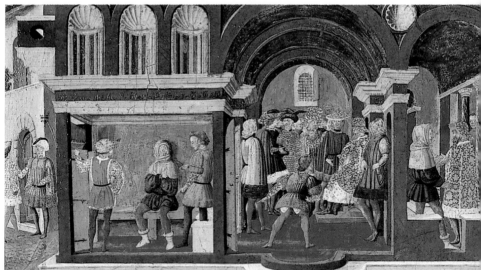

Top:
Filippino Lippi
Three Scenes from the Story of Esther (detail), c.1480 (Musée du Louvre, Paris). An outstanding example of a 'story' spread out over two *cassoni*, the six

panels of which originally formed a whole and are today dispersed throughout the world. The complex chronological sequence of the biblical story (taken from the *Book of Esther*) is somewhat

disrupted by the use of recessed scenes depicting minor episodes. The young Filippino Lippi here shows that he is already master of his medium, but this painting contains none of the whimsical

exuberance of his later work. Here he aims for a confident treatment of perspective and light, in which skilful simplicity and translucent colours are appropriate to the symbolism of marriage.
Photo © RMN

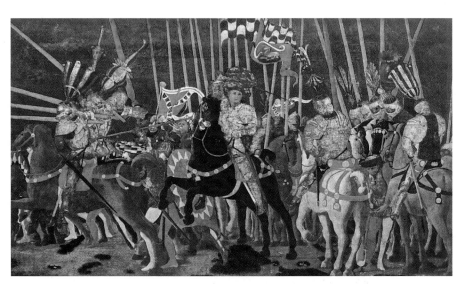

Paolo Uccello, *The Battle of San Romano*, third and final episode, 1456 (Musée du Louvre, Paris). There is great stylistic unity between one panel and the next. The horses, suits of armour and standards are broken up into volumes and recomposed, not for 'cubist' reasons, but as a way of inviting the viewer to reflect on the stability of appearances. The mêlée portrayed resembles a piece of marquetry, with bright non-realistic colours on a background set very high up and against the light, thus emphasizing the ghostly appearance of the figures.
Photo © Focus/T

Filarete (1400 to after 1465), who designed the hospital founded by Sforza in Milan (1465) and who was also the sculptor of the bronze doors of the Vatican: he dedicated his meticulous picture of an imaginary city filled with pagan-inspired architecture (including the churches) to Piero de' Medici. Simone del Pollaiolo (1457–1508), known as Il Cronaca (the Chronicle) was to finish the Palazzo Strozzi (begun in 1489) in the same typically Florentine style: massive on the outside and light and delicate inside.

Finally, the Medicean villa *par excellence*, at Poggio a Caiano (Giuliano da Sangallo, 1485), bears no resemblance to a fortified castle and opens delightfully onto a natural setting. Giuliano (1445–1516), the first of the 'three Sangallos', a craftsman discovered and given patronage by Lorenzo, adjusted effortlessly to humanist sophistication, and indeed to notions that Brunelleschi had left undeveloped. The author of archaeo-logical studies, he was also an innovator (the Church of the Madonna delle Carceri in Prato, the courtyard of the Palazzo Gondi in Florence, the sacristy of the Church of Santo Spirito, as well as fortified villas). Even before 1490, he was being imitated in Naples.

At the same time, sculpture was slowly relinquishing the guiding role it had had at the beginning of the century, even in relation to painting. It developed a tendency for ornamental eclecticism (Benedetto de Maiano) before complying with Alberti's injunctions and incorporating numerous classicizing motifs (Agostino de Duccio). Alberti played such an impor-tant role – perpetuated by the posthumous reputation he enjoyed among scholars – partly because he intervened authoritatively in the debates on perspective.

These debates do not, in themselves, account for the singularity of Paolo Uccello (1397–1475). Too often regarded as a late representative of Gothic or as a 'comic' artist, he began his career in rather difficult cir-cumstances as an apprentice to Ghiberti, and then as a mosaicist in

IN AND AROUND FLORENCE

Piero della Francesca, *The Invention of the True Cross: the Queen of Sheba*, detail, 1452–9 (Church of San Francesco, Arezzo). In this damaged fresco, a fusion of landscape and figures is achieved in a space defined by numerous subtle effects of light, transcending a style that is deliberately inexpressive and grainy and that looks as if it is enamelled or glazed. *Photo Scala © Larbor/T*

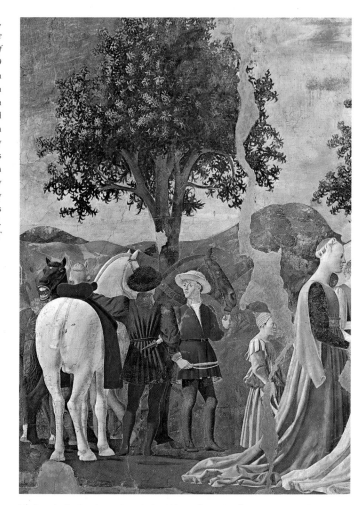

Venice. In Padua he painted the *Giants* (now lost), which was admired by Mantegna, and in Bologna he painted a *Nativity* (fragments of which have recently been found) which is wholly humanist in inspiration. In Florence his career – the chronology of which remains very much a matter of debate – was dominated by *The Battle of San Romano* (1456, dispersed between Florence, London and Paris), painted for the Medicis, and by the frescoes of the Chiostro Verde (Green Cloister) at the Church of Santa Maria Novella. An enigmatic artist (*Miracle of the Host*, Urbino), a skilled practitioner of bifocal perspective, which he dismantled and reconstituted as he saw fit, and an occasional imitator of the relief sculptures of his friend Donatello, he arranged volumes and colours with no concern for realism other than that conveyed by the atmosphere (*Hunting Scene*, Oxford) rather than the action.

We are scarcely better informed about the background of Piero della Francesca (c.1416–92). Born on the borders of Tuscany, this painter and mathematician was influenced by Masaccio (c.1450) but surpasses him in the subjection of perspective to a strikingly rigorous geometry. He

EL ANGELICO NICOLA PISANO PACHER PANNINI MASACCIO MATISSE MEMLING MERIANO PATINIER GHIRLANDAIO GIORGIONE GIOTTO GIOVANNI PISANO GRÜNEWALD HO
CCHIO VAN EYCK SYBERG ANTELAMI NUOMI HISTORY DOMEN ANTONIO FLORIGERO IL VECCHIO ANDREA DEL CASTAGNO UNTORICCHIO GIOVANNI LO TOLI LIPPI DI VINCI
LIPPI GHIRLANDAIO GIORGIONE GIOTTO GIOVANNI PISANO GRÜNEWALD HOCHEN FRANCESCO ANGELICO CARAVAGGIO CARAVAGGIO GIOVANNI DA VINCI LIM
STEFI GHIRLANDAIO GIORGIONE GIOTTO GIOVANNI PISANO GRÜNEWALD HOCHEN FRANCO JEAN DE BOULOGNE DA VINCI LIMBOURG LIPPI LORENZETTI LOTI

showed his artistic allegiance in Arezzo in the fresco cycle *Discovery of the Wood of the True Cross*. The light, spacious and limpid, but almost inhuman, atmosphere in these frescoes becomes more mellow in several Madonnas that the artist executed later in his career (although these are still fairly austere), a balance being achieved in the panel *The Flagellation of Christ* (Urbino). The painter codified his highly cerebral art in several written works published after 1470, but it was his paintings and frescoes which, in the short term, influenced Antonello da Messina and Giovanni Bellini, and some time later Perugino and, through him, Raphael. Soon forgotten in the 17th century, rediscovered more recently (and perhaps excessively praised), Piero della Francesca rid painting of a certain element of pathos. He had fewer disciples in Florence than in Urbino, the Veneto, and especially in Rome and its surrounding region (Lorenzo da Viterbo, 1469), where his influence was quickly spread by Melozzo de Forli and Antoniazzo Romano.

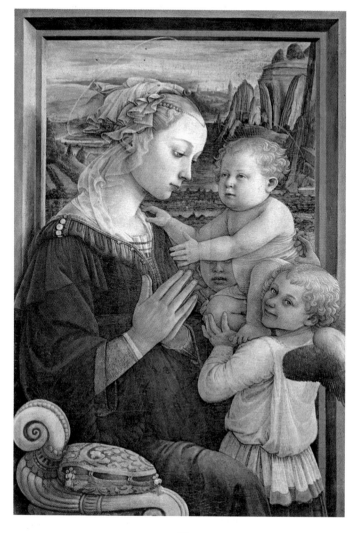

Filippo Lippi, *Virgin and Child with Angels*, c.1465 (Uffizi Gallery, Florence). The only Florentine master not to have depicted Christ's Passion, Lippi bridged the gap between Masaccio's solemn style and the popular fashion for more accessible images of religious devotion. But it would be wrong to focus too much on this emphasis on joyfulness (which led him to use his mistress as the model for his Madonnas): this would mean overlooking the perfect harmony of this famous painting, and the daring way in which the Virgin and the interceding angel with the bewitching smile are effectively placed outside the painted frame which forms a window.
Photo Scala © Larbor/T

IN AND AROUND FLORENCE

Antonio Pollaiuolo, *Tomb of Sixtus IV*, detail, 1493 (Vatican Grottoes, Vatican City). One of the bronze reliefs which adorns the tomb of the archaeologist Pope Sixtus IV. The word 'Astrologia', according to a custom going back to Plato, here appears to refer to astronomy, a science promoted by the deceased. The flowing folds of drapery and the enraptured expression of the face are worthy of note in a decorative scheme in which every detail (down to the sandals) is exquisitely rendered in a Hellenistically inspired style. *Photo Scala © Larbor/T*

A different stylistic approach informs the work of the most famous Florentine painter of the period, Filippo Lippi (1406–69). The colourful adventures of this monk, who had no vocation for the Church, have detracted from a serious examination of his work. A novice at the Santa Maria del Carmine monastery at the time when Masaccio was painting there, he never equalled the dramatic intensity of the latter artist's work but kept his structural harmony (in the lines of the composition and the invisible lines that seem to be created by the gazes of the figures), infusing it with a tenderness which made him, unjustly, the specialist in Madonnas. He gave a more physical form to Fra Angelico's vision while prefiguring the subtle undulating lines of Botticelli. His frescoes (Prato, Spoleto, etc) attest to the extent of his culture and his optimisim.

The same temperament informs the peripatetic career of Benozzo Gozzoli (c.1442–97), a pupil of Fra Angelico in Rome. Far from incurring the displeasure of his patrons as has been claimed, his famous version of the *Procession of the Magi* (1482, Palazzo Medici-Riccardi) – representing, in fact, the Council of Florence – resulted in commissions at Volterra, San Gimignano, and later Pisa. His narrative skill and his delightful inventiveness counterbalanced his artless excess. In almost total contrast, Andrea del Castagno (d.1457) emphasized more austere values: he glorified the life force of the human body and transposed perspective into lack of depth.

The fame of the Pollaiuolo brothers, Antonio (1431?–98) and Piero (1443?–96), derives mainly from the multiple talents of the elder brother. A goldsmith, binder of art books and designer of embroidery, he was the first artist to feature the male nude in an engraving and in frescoes. His rare paintings (c.1480) are remarkable for their anatomical vigour, for the use of aerial perspective – allowing an immense background (not layered as in the work of the Flemish painters) to recede within the pictorial space without entirely vanishing – and for a kind of exuberance in the use of pagan allegories and myths. He was also an outstanding

Andrea Verrocchio,
Bartolommeo Colleoni,
1482–8 (Campo dei
Santi Giovanni e Paolo,
Venice). Erected after
the premature death of
the artist, this majestic
statue of a Bergamo
condottiere in the
service of Venice had
been requested in
Colleoni's will in
exchange for a
substantial bequest to
the Venetian Republic.
'The finest equestrian
statue in the world' and
a stylized vision of the
'hero' dear to the
Renaissance, it was to
have a huge influence
on sculpture, and
indeed on painting, up
until the Baroque era.
Photo Scala © Larbor/T

sculptor. He impressed Mantegna, Dürer and Michelangelo. His brother
and collaborator seems to have been given several commissions for
paintings on the basis of Antonio's fame: the linear intensity and rich-
ness of colour which were Antonio's hallmark appear cumbersome in
Piero's work.

A restorer of antique art pieces for the Medicis, Verrocchio (d.1488)
was also influenced by Donatello as a sculptor, but his fame derives from
his painting workshop (where mathematics and music were discussed):
no painting can be attributed with certainty to Verrocchio alone. Among
his assistants were Lorenzo di Credi, Perugino and Leonardo da Vinci at
the beginning of their careers.

The Ghirlandaio workshop was more firmly focused on painting. The
eldest son of this prolific family, Domenico (1449–94), placed the fresco
in an intimate, almost photographic, narrative framework. The fact that
the bourgeoisie found themselves cosily reflected in his anecdotal paint-
ings (cycles of Santa Trinita and Santa Maria Novella) should not cause
us to overlook his truly scientific approach to portraiture, its humanist
implications, his measured and clear style – elegant but firm – and the
discreet emotion involved in his evocation of
Florentine life around 1480–90.

Sandro Botticelli (1445–1510) had no
luck at all. His fame has (for the last
hundred years) hinged on a group of
Madonnas which were for a long time
confused with those of Lippi, and on
the *Mystic Nativity*, which he execut-
ed late in his career. Contemporaries
praised his *aria virile* (viril air) and
his knowledge of perspective, before
an absurd fashion suddenly

IN AND AROUND FLORENCE IN AND
AND AROUND FLORENCE IN AND
AND AROUND FLORENCE IN AND
AND AROUND FLORENCE IN AND
AND AROUND FLORENCE IN AND
AND AROUND FLORENCE IN AND
AND AROUND FLORENCE IN AND
AND AROUND FLORENCE IN AND
D AROUND FLORENCE IN AND

IN AND AROUND FLORENCE

transformed him into the precursor of the sentimental Pre-Raphaelites. A determined artist, he portrayed complex allegories bathed in the light of Tuscan gardens (*Primavera*) and painted the first true female nude (*The Birth of Venus*) with the same skilful simplicity with which he depicted his Madonnas, who are more childlike than maternal. His work is the expression in art of the Medicean world, full of references to the unattainable but desirable glory of the Platonic ideal of beauty. Despite a persistent legend, there is no tangible proof that this serene and visionary painter, who sometimes displayed a lightness of heart (*The Madonna of the Magnificat*), was seriously shaken by the prophecies of Savonarola.

In conjunction with Botticelli, mention must be made of Jacopo del Sellaio, a skilful creator of *cassoni*, and Francesco Botticini, a not untal-

ROSSELLI SISLEY TINTORETTO TITIAN UCCELLO VAN DER WEYDEN VAN EYCK VASARI VERONESE VERROCCHIO ZUCCARO ALBERTI ALCANIZ ALTORI ALTDORFER AMBROGIO DA PREDIS ANGELICO BALDUNG BELLINI BERRUGUETE BLOEMAERT BORDONE BOSCH BOTTICINI BOUTS BRAMANTE BRUEGHEL LE JEUNE BRUEGHEL LE VIEUX BRUNELLESCHI MICHELANGELO NICCOLÒ PISANO PACHER PARMIGIANINO PATINIR PERUGINO PIERO DELLA FRANCESCA PIERO DEL POLLAIUOLO PISANELLO POLLAIUOLO PONTORMO POLLAIUOLO ZOCCHIO ROBERTI ROMANO ROSSO ROSSELLI FIORENTINO SARTO SASSETTA SIGNORELLI SOGLIANI TADDEO DI BARTOLO CARACCIOLO CARAVAGGIO CARPACCIO CASTAGNO CATENA CAVALLINI CIMABUE ALBERTI GHIRLANDAIO GIORGIONE GIOTTO GIOVANNI PISANO GRÜNEWALD HOLBEIN INGRES JEAN DE BOULOGNE LEONARDO DA VINCI LIMBOURG LIPPI LORENZETTI LOTT

ented imitator of his near namesake. Botticelli was responsible for the designs of several marquetry pieces at Urbino. This art form had already acquired importance with the work of Giovanni da Verona and Damiano da Bergamo. Its development was affected by experiments in perpective, and was marked by the influence of Piero della Francesca (and the Lendinara brothers in Modena). Marquetry eventually produced some outstanding trompe l'œil achievements which could hold their own with Flemish painting (*Pontelli*, in Urbino).

Influenced at first by his father Filippo and Botticelli, Filippino Lippi (1457?–1504) intensified the pathos found in their work, alternating such paintings with brilliant decorative schemes full of archaeological allusions; then the 'Roman' style of Mantegna modified, indeed

Domenico Ghirlandaio, *The Funeral of Saint Francis*, c.1483 (Santa Trinita, Florence). A first-class fresco painter who skilfully absorbed the most diverse influences, Ghirlandaio manages to breathe new life into a theme which some might have thought the Giottoesque painters had exhausted. He does this by inserting the dramatic scene into an everyday setting which he treats with virtuosic skill, both as regards landscape and architecture (the giant candles increasing the sense of depth, for example). The figures are depicted with a 'realist' sense of variety and a technical finesse which had already made an impression on Vasari.
Photo © Alinari/ Giraudon

Botticelli

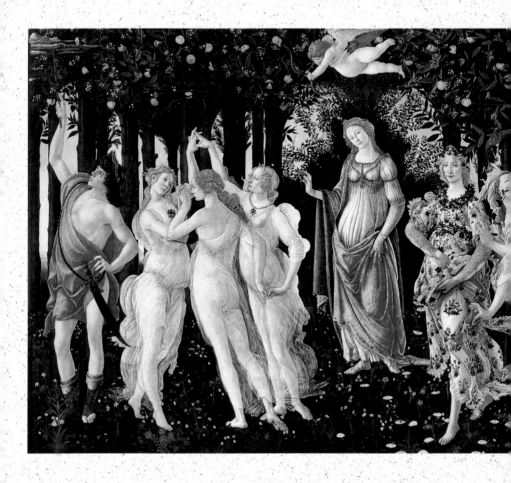

Above:
Primavera ('Spring'),
c.1478 (Uffizi Gallery,
Florence). The picture
could well be entitled
'The Reign of Venus'. The
goddess, depicted here in
terms of the Humanitas
(civilized harmony) of the
humanists, gently directs
the dance of the Three
Graces, while Mercury
halts the clouds. On the
right, the nymph Chloris
('the verdant one'),
courted by Zephyr,
undergoes a surprising
dual incarnation to
become the goddess
Flora, the poetic
personification of Spring.
*Photo © Nimatallah-
Artephot/T*

The Virgin and Child with John the Baptist, c.1470 (Musée du Louvre, Paris). An exquisite work. Botticelli introduces a new atmosphere – one of mutual trust between Madonna and Child – into a peaceful natural setting: the poetry of Virgil comes to mind. The details of precious items in the foreground are evidence of familiarity with the art of Verrocchio.
Photo Hubert Josse © Larbor/T

The Birth of Venus, detail, c.1484 (Uffizi Gallery, Florence). The expression of the goddess – as though amazed to find herself in the world – is rightly famous, but it has unjustifiably been interpreted as being melancholy (in the modern sense). The painting is closely modelled on a poem by Angelo Poliziano, who was acquainted with the Medicis. The writhing hair conveys the quivering of the luminous air surrounding the beautiful apparition who is being blown by the Zephyr's breath towards the land.
Photo Scala © Larbor/T

1445. Birth of Alessandro Filipepi, later nicknamed Botticelli. He serves his apprenticeship in a goldsmith's, which he leaves to go to work in Lippi's workshop.

1470. He becomes the owner of his own workshop and paints *Allegory of Fortitude* for the Court of the Mercanzia.

1472–5. He paints several versions of *The Adoration of the Magi* and numerous 'Medici' portraits.

1478 (probable date). He paints *Primavera*, for Lorenzo di Pierfrancesco.

1480. He paints frescoes at the Villa Lemmi (fragments preserved in the Louvre, Paris) for the Tornabuoni family.

1481. He is called to Rome along with Cosimo Rosselli, Perugino and Ghirlandaio by Sixtus IV (decoration of the Sistine Chapel).

1482–4. Back in Florence, he obtains numerous commissions from the Medicis: *Pallas and the Centaur, The Birth of Venus*, and finally (for Lorenzo de'Medici) *Mars and Venus*.

1483. For Lorenzo, known as Lorenzo the Magnificent, he executes four *cassoni* recounting *The Story of Nastagio degli Onesti*, based on the version by Boccaccio.

1485. *The Madonna of the Magnificat*, the most famous of his *tondi*.

1488. *Annunciation* at Santa Maddalena degli Pazzi.

1491. He is appointed to a committee in charge of adjudicating a project for the façade of the Duomo. It is probably at this time that he executes the *Calumny of Apelles* in accordance with a humanistic programme proposed by Alberti many years before.

1495. At the instigation of Lorenzo di Pierfrancesco, he begins a series of remarkable drawings illustrating *The Divine Comedy*.

1498. He works for the Vespucci (*Stories of Virginia and Lucretia*).

1501 (January). He finishes the *Mystic Nativity* (London): the only one of his works which is dated and authenticated by a very unclear autographical inscription in Greek. The few paintings executed after this date have survived only in a fairly poor state of repair.

1503. He is mentioned in a Florentine poem as one of the celebrities of contemporary painting.

1504. He is a member of the commission charged with finding a site for Michelangelo's *David*.

1510. Botticelli dies on 17 May. Neither poor nor forgotten, he is buried in the cemetery (today the Chapel) of the Ognisanti.

AND AROUND FLORENCE IN AND
ND AROUND FLORENCE IN FLO
ND AROUND FLORENCE IN AND
AND AROUND FLORENCE IN FLO
ND AROUND FLORENCE IN AND
ENCE IN AND AROUND FLO
J AROUND FLORENCE IN AND

IN AND AROUND FLORENCE

Right-hand page:
Andrea Mantegna,
The Bridal Chamber,
ceiling oculus, c.1473
(Palazzo Ducale,
Mantua). The eight
putti grouped around
the parapet are
inspired by Donatello,
with the black woman
attesting to the
documented presence
of African slaves at the
Mantuan court. The
peacock symbolizes
Juno, the goddess of
marriage. The
consummate artistry of
this masterpiece was to
have an influence on
all painting, from
Correggio onwards, as
well as on the
Mannerist and Baroque
domes executed
(notably) by Jesuit
specialists up until the
18th century.
Photo © Scala.

radically altered, his well-ordered compositions (the Strozzi Chapel of Santa Maria Novella). He worked in Spoleto, in Patro and even in Rome. An important place for Tuscan painting outside Florence was the town of Arezzo – a cultural centre since the discovery in medieval times of Greek-style Roman pottery ('Aretine ware'), and the site of intensive artistic activity. Arezzo was where the great painter Spinello Aretino made his career (at the end of the *trecento*). Aretino was succeeded by Bicci di Lorenzo, and then by Piero della Francesca.

As for Siena, a humanist tendency emerged there as a result of Donatello's stay in the city: this was initially reconciled by Vecchietta with local tradition, but was then boldly asserted in the work of Francesco di Giorgio Martini (1439–1502). The latter – a sophisticated painter showing affinities with Botticelli – was instrumental in taking the traditional artistic practices specific to Siena (Matteo di Giovanni, c.1470; Girolamo di Benvenuto, 1498) in the direction of the Renaissance. An architect in the mould of Alberti, as well as a sculptor and decorator, Francesco was also one of the great engineers of history (he designed hydraulics and fortifications). He worked not only in Siena

Cosmè Tura,
Pietà, 1468 (Museo
Correr, Venice). Tura's
severe style of
draughtsmanship,
common to most artists
in Ferrara, highlights
his Paduan training,
from which he also
retained his taste for
craggy landscapes. A
German influence is
also probable, both in
the formal eccen-
tricities and in the
symbols (the monkey is
the emblem of sin
'frightened' by the
death of Christ, which
announces the
Redemption.) The
intense dramatic
emotion is reflected in
the almost cruel
distortions of anatomy.
Photo © Titus/T

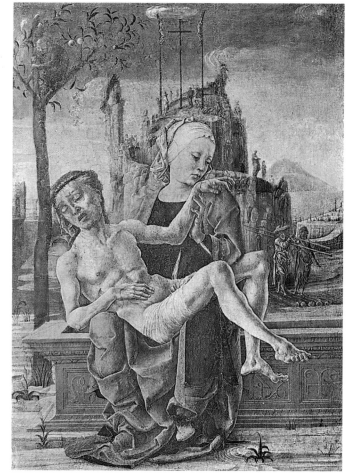

but also in Cortona, Rome, Naples, Milan and especially Urbino.

As the example of Gentile da Fabriano shows, there had been connections between Tuscany, Umbria and the Marches for a very long time. The influence of the growing circulation of works of art is particularly evident in the case of Luca Signorelli (1445–1523). Born in Cortona, a disciple of Piero della Francesca (1475), he completed the fresco cycle at the Cathedral of Orvieto (1499–1502) that had been begun by Fra Angelico, adding *Damned Souls Consigned to Hell* and *Antichrist* (doubtless intended as a condemnation of Savonarola) in a style which owed more to Pollaiuolo than to anyone else, and which was to make an impression on Michelangelo.

Signorelli's emphasis on linearity counterbalanced the colouristic effects he strove to achieve in his work, giving his painting an original power (*Annunciation* at Volterra), while his picture of *The School* (or *Realm*) *of Pan* (destroyed) was an evocation of the world dreamed of by Lorenzo de'Medici (whose humanist friends compared him to Pan) exe-

Luca Signorelli,
Dante at the Gates of Purgatory, fresco medallion, 1499–1500 (Orvieto Cathedral). In the decorative scheme at Orvieto, Signorelli puts the poet of *The Divine Comedy* on the same level as the poets of classical antiquity (Homer, Virgil). This episode in Dante's journey to the afterlife is treated by the painter in his most austere style: clear contours, monochrome colours and very heavy chiaroscuro.
Photo Scala © Larbor/T

cuted in the same vigorous style, but pervaded with a melancholy mystery. It is hard to tell the difference between the work of his main assistant, the Florentine Bartolomeo della Gatta, and his own.

For two centuries Padua had been a cultural metropolis: its university was renowned for its school of non-orthodox Aristotelian philosophers, its doctors and its botanists, and the memory of Roman history was very much alive there (Livy was a native of the locality). It was in this atmosphere that Andrea Mantegna (1430–1503) emerged. Initially the pupil and servant of Squarcione – a rather curious figure who was a dealer in antiquities, a swindler and an amateur painter – Mantegna subsequently freed himself. His art, although dominated by references to antiquities and natural curiosities, was altered through the influence of Donatello, and later Florentine art. He was the official painter of the Gonzaga family in Mantua (1459), and his paintings feature obsessively reconstructed historical architectural settings (*Triumph of Caesar*, Hampton Court), characterized by the same tension that informs the mural paintings which he executed within the setting of a private suite of apartments (*Bridal Chamber*, Mantua). He left an inexhaustible repertoire of motifs derived from Classical antiquity (*Parnassus*, Mantua). His is a wholly cerebral art, with a tragic anatomical power (*Saint Sebastian*, c.1470, Kunsthistoriches Museum, Vienna, and c.1480, the Musée du Louvre; *Dead Christ*, c.1481, Brera, Milan) and at the same time full of erudite allusions: an idiosyncratic, almost dreamlike, version of the desire for heroism that characterized the early *quattrocento*.

His formal innovations were quickly taken up by the artists of the Ferrara School, who retained his rigid, hard forms, subjecting them to further adaptation (in the wake of van der Weyden's stay in Ferrara). The decoration of the palace of the d'Este family, the Schifanoia, marked the climax of Ferraran art (c.1470): an imposing set of frescoes (Cosmè Tura, Francesco del Cossa, Ercole de'Roberti) executed according to a complex programme. In these frescoes, the cosmos is linked with the life of the court and the people. This is a fascinating, if slightly clumsy, reflection of the spirit of the Renaissance, at the time when Regiomontanus, Copernicus's master and protégé of Pope Sixtus IV, was openly criticizing the Ptolemaic astronomical system with its immutable skies. The signs of the zodiac and the planets had formerly been manifestations of divine order (as can be seen in the work of the Limbourg brothers), if not of a terrifying destiny. The use of the entire pantheon of pagan deities, both major and minor, transformed them into symbols of an organized system

CAEDMON SULLER UNFORELLIJ JULIAN GILGEHU VAN DER &STUEN LYON EUX XAXAN VERONESE VERROCCHIO AVELLANO AURELIUS AMANZ ANDON ALLI GHIBER AMERI KHY BE
MELANGE MANTEGNE BELLINI BOUKO GNONE RIENTO BEKKOGOULTE BEGEMAERY JENSEN BOSCHT BOTTIGLIANI SOTTICINI CUOLO HUMANITE FRONTINI JAN CRI VURON BAWDHI LBE
LASGUIO NICOLA PISANO JACHUE LIZARHGIM UNO OU FINI PERNU PERUGINI PIERO DELLA FRUGLIO IERO MALLAI TANGER CAPPERO DAI COSTA PONTO WIRGO ANCHIANO NO PONTAIO DA XANTUN
FECELLI RO USANI BOTUS BRUUNNE BROTIFREAN BREUGEL BRONWARIG FU RUEN MAREG JEAN DE ROMAGNOL LEONARDO DA XARIVO DA VINCHIRIMOUR AG LIPPI FLRESZ LELTIVIT
ART GHIRLANDAIO GIORGIONE MIOTTO GIOVANNI PISANO GRUNEWALD HOLBEIN MAREG JEAN DE ROMAGNOL LEONARDO DA VINCI DA VINCI

Hugo van der Goes, *Portinari Triptych: The Adoration of the Shepherds*, central panel, 1476–8 (Uffizi Gallery, Florence). A disciple of van Eyck, the artist had only a short career (he suffered from mental illness). Delivered to Florence in 1480, this triptych was very influential there, although the extent of this has often been exaggerated. It juxtaposes elements that were already archaic (tiny kneeling donors, monotonous facial expressions) with details depicted with masterly realism, heightened by a bold harmony of predominantly warm and light colours. *Photo © Giraudon/T*

of mythology, but one which was no longer insensate. From now on, man, alone in the universe, was neverthless not lost, for the Platonic system of universal analogy reconstructed an inhabitable world.

Central Lombardy (Milan), the home of manuscript illumination, was introduced to great painting by Vincenzo Foppa (c.1460), but it was the arrival of Leonardo da Vinci (1481) which was to make a profound impact. The art of Mantegna and the Ferraran painters was emulated more in Padua, Bologna (Zoppo, c.1460) and Venice. Dominated for a long time by Byzantine canons, the local style only shook off this influence with the emergence of Lorenzo Veneziano and especially Jacobello del Fiore (c.1400), who was acquainted with Gentile da Fabriano. The Tuscan Renaissance reached Jacopo Bellini and Antonio Vivarini in successive waves. However, in 1454 Mantegna married Jacopo's daughter and brought Paduan sophistication to the Venetian workshops: this was expressed even more vividly in the work of Crivelli and, to a lesser degree, in the Murano School (Bartolommeo Vivarini). The Paduan influence was absorbed most markedly by Gentile Bellini, who experimented with new perspective theory, and especially by Giovanni Bellini. The latter incorporated the light of Antonello and the spatial effects of Piero della Francesca into his paintings (1465–80).

This phenomenon spread to workshops that up until then had been quite ordinary affairs, and this in the volatile political climate of the Most Serene Republic of Venice: Alvise Vivarini (in Venice itself), Montagna (in Vicenza), Cima de Conegliano – a whole series of minor masters who were far from insignificant. In Venice, Cima de Conegliano produced paintings of mythological subjects alongside religious subjects, and the crystalline purity of his landscapes prefigures Giorgione. Bellini's grand style introduced Venice to the Renaissance at its height.

FROM ROME
TO VENICE

A t the very end of the *quattrocento*, several artists – not all of whom were native to the city – met in Florence. One of these, Perugino (c.1445–1523), was a pupil of Verrocchio, but he hailed from Umbria and showed a clear interest in Domenico Veneziano and Piero della Francesca. He did not share his masters' preoccupation with order and relief; he concentrated instead on spatial composition based on a tiered sequence of planes, consisting of foreground, middle distance and background, and in particular on the rendering of a 'natural' light. Real Tuscan skies appeared, sometimes combined with contemporary architectural settings in biblical or even mythological scenes (*Apollo and Marsyas*). The art of Perugino went into decline after 1505 and his reputation is today unjustly discredited.

The same could be said about Pinturicchio (1454–1513), a Sienese artist who was something of a maverick and whose lush, delicate and meticulous manner blended, not entirely smoothly, with a vein of classicizing archaeological erudition reminiscent of Filippino Lippi. Having worked extensively in Rome (the Sistine Chapel in 1481, the Borgia apartments which he began in 1491 and worked on until 1510), he produced his best work in Siena, in the fresco cycle of the Piccolomini

Piero di Cosimo, *Simonetta Vespucci*, c.1503 (Musée Condé, Chantilly). The title is based on a romantic tradition and an inscription at the bottom of the painting, which X-ray photography has revealed to be apocryphal. The painting probably represents Cleopatra (note the asp, the cloak which is probably just an oriental rug, and the pearls in her hair) and has an allegorical meaning which is now lost to us. An extraordinary lyricism emanates from the relationship between the profile, which seems to gaze quizzically into space, and the landscape, where threatening clouds rise up in the background.
Photo H Josse © Larbor/T

SELMI BELLANGE BELLINI BERRUGUETE BERNINI BERRUGUETE BLOEMAERT BOSCH BOTTICELLI BRAMANTE BROEDERLAM BRUEGEL BRUNELL
SELMI BELLANGE BELLINI GENTILE BELLINI GIOVANNI BERRUGUETE BLOEMAERT BOSCH BOTTICINI BOTTICINI BOUTS BRAMANTE BROEDERLAM BRUEGEL BRUNELLI D
ANGELO NICOLA PISANO DAGHER PARMIGIANINO PATINIR PESELLINO PIERO DELLA FRANCESCA PIERO DI COSIMO PONTORMO POUSSIN RAPHAEL REMBRANDT
ICELLI BOTTICINI BOUTS BRAMANTE BROEDERLAM BRUEGEL BRUNELLESCHI BUFFALMACCO CAMBIO CAMPAGNOLA CARAVAGGIO CARON CARPACCIO CARRACCI CAVAL

Perugino (real name Pietro Vannucci), *The Crucifixion*, 1493–6 (Convent of Santa Maria Maddalena dei Pazzi, Florence). This fresco is an example of the manner of the Umbrian master at its best. It is arranged like an easel painting of horizontal format. What is important is not so much the scene itself as the opportunity which it affords for the expression of emotion: the Virgin kneeling in contemplation, the sorrowful admiration of Saint John. The event belongs to the past but the emotions are timeless. The clear landscape heightens this impression: it has no depth other than that of the sky, and it is framed within three fake Roman arches, which give the illusion of shallow projection from the wall. *Photo © Scala/T*

Library of the Duomo (*Life of Pius II*, 1504) and for the tyrant Pandolfo Pettrucci (*Story of Ulysses and Penelope*). Piero di Cosimo (1462–1521) was the heir, via Cosimo Rosselli, of a Florentine tradition of craftsmanship which set little store by intellectual ideals, but he nevertheless revealed his sensitivity to these ideals in his mysterious, sometimes ironic, works. His naturalistic tendency – even more so than in Flemish painting – found inspiration in unusual mythological subjects which were at the same time materialist and dreamlike and which revealed a hypochondriac temperament: *The Discovery of Honey, The Forest Fire, Vulcan and Aeolus, The Battle of the Centaurs and the Lapiths*. In the course of his opportunistic career he enjoyed the patronage of both the Medicis and their rivals.

Florence in Crisis

The close of the *quattrocento* was a time of terrible crisis for Florence. The unexpected death of Lorenzo the Magnificent (1492) left power in the hands of his son, the incompetent Piero. For several months, the city had been shaken to the core by the prophecies of Savonarola. This monk inveighed against Pope Alexander VI and predicted the vengeance of God in the guise of an impending calamity: when the French then invaded Italy, Piero fled in terror (1494). The popular uprising that is said to have taken place is a myth: the Medici palace was only pillaged after the art collections had been removed from it, most of them being sent to Rome for safe-keeping. A fanatical theocrat, Savonarola behaved by turns

69

brutally and irresolutely in his dealings with a moderate, 'republican' but ultimately useless Signoria. His influence on art was as brief as it was disastrous: for a carnival (his second attempt at it was to be a failure) he revived the medieval custom of the bonfire of the vanities where frivolous items, including perhaps drawings and paintings, were burned. The city was racked by a civil war between his supporters, the 'weepers', and his enemies, the 'mad dogs'. Excommunicated, attacked even from within his own order (the Dominicans), Savonarola was arrested and put to death (1498). Frightened by the attack on the monastery of San Marco, a young painter – a pupil of Perugino and Rosselli, and a reluctant member of the 'weepers' – vowed to become a monk if he escaped: this was Fra Bartolommeo, noted for his imposing compositions and taut but delicate draughtsmanship. With the modest Albertinelli (they painted pictures together), he was to pave the way for Raphael's classicism (c.1500) before subscribing to it himself.

Lorenzo di Credi, *Head of an Old Man,* c.1491 (Cabinet des Dessins, Musée du Louvre, Paris). A faithful disciple of Verrocchio (who made him his heir), and subsequently an imitator of Leonardo da Vinci, this prolific but rather unimaginative artist was saved from obscurity by the acuteness and precision of his draughtsmanship and by the verve and transparency of certain paintings executed in his youth. *Photo © RMN/T*

In 1503–4 a competition was held in Florence between Michelangelo (who had returned after having fled, 'terrorized' by the approach of the French) and Leonardo da Vinci, who had also returned after a stay in Milan that was to have important artistic consequences. The two artists were invited to execute two frescoes for the Great Council Chamber of the Signoria, and their cartoons for these were publicly exhibited. Their mutual jealousy was already plain to all. In the same year, the new pope, Julius II, decided to transform Rome and the Vatican into the capital of an Italy which he dreamed of freeing from the 'Barbarians' (the French of Louis XII and, above all, the Spanish). Dubbed 'the Soldier-Pope', it was not for nothing that he had chosen the rather un-Catholic name of Julius: he saw himself as Caesar. However, he was the nephew of Sixtus IV, the humanist who had provided Rome with its first public art gallery, on the Capitoline Hill, and Julius intended to pursue a policy of prestige. Although the influence of Florence as a centre of diplomacy was beginning to wane, it was to continue to play a leading role as an artistic centre for some time yet: in 1505, Michelangelo was invited to Rome; Raphael was also invited there, unexpectedly, in 1508, apparently on the recommendation of his distant relative Bramante. This latter was a great architect (also a painter) and a disciple of Laurana and Francesco di Giorgio at the dazzling court of Urbino, where the Castilian Pedro Berruguete (who took Renaissance innovations in painting to Spain) and the Flemish artist Joos van Gent worked together.

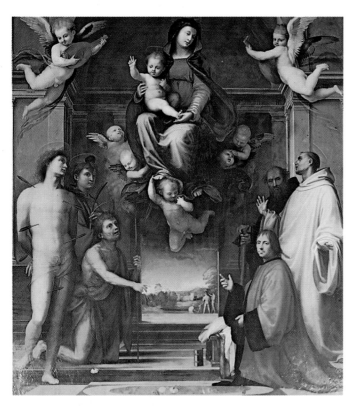

Fra Bartolommeo, *Virgin with Saints*, 1511–12 (Besançon Cathedral). The rhetoric of gesture marks a new phase in religious painting, while the execution remains faithful to Raphael-esque classicism. The 'picture within a picture', which adds to the virtuosity of the artificial architecture and the angels, shows Adam and Eve after their expulsion from Paradise.
Photo Studio Meusy © Larbor/T

Giovanni da Udine, *Decoration of Grotesques*, detail, c.1517–19 (Raphael Stanze, Vatican City). At the end of the 15th century, the emperor Nero's Golden House was discovered in Rome and explored like a grotto, for it was half-buried beneath the Oppian Hill. Hence the name 'grotesques' given to the painted ornamentation which was found there, especially by Raphael, and to the various imitations to which these gave rise.
Photo © Larbor/T

Leonardo da Vinci

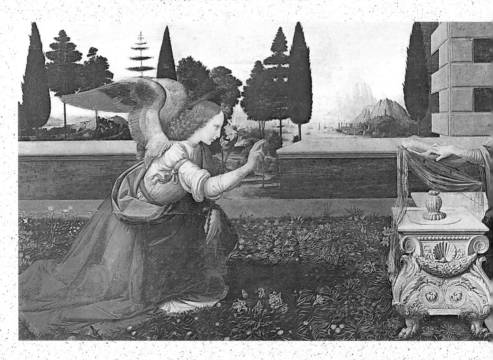

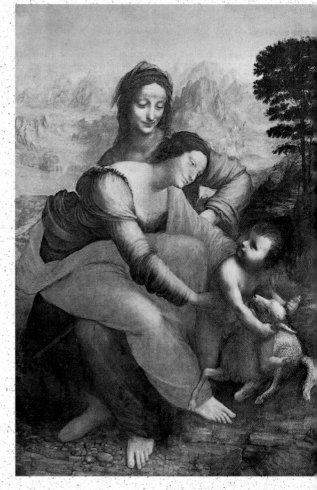

Above:
Annunciation, 1472–5
(Uffizi Gallery, Florence).
The arrangement of the
figures is traditional, and
the motifs are common
to the workshops of both
Verrochio and the young
Ghirlandaio: the
landscape bears no
similarity to the rocky
landscapes, devoid of all
human presence, which
Leonardo would favour in
his mature works. What
makes this painting,
begun by the artist in his
twentieth year, an
authentic Leonardo is the
distinctive radiance of
the archangel and the
slightly misty and idyllic
morning light in which
both the garden
vegetation and the
distant horizon
are bathed.
Photo Scala © Larbor/T

Right;
Profile of Man and Studies of Riders, drawing, c.1490 (Galleria dell'Accademia, Venice). This set of studies shows Leonardo's attentiveness to anatomy and movement, as well as revealing how, through the exaggeration of certain essential facial features, he was one of the fathers of caricature.
Photo Larbor Archive Collection/T

Virgin and Child with Saint Anne, c.1508–10 (Musée du Louvre, Paris). The rocky landscape is enigmatic, prehistoric, even timeless. The subject had already been treated by a few earlier artists, but here Leonardo's emphasis on the figure of the 'grandmother' Anne (whom he had already portrayed, in 1496, in a picture now in London) justifies interpreting the painting in terms of a symbolic obsession: is this Nature protecting an original innocence, which contrasts with the sole tree in the landscape, a biblical tree of 'good and evil'? The poses and movements of the figures still have to be properly deciphered.
Photo Scala © Larbor/T

1452. Leonardo is born in Vinci, Tuscany, the illegitimate son of a notary and a maidservant.
1469. He enters the studio of Verrocchio.
1472–6. Produces his first signed work (a drawing of a landscape). Paints a famous angel in Verrocchio's *The Baptism of Christ*, as well as other works that are now lost or whose attribution is disputed.
1480. Restorer and sculptor in the garden of San Marco. *Saint Jerome* (Vatican); *Adoration of the Magi* (unfinished).
1482. Leaves unexpectedly for Milan. Signs a contract for *The Virgin of the Rocks* (1486). Begins work on the huge equestrian statue of *Sforza*, destroyed (in its clay model form) by the French in 1499.
1490. Director of festivities for the wedding of a member of the Sforza family to a Princess of Aragon, for which he stages a masque of the seven rotating planets. *Lady With An Ermine* (Cracow). Undertakes journeys of scientific and technical investigation in the Milanese region.
1495–7. *Last Supper* (Milan). The fresco begins to decay almost as soon as it is finished.
1498–1500. Isabella d'Este tries to attract the painter to Mantua, but only succeeds in getting him to execute her portrait (drawing in the Louvre, Paris).
1502. Military engineer (inspecting and designing fortifications) for Cesare Borgia.
1503. The Signoria of Florence commissions the *Battle of Anghiari* from him (based on an idea by Niccolò Machiavelli). Rivalry with Michelangelo. Probable date of *Leda* (now lost, although numerous copies and drawings exist) and the *Mona Lisa*.
1506–10. Comes and goes between Milan and Florence. Writes extensively in his *Notebooks*. Paints the *Virgin and Child with Saint Anne*.
1511. Paints *Bacchus* (originally 'Saint John the Baptist', but repainted as *Bacchus* by religious fanatics in the 17th century).
1517. Leaves for France following the death of his patron, Cardinal Giuliano de' Medici: he takes with him the *Mona Lisa* and an 'authentic' *Saint John the Baptist* (Louvre). Assigned a residence by Francis I at Clos-Lucé, he draws, devises projects (irrigation, architecture) and organizes festivities at Amboise.
1519 (May 2). Leonardo da Vinci dies at Clos-Lucé.

FROM ROME TO VENICE

Leonardo da Vinci

Leonardo, Michelangelo, Raphael: we are in the habit of seeing in these three names a distillation of what some historians call the 'High Renaissance'. However, this overlooks the fact that Leonardo da Vinci (1452–1519) was much older than Michelangelo, and that Raphael was much younger than Michelangelo. Leonardo underwent extensive training in the studio of Verrocchio, and had a complex relationship with the humanists: he pretended to despise scholars while at the same time presenting himself as a 'new Pythagoras', for example in the *Self-Portrait* done in red chalk, in which he immortalized his features, deliberately making himself look older.

A multi-talented scientist, capable of the most practical discoveries and inventions as well as the most fanciful utopian ideas, he only saw himself secondarily as a painter, architect and sculptor. However, he ranked painting above poetry in his famous *Notebooks*: this is the name given to the set of extensively illustrated manuscripts, amounting to more than 5,000 sheets, where he recorded his experiments and projects in optics, astronomy, geology, botany, hydraulics and so on.

Although he never managed to finish his *Treatise on Painting*, Leonardo owed part of his fame as an artist to his writings: these reveal, as far as painting is concerned (his efforts as a sculptor met with failure), a prodigious draughtsman, an attentive observer of atmosphere and faces, and a specialist in quasi-alchemic activities. We know that a large number of his pictures and frescoes suffered from his urge to experiment endlessly with ingredients of his own invention: before it evolved into the chiaroscuro in which forms were shrouded, Leonardo's sfumato was a hitherto unknown mixture of oil and other mediums. The creator of the most famous painting in the world – the *Mona Lisa* – presented himself both as a philosopher for whom painting was a mirror capable of capturing the reality of all phenomena, and as a magician who left to the public 'the vestiges of God knows what great games' (Paul Valéry).

This perpetually discontented man, in the course of a nomadic life whose details are sometimes sketchy, achieved renown by virtue of his 'aura', thereby encouraging patrons to recognize the independent status of artists. He had disciples, some of whom belonged to his own generation (Bergognone, Ambrogio de Predis); but many of them were young members of the miniature court which accompanied him on his travels (for example, Solario and Boltraffi, the most talented ones, and Cesare da Sesto). We know a certain amount about some of his lost works from the copies that were made of them, while there are other works whose attribution remains as mysterious as the enigmatic Leonardo smile.

LTO LUCA VAN EYCK MASYS AN MAN HIN NA MARURI MANTER FVE MEMVAS MAYV MEMVMNRI EVERROCCHIO ROGGIO ALBERTI A CASER MATERLALTDORER RAMBROGIO DE
SELLALILANCOBELUB TOMAS SCORE DI SAN GE BERT TIEEN AN FVCEN VASAL MARV ARE PARADIAMTOR LO GUILERIO IOBS BRAMANTE BROGHLAN LABORIAMBRO
LANTIDO CAND OLOCONSINO MACHERACE PARI KI ALV NICO BATISOK PISLV PERUGINA MERON BELLATHLO CALMAGRO DE COSIMOLO MAN DRRIGIO PRASTI TO KOLLATODO KAS
DECELLI BOTTICINI BOTIS BRAMANTE ERO HLA ERO REI AMBROGIO DE PRIO BI AMMANCO SANRI CHEL MPLENLO LIO ANDREA CHS NA CRSV ERRI PAGLO CERISE CO NO

Michelangelo

Michelangelo (1475–1564) also aimed at becoming the supreme artist. He regarded himself essentially as a sculptor (although his works of architecture and painting are first-rate), and he was also the author of some admirable poems. His personality seems less enigmatic to us than does Leonardo's, although his intellectual biography is quite obscure. According to some, he listened to Savonarola passionately, to the extent that later he reread his sermons; according to others, his flight in 1495 was due to terror inspired by the monk's threats. He was, without any doubt, a devout Christian (unlike Leonardo), but Christ's pose in the *Last Judgement* is not an echo of the Reformation: it is a literal borrowing from the figure of Apollo, God of the Sun and Justice, who chases away the darkness. As for the *ignudi* in the Sistine Chapel, they are on the one hand spirits, perhaps of astral origin, that protect the soul as it gradually rises towards God (according to Neoplatonic doctrine) and on the other hand the glorification of a troubled homosexuality.

It was specifically in the Sistine Chapel of the Vatican that Michelangelo – soon finding himself involved in the saga of the biggest

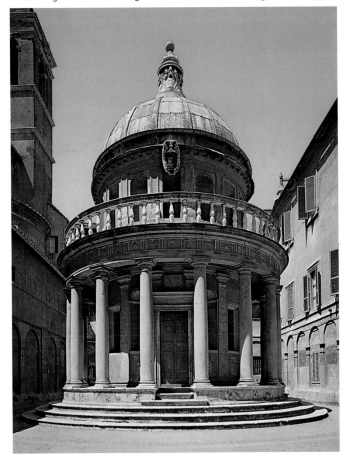

Bramante (originally Donato di Angelo), The Tempietto, 1502 (San Pietro in Montorio Monastery, Rome). An imposing building despite its modest proportions, this rotunda was designed to form part of a cloister which was never built. Its Doric columns are a very pure example of the style of Bramante (who had just arrived in Rome) – one which had progressed beyond the Lombardy style and assimilated that of the Urbino masters. *Photo © Garanger-Giraudon/T*

Michelangelo

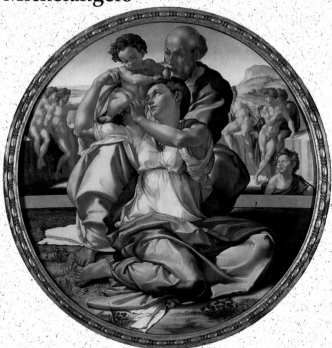

1475. Birth of Michelangelo at Caprese (Arezzo), where his father is a Florentine magistrate.

1488. He joins Ghirlandaio's workshop. Favoured by Lorenzo de' Medici, he visits the garden of San Marco and its collection of Graeco-Roman antiquities, which is in the care of the old sculptor Bertoldo. He sculpts a *Cupid* (which he possibly passes off as an antique), and his first relief sculptures: *Madonna of the Stairs*, *Battle of the Centaurs*. Executes statuettes for San Domenico in Bologna (1495).

1496. Obtains the commission for a *Pietà* in Rome, where he spends five years. Sculpts a classicizing *Venus* and *Bacchus*. Back in Florence, he executes a *Madonna* for Notre-Dame de Bruges.

1501–4. His *David* is greeted with enthusiasm both by artists and the people. *Tondo Doni*, his first painting. Cartoon for the fresco (never executed) of the Battle of Cascina.

1505–8. Summoned to Rome by Julius II to build his future mausoleum, he quarrels with him (1506), returns and begins work on the ceiling of the Sistine Chapel (episodes from *Genesis*, painted in reverse order: from the *Drunkenness of Noah* to the *Creation of the World*); *Prophets*, *Sibyls*, etc. The ceiling is finished in 1512.

Night, 1520 (Tomb of Giuliano de' Medici, Duke of Nemours, Medici Chapel, Florence). This superb marble sculpture, inspired by a medieval sarcophagus representing *Leda*, is inseparable from its counterpart, *Day*, and from the other two sepulchral allegories in the chapel, *Dawn* and *Twilight*. It is a Platonic evocation of the souls who, in the afterlife, calmly remember the tribulations of their past lives.
Photo Scala © Larbor/T

1513. New contract with the heirs of Julius II for the mausoleum, followed by another quarrel. *Moses and The Slaves* feature in a simplified version of the tomb.
1516–20. In Florence, he creates the funeral chapel of the Medicis (who returned to power in 1512): his most majestic achievement in architecture and sculpture.
1524. Begins work on the Laurentian Library (finished by Ammanati, 1560).
1527. Republican uprising in Florence. Michelangelo oversees the strengthening of the fortifications during the siege (1529–30) of the city by Charles V, ally of Pope Clement VII (a member of the Medici family). The latter, however, tries to persuade Michelangelo to return to Rome. The artist's reconciliation with the papacy (a reconciliation of 'equals', although not without its share of comedy) only came about in 1534 after the election of Paul III. Michelangelo sculpts a *David-Apollo*;

he paints a famous *Leda* (now lost); draws a cartoon for *Venus and Cupid* (from which Pontormo would make a painting); and produces numerous drawings.
1534–41. In the Sistine Chapel, Michelangelo paints the fresco of *The Last Judgement*. He becomes famous throughout Europe.
1542–5. Executes frescoes for the Pauline Chapel. Friendship with Princess Vittoria Colonna and her circle of pious 'reformers'. Designs plans for the palaces and square on the Capitoline Hill. Finishes work on the tomb of Julius II (reduced in scale and with fewer figures).
1546–61. Chief architect of Saint Peter's Basilica in Rome. Works on various projects in the Holy City.
1555–64. *Pietà* in Florence; and *Pietà Rondanini* (Milan).
1564. Michelangelo dies in Rome. His body is brought back almost surreptitiously to Florence, where he is given a lavish funeral.

NICE FROM ROME TO VENICE
ROME TO VENICE FROM ROME
NICE FROM ROME TO VENICE
ROME TO VENICE FROM ROME
NICE FROM ROME TO VENICE
TO VENICE FROM ROME TO

FROM ROME TO VENICE

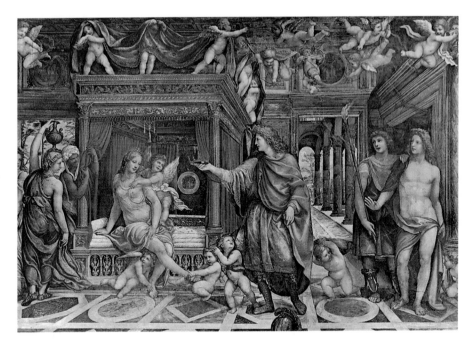

Il Sodoma (name given to Giovanni Antonio Bazzi), *Marriage of Alexander and Roxana*, fragment, 1512 (Palazzo della Farnesina, Rome). The primacy of drawing over all the other arts, as Michelangelo was to formulate it, is here expressed in a decorative painting in which the forms are strongly defined: the sensuality of the ancient world is evoked in a manner that is both joyous and grandiose, in a meticulously constructed setting in which the figures have the appearance of sculpture.
Photo Scala © Larbor/T

ceiling ever to be painted – reinvented the art of the fresco in such a way as to defy anyone else to try their hand at it (hence his later mockery of Raphael). In the same way, in sculpture, he went beyond the influences he had absorbed from his masters (Donatello, Pollaiuolo, Verrocchio) – as well as from the art of classical antiquity, the collections at San Marco and the *Laocoon* discovered in Rome in 1506 under his supervision – to such an absolute degree that he invented (in the *Slaves*) the *non finito*, whereby works were left with an unfinished appearance. In order to fully understand his wholly cerebral art, with its surface pomp and ceremony, straining muscles and melancholy – an art that the famous *terribilità* (an indication of its compelling nature) simplified while remaining true to it – we should remember Michelangelo's supposed exclamation to the Portuguese ambassador: 'The only reason that people paint in Flanders is to deceive the eye!'

This master creator of the funeral chapel of the Medicis was also an admirer of Brunelleschi, whose influence he inherited. Architecture was transformed as a result: the murky feud against Michelangelo pursued by the Sangallo clan (including Antonio – the younger brother of Giuliano, whose career only began when he was 60 years of age – and especially their nephew Antonio the Younger) is revealing in this respect. Antonio the Elder was working in the smaller towns of Tuscany (in around 1528) and anticipating classicism in his work, while in Rome Antonio the Younger found himself directly up against Michelangelo, to such an extent that he ended up abandoning a project on which he was working. Michelangelo began work on the Palazzo Farnese, in Bramante's purified Tuscan style, and built the Pauline Chapel in the Vatican and the Rocca Paolina in Perugia. His pupil Sanmicheli was to be a precursor of Baroque

CARDM BELLANGE BELLINI BORGOGNONE BERNINI BERRUGUETE BLOEMAERT BOSDOL BOSCH BOTICELLI BOTTICINI BOUTS BRAMAN LE BROUDELIAM BRUEGHI ARNELLINI
SETTIGNANO DONATELLO DURER DYCK TANGHEGLIANI ELSHEIMER FABRIANO GHIBERTI GHIRLANDAIO GIORGIONE GIOTTO GIOVANNI PISANO GONE GOYA GRECO GRUN
SCCHIO ZUCCARO ALBERTI ALTDORFER ANGELICO ANTONELLO DA MESSINA ARCIMBOLDO BASSANO BECCAFUMI BELLANIS BELLINI IMACCIO CAMBIO CAMPAGNOLA CARA
TICELLI BOTTICINI BOUTS BRAMANTE BROEDERLAM BREUGEL BRUNELLESCHI CAMMACCO CAMBIO CAMPAGNOLA CARAVAGGIO CARON CARPACCIO CERRA CA MAVINATA

in Verona and Venice. Closer to Michelangelo were Domenico Fontana (who designed the façade of the Quirinal Palace and did further work at Naples in around 1590) and especially Giacomo Della Porta, who finished the Palazzo Senatorio on the Capitoline Hill from his designs, and built the façade of the church of Il Gesù (1573) and the Villa Aldobrandini at Frascati (1600).

As for Bramante (who died prematurely in 1514), he remained more famous perhaps for the projects he planned than for the actual buildings he constructed (churches in the Milanese region, the *Tempietto* on the Janiculum); the architectural setting in *The School of Athens* is Raphael's homage to his imposing design for the Vatican. It was also Bramante who directly inspired Serlio and, to a certain extent, Vignola (c.1560), the last exponent of Renaissance Vitruvian architecture.

Raphael, *Group of Nude Men Fighting*, pen and brown ink, c.1508–9 (Musée des Beaux-Arts, Lille). This 'frieze' study was used for the detail of a bas-relief sculpture in *The School of Athens*. It demonstrates Raphael's ability to capture fleeting movement in a more or less imaginary scene, in which the figures are drawn with an unerring sense of anatomy. *Photo © the Museum/T*

Raphael

Only 40 years ago, Raphael (1483–1520) was overshadowed by two figures who were icons of Romanticism. Compared with the enigmatic Leonardo da Vinci and his encyclopedic mind, and the tortured, rebellious Michelangelo, Raphael – the 'charming', even 'divine', young man described by Vasari – did not seem very interesting. Some overly familiar Madonnas, and a long academic tradition that cast him in the role of a professor (seen as all the more inimitable for having been imitated), meant that one of the greatest painters who ever lived was overlooked.

Besides, success is unpopular, as is a facility for work (and Raphael was constantly working). The truth is closer to Goethe's remark: 'Basically, he managed to achieve what others only dreamed of.'

Raphael experimented with poetry and sculpture, was a passionate archaeologist and a great architect (the Chigi Chapel in Santa Maria del Popolo; the Villa Madama; the plan for the Pandolfini Palace), but he undertook all of this as if it were a game. He mixed with eminent humanists, but reconciling the Christian faith with the all-pervasive philosophy derived from Platonism does not appear to have posed any problems for him. It is tempting to say that he was only a painter: but this would be to overlook the great importance which he attached to his art. Nobody carried further the Renaissance ambition of 'vying' with life itself and not just

Raphael

1483. Birth of Raffaello Santi in Urbino. His father, Giovanni Santi, is a respectable painter, with good social connections.
1500. Raphael, commissioned to paint a *pala* (altarpiece), *San Nicola da Tolentino*, is designated a 'Master'.
1502–3. Works with Perugino.
1504. Raphael paints his first masterpiece, *Marriage of the Virgin* (Milan), inspired by Perugino's masterpiece (Caen). Travels to Florence. Paints *The Dream* (known as *The Knight's Dream*), the *Three Graces* (Chantilly) and *Saint George and Saint Michael* (Musée du Louvre, Paris).
1508. Departs for Rome, where he immediately proposes a new plan to Julius II for the Vatican Stanze (with the aid of Bramante). Around 1510, he finishes *The Dispute Concerning the Blessed Sacrament*, and then *The School of Athens*.
1511. Paints *Parnassus* and *The Virtues* in the council chamber of the Signoria.

Pope Leo X with Cardinals Luigi de Rossi and Giulio de' Medici, 1518–19 (Uffizi Gallery, Florence). Leo X appears, flanked by two of his nephews, in a pose suggesting barely contained energy. The volumes are treated so forcefully that they almost disrupt the perspective. The magnifying glass is echoed in the golden orb on the armchair, in which a window is reflected.
Photo © Alinari-Giraudon

1512. *The Madonna di Foligno* (Rome); *Portrait of Julius II*; the *Mass of Bolsena*.
1513–14. Leo X officially confirms Raphael in his post as architect of Saint Peter's, Florence, at a fee of 300 gold ducats a year. *The Sistine Madonna* (Dresden); *Saint Cecilia* (Bologna); *Madonna della Sedia* (Florence); *Portrait of Baldassare Castiglione* (Louvre, Paris).
1515. Exchanges letters (and possibly portraits) with Dürer. Tapestry cartoons for the Vatican. He is appointed custodian of Roman antiquities.
1518. Executes paintings at the Villa Farnesina (*Triumph of Galatea*). The *Fornarina* (Rome). Paints the *Great Holy Family* (Louvre, Paris) for Francis I. Devotes a great deal of

time to architecture; produces a study for the Pope of a new urban design for Rome. *Vision of Ezekiel* (Pitti Palace, Florence).
1519. Sends Leo X a report on excavations and the preservation of antiquities. Designs stage scenery for the performance of a play by Ariosto. In the Vatican, he finishes the Stanze with the aid of the assistants from his studio.
1520. Dies suddenly at the height of his fame, on March 6. He had virtually finished his last painting, the *Transfiguration*. The fact that the day of his death was the same as that of his birth (Good Friday) contributed, despite malicious rumours, to the 'legend' which quickly grew up around Raphael.

The Virgin and Child with Saint John the Baptist, 1507 (Musée du Louvre, Paris). The grace and strength of the curves of the figures, against a luminous Florentine background, assured the success of this painting. Apparently commissioned by a Sienese client, it was soon acquired by Francis I and taken to France, where it remained popular under the name of 'La Belle Jardinière'.
Photo © Focus/T

ROM ROME TO VENICE FROM
ROME TO VENICE FROM ROME TO
NICE FROM ROME TO VENICE
ROME TO VENICE FROM ROME TO
ROME TO VENICE FROM ROME
TO ROME VENICE FROM ROME TO
NICE FROM ROME TO VENICE
ROME TO VENICE FROM ROME TO
NICE FROM ROME TO VENICE
TO VENICE FROM ROME TO

FROM ROME TO VENICE

Raphael, *The Marriage of the Virgin*, 1504 (Pinacoteca di Brera, Milan). Here the young master combines geometrical experiments (in vogue at the Court of Urbino) and symbolical experiments: the graduated spatial recession of the temple and the way it opens onto the background of the sky suggest the complex process which should lead to harmony between 'true faith' and reason. The meditative, pleasing appearance shared by all the characters transcends the level of mere anecdote. It is for this reason that in Italy the painting is affectionately known simply as 'The Marriage'. *Photo © Scala/T*

with its image, and no artist formulated such a radical basis for this: not a vague ideal of beauty, but the idea of the beautiful itself, to which 'I must hold', he wrote, 'when it impresses itself upon me'. It has only recently been discovered how much his deserved reputation as a peerless draughtsman had come to eclipse his qualities as a colourist and his excellence in composition. He was a portraitist whose intense psychological veracity remained subordinate to stylistic veracity; he was a narrator of the most charming mythological subjects (bathroom of Cardinal Bibbiena) as well as the drama of the *Deposition of Christ*; and he was a semi-abstract master of composition with a strong sense of rhythm. He designed the frescoes for the Stanze of the Vatican with the same confidence with which he executed a tondo. He gave the same female face to *Saint Cecilia* and to his *Galatea*, showing the same audacity as his inclusion of three separate sources of light in the nocturnal scene depicted in his *Liberation of Saint Peter*. His appeal (acknowledged during his lifetime, even by his enemies) was matched only by his power, which seems occasionally

to be barely contained (*Expulsion of Heliodorus*). Masaccio's solidity, the clarity and spaciousness of the Umbrian landscape, Leonardo's magical enchantment, certain aspects of Venetian painting, antique statuary, Tuscan glyptics – the assimilation of all these only served to feed his genius.

In the prolific output of this young prodigy, the role of his studio should not be overlooked. However, the work carried out by the studio (up until the *Hall of Constantine*, which the studio executed in its entirety) was based almost exclusively on drawings by Raphael. Of all his assistants, the most important was Giulio Romano. Resident in Mantua since 1527, he established an illustrious career as an architect and a painter-decorator, strongly influenced by Michelangelo and carrying anatomical illusionism to amazing heights. Il Sodoma, who was older than Raphael, collaborated with him on the Vatican and the Villa Farnesina, and later pursued a career in Siena (1520) with diverse sources of inspiration (Pinturrichio, but also Leonardo da Vinci and the Lombard Gaudenzio Ferrari) and characterized by an imaginative use of humanist motifs. From this studio emerged Peruzzi, also an architect, Giovanni da Udine, a specialist in 'grotesques', the Penni brothers (Gianfranco and Luca, who was to move to France), Pierino del Vaga, and Polidoro da Caravaggio (a highly accomplished painter of grisaille frescoes). Through them, and especially through the medium of engraving (in which Raphael supervised expert practitioners such as Marcantonio Raimondi), classical art spread throughout Italy and beyond.

The combined influence of Raphael and Leonardo was, fundamentally, what dominated painting north of Rome in the period around 1525; otherwise, the names of Bramantino and Genga in Urbino itself and in Siena, Francia and Costa in Bologna, Franciabiggio in Florence, Luini in Milan,

Correggio (name given to Antonio Allegri), *Danae,* 1530–32 (Galleria Borghese, Rome). This is one of the paintings commissioned by the Duke of Mantua for Charles V. The voluptuous abandon of this sarcastic Danae (the Cupids at her feet are counting coins) points to the increasing 'secularization' of mythology. In a composition based on diagonals, the purity of the undulating lines is masked by the chiaroscuro that is such a distinctive feature of Correggio's work. *Photo © Nimatallah/ Artephot*

FROM ROME TO VENICE FROM
TO VENICE FROM ROME TO
FROM ROME TO VENICE F
ROME TO VENICE FROM RO
TO VENICE FROM ROME TO
NICE FROM ROME TO VENICE
TO VENICE FROM ROME TO

FROM ROME TO VENICE

Giovanni Bellini,
Madonna of the Pear,
c.1491 (Galleria
dell'Accademia
Carrara, Bergamo). The
son of Jacopo Bellini
and the step-brother of
Gentile Bellini,
Giovanni is deservedly
the most famous of the
three: he was the
definitive founder of
the great Venetian
tradition. Eliminating
the distance separating
sacred and secular
worlds, he here
expresses an
unsentimental
gentleness and a
discreet sobriety,
conveyed through the
brilliance of his
compositional layout
and through the spatial
effects achieved
by his unequalled
handling of light.
Photo © Giraudon/T

and Savoldo in Brescia are worth noting – even if some of these artists
already showed traces of a certain Mannerism (Aspertini, for example) or
were becoming aware of the new attraction exerted by Venice (Garofalo
in Ferrara). As for Correggio (c.1490–1534) in Parma, he remains unclas-
sifiable: the mellow atmosphere of his work, his sense of spatial rhythm,
and his febrile sensuality made of this provincial artist – essentially a
decorative artist, and one who was to have a certain influence on the
development of Baroque art – a great painter who was ultimately a vic-
tim of his own fame.

Venice: Splendid Isolation

The long and harmonious career of Giovanni Bellini (c.1430–1516) per-
fectly epitomizes the Renaissance in Venice after 1475 (mythological
drawings, etc). He solved the problem of the coexistence of saturated
colours and the diffusion of light, while making Tuscan 'naturalism' his
own: historical, imaginary and real landscapes merge (*Transfiguration*,
1480; *Sacred Allegory*, 1500). He had no compunction about borrowing
from his young rivals, Carpaccio (1455–1526) and Giorgione (1477–
1510). Carpaccio trained in the Vivarini workshop, and he was familiar

NORITELY MITTE ANTONELLO ANTONINOTY MATILIO VAN DER WEYDEN VAN EYCK VASARI VERONESE VERROCCHIO ZUCCARO ALBERTI ALCANIZ ALTDORFER AMBROGIO DECASTELLO FILET ANSELBETTO TORRIGONONE BELLINI II FEBBO DUELL BINCKMAERT ANSOUT BOSSI BOTTICELLI BOTTICINI BOULTS BRAMANTE BROEDERLAM BRUEGEL BRUXELLE ERA SECULO AND DE NOVELLO DUCALNUNO DE ALVERDE RENO BERNARD GUERINCI CIMABERG FROMENT DI CREDI CIONNI OPIS GIORGIONE GOTICO JEAN POLLAINO BOUTS ERNO CHITO ZUCCARO ALBERTI ALCANIZ ALTOREJ ALTDORFER AMBROGIO DE FEDELI AMMANATI ANDREA DEL CASTAGNO ANDREA GIOCONDO CAROTO CARLO CRIVELLI DA MILANO BOTTICELLI BOTTICINI BOULTS BRAMANTE BROEDERLAM BRUEGEL BRUXELLE CHITO CIMA CCI CAMBIO CAMPAGNOLA ANDREA GIOCONDO CAROTO CARPACCIO DERI SCA CRIVELLI

Vittore Carpaccio, *Vision of Saint Augustine,* detail, 1502–7 (Scuola di San Giorgio degli Schiavoni, Venice). The Bishop of Hippona hears the voice of Saint Jerome announcing his own death to him. This motif of the *Golden Legend* is adapted by Carpaccio into a Renaissance *studiolo*; it would appear that the portrait of the saint is in fact that of the great humanist Bessarion, the first patron of the Scuola. Carpaccio's encyclopedic work, exceptional in the history of Venetian painting, is a visual delight: all of the intellectual curiosities of the time are on display in this detail of the fresco. *Photo Scala © Archives Larbor/T*

with the work of Antonello. He travelled widely (perhaps as far as the East) and showed a rare intellectual versatility. His chromaticism prefigures tonal painting (*The Legend of Saint Ursula,* 1490) but is based on detailed perspectival analyses. He wove incongruous, precious, funereal or vivacious details into his narratives (*Story of Saint Jerome,* after 1500), although a certain dryness creeps into his later works. As regards Giorgione, there is, even today, a 'Giorgione controversy': after he had died at the young age of 33, various famous pictures (*Concert Champetre,* for example) were first attributed to him and then (some believe, wrongly) declared not to be by him, for want of precise documentation. His most famous work, *The Tempest,* still witholds its secret from us. *The Portrait of an Old Woman,* which hangs beside it in the Galleria dell'Accademia in Venice, seems to be an enlarged and aged fragment of it, making the secret even more enigmatic.

Giorgione's vision introduced a major innovation into the history of landscape painting, apart from his (essentially luminous) chiaroscuro. He interpreted humanist fables in a rather artificial, dreamlike manner. Also, his female nudes are completely different from those of Titian (who, according to tradition, is said to have completed some of Giorgione's paintings): they 'come from another world', despite the fact that they are slipped into lyrical natural settings, whereas Titian's passive Venuses appear to be courtesans who are simply idealized in paint.

With Titian (1488/89–1576), whose style crystallized from around 1520 onwards, we meet the first painter for whom colour takes priority over all other aesthetic and formal elements. There are very few drawings by him. Colour is responsible for establishing the setting, creating atmosphere and embodying in a thousand different ways the noble rhetoric and opulent sensuality of his subjects. In Titian, visible brushwork and strongly textured surface replaces the 'smooth finish'. Through the sole application of his prodigious skill, the artist enjoyed an exceptionally long and brilliant career. The 'triumvirate' which he formed with the architect Sansovino (the Zecca, 1545), who was also a Michelangelesque sculptor, and Aretino, the scurrilous writer who became both Titian's publicity agent and a perceptive analyst of him, reigned over Venetian cultural life. Titian, whose style barely developed except in the sense of acquiring a looser rhythm, blithely produced numerous portraits of the rich and powerful, devotional pictures and pseudo-mythological nudes.

Below: **Giorgione**, *The Three Philosophers*, c.1500 (Kunsthistorisches Museum, Vienna). Critics have interpreted this as a portrayal of the Three Wise Men, or of the three ages of man. In fact, it represents three 'learned men', and Giorgione appears to have hesitated over the attributes with which they are associated (parchment, compass, set square). There is probably a reference to the three philosophies of Platonism, 'Arab' Aristotelianism and the science of Christianity. There is another hypothesis: the painting depicts the three religions whose reconciliation the humanists dreamed of: Judaism, Islam and Platonic Christianity.
Photo © Bridgeman-Giraudon

Left:
Giorgione, *The Tempest,* c.1506 (Galleria dell' Accademia, Venice). The subject of this painting has given rise to no less than 30 different interpretations since it was rediscovered a century ago. Is it a legend from mythology; a gypsy and a soldier; Adam and Eve after the Fall; an abstract humanist allegory; or a complex meditation on human destiny and its relationship with time? It was commissioned by a wealthy, cultured Venetian, who allowed Giorgione's lyricism full rein in the attention paid to the complicity between the two human figures, who are shown isolated from each other (and not communicating), and the unfathomable power of nature. *Photo © Dagli Orti*

Palma the Elder, *Portrait of a Young Woman,* c.1515–19 (National Gallery, London) Probably a portrait of 'an honest lady', meaning a high-class courtesan. A talented follower of Titian, Palma skilfully renders the radiant complexion of a placid beauty. He helped to popularize the hair colour now known as 'Titian' (which must have been more flamboyant originally, as the colour was artificially obtained). *Photo E Tweedy © Larbor/T*

Overwhelmed with commissions from clients, which he never refused, confident of his own superiority but at the same time pragmatic, Titian was obliged to accept the growth in stature of Tintoretto, and indeed of the Bassano dynasty of painters; the Bergamo painter Palma the Elder subtly absorbed elements of his style, but Palma the Younger (c.1570) simply copied his work. Sebastiano del Piombo, a Venetian artist who left Venice for Rome in around 1511, was to become a great admirer of Michelangelo (who gave him drawings). Having made a futile attempt to rival Raphael as a portraitist, he turned to painting religious subjects in a monumental and austere style.

Titian's other rivals – Paris Bordone (whose fame spread as far as France and was almost as great as Titian's), Pordenone and Lotto – were relegated, despite their talent, to a dingy backwater on the periphery of the Veneto: it was at this very time that Venice was at the height of its prosperity (a state of affairs that was destined to be short-lived). Despite his ambiguous and perhaps sarcastic attitude towards humanism, Titian was largely responsible for the way in which Renaissance art permeated all of Europe. In order to understand this phenomenon, which extends throughout the *cinquecento*, it is necessary to go back in time a little.

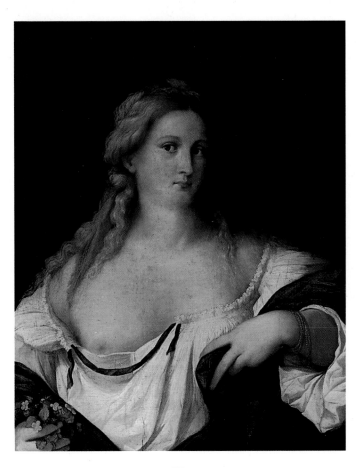

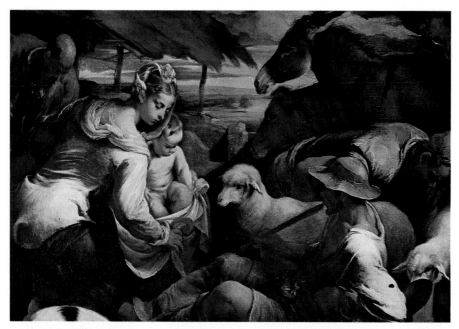

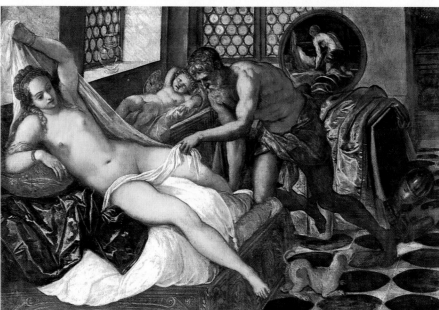

Top: **Bassano** (name given to Jacopo da Ponte), *Adoration of the Shepherds,* c.1550 (Galleria Borghese, Rome). The contrast between the cold sky and the shadowy warmth of the fabrics is typical of the art of this 'Venetian' master. He swathes a

Mannerist drawing in a range of colours that are by turns subdued and dramatic. His œuvre is unfortunately cluttered with copies which were executed by his son to satisfy the demands of a large clientele.
Photo © Scala/T

Tintoretto (name given to Jacopo Robusti), *Mars and Venus Surprised by Vulcan,* c.1555 (Alte Pinakothek, Munich). Even when, as here, he is treating a mythological subject in a rather unsympathetic manner, Tintoretto

remains faithful to his style of composition based on dominant diagonals. The almost tragic expressiveness of the gestures contrasts with the comic figure of Mars, who looks like a character from a farce.
Photo © Joachim Blauel/T

Titian

The Man with the Glove, 1523-4 (Musée du Louvre, Paris). This is the masterpiece among the 'black on black' paintings, the series of boldly executed portraits which were to influence Velázquez, Manet and Post-Romantic art.
Photo H Josse © Archives Larbor/T

Venus of Urbino, 1538 (Uffizi Gallery, Florence). This nude was to spawn many imitations and variations down the centuries, most notably by Ingres and Manet. The curtain which divides the space, virtually introducing a picture within the picture, undermines the mythological aspect of the scene.
Photo Scala © Larbor/T

c.1489. Birth of Tiziano Vecellio at Pieve di Cadore.
1508. Works as an assistant to Giorgione.
1510. Death of Giorgione. Titian goes to Padua.
1513. Cardinal Bembo attempts to employ him, but Titian prefers to offer his services to the Most Serene Republic of Venice.
1515. Paints Sacred and Profane Love (a work of humanist inspiration).
1516. Beginning of his relationship with the Court of Ferrara: Bacchanal (Madrid); Bacchus and Ariadne (1522, London).
1521. Executes works in Brescia, Vicenza and Mantua.
1530. In Bologna, he paints a portrait of Charles V who, in 1532, makes Titian Count Palatine and member of an imperial order of knighthood.
1540. Portrait of Francis I (from a medallion by Cellini).
1545. Triumphant journey to Rome.
1546. Back in Venice, he produces many ceremonial portraits.
1550. Visits Charles V at Augsburg. Venus and Cupid with a Partridge.
1552. Start of a long and ultimately disappointing correspondence with

Philip of Spain: one wants paintings, the other wants money.
1562. He is visited by Vasari. Venus Blindfolding Cupid (notable for its 'Mannerism' and treatment of light).
1567. Titian presides over an interview between the Turkish and Spanish ambassadors. Paints The Martyrdom of Saint Lawrence.
1568. Offers what could be copies of numerous mythological paintings already done for Philip II to Emperor Maximilian II (The Flaying of Marsyas, etc).
1575. Spain Succouring Religion (Madrid).
1576. Dies during a plague epidemic. His house is pillaged later that year, after the death of his son. Palma the Elder completes Titian's last work, a 'Baroque' Pietà (Venice).

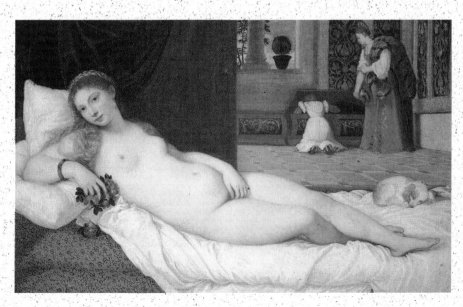

EUROPEAN-WIDE MOVEMENT A EURO-
WIDE MOVEMENT A EURO
EUROPEAN-WIDE MOVEMENT
EUROPEAN-WIDE MOVEMENT
WIDE MOVEMENT A EURO-
EUROPEAN-WIDE MOVEMENT
MOVEMENT A EUROPEAN-WIDE
EUROPEAN-WIDE MOVEMENT
WIDE MOVEMENT A EURO-

A EUROPEAN-WIDE MOVEMENT

Leaving aside the Châteaux of Vincennes (built shortly after 1350) and Mehun-sur-Yèvre (c.1397), since nothing remains of their painted Italianate décors, some degree of awareness of the early manifestations of the Renaissance was evident in France (in around 1430), earlier than was once thought, although this awareness was displayed essentially by diplomats and writers. If we leave the Flanders-Burgundy-Avignon axis – examined earlier – out of the equation, we have to wait until the second half of the *quattrocento* for the Renaissance fully, if unevenly, to permeate all of Europe.

To refer to all of Europe is not to overstate the case, if we remember that Italian architects visited Moscow in 1491. As early as 1460, Italian art was appreciated in Bohemia and in Hungary: Andrea da Fiesole built a chapel in Granz (1502); the Cathedral of Cracow was built only slightly later. The Belvedere at Prague Castle was modelled on the Cathedral of Vicenza (1530); the Church of Santa Maria Maggiore in Trent was decorated by Pordenone and Dossi. The Florentine aesthetic, relayed via Venice, was to last for a century in Austria. In France, the young Charles of Anjou summoned Francesco Laurana, who already enjoyed a reputation as a medallionist, to work on the Cathedral of Le Mans and in Marseilles (1475); Girolamo da Fiesole collaborated with Michel Colombe on the Cathedral of Nantes (1500), and the latter was to display his Italianate style in the *Saint George* (1509) of Cardinal d'Amboise. These works of sculpture clashed with a profoundly conservative religious architecture. The remarkable décor of the Cathedral of Albi, the work of Italian painters and of sculptors described as 'Burgundian', all of whom were anonymous (c.1500), did not escape this clash of styles. It was in the field of civil architecture that stylistic change would occur most swiftly.

Château de Chambord, 1519–37. 'From afar [...] the edifice appears like a woman, a gentle breeze rippling through her hair.' This aerial photograph justifies the sublime image used by Chateaubriand to try to convey the magical fascination of this Renaissance jewel, a masterpiece of delicacy, harmony and fantasy.
Aerial Photograph © Bernard Beaujard/T

The Tower of Belem, 1515–20 (Lisbon). Portugal anticipated the Renaissance through its seafaring expeditions, but only experienced a brief flowering in the field of painting (in the work of Nuno Gonçalves, an imitator of Jan van Eyck). On the other hand, it developed a fairly original architectural style, the 'Manueline' style, in which echoes of classical elements form the basis of an ornamentation that is sometimes rich in exotic detail.
Photo © Pérousse Bruno/Hoa Qui

The impact of the wars in Italy soon made itself felt in France: Charles VIII returned to Amboise with gardeners, artisans and costumiers in his train, while Louis XII summoned Fra Giocondo, the famous Veronese architect, to France. Raphael's future assistant at the Vatican, Fra Giocondo built the Pont Notre-Dame in Paris and may also have worked on the Château de Gaillon. The same monarch commissioned a *Madonna* (presumably lost) from Leonardo da Vinci. The transformation of medieval fortresses into Renaissance palaces began with Blois (1498), and this trend was continued at Gaillon, and especially at Chambord, and in the cube-based design of Chenonceaux: within a few years the Touraine region, and the Île-de-France, were dotted with architectural masterpieces (Azay-le-Rideau, Ussé, Villers-Cotterêts). One of the great instigators of this metamorphosis was Domenica da Cortona, known as Il Boccador, who built Chambord and the old town hall in Paris. However, it was the decorative freedom, more than the rationality, of Italian architecture which predominated until around 1530 (the Hôtel Bourgther-oulde in Rouen, begun in 1499; the Hôtel de Berny in Toulouse). The factors which changed this were Philibert Delorme's journey to Rome and the edition of Vitruvius published by the Bolognese architect Serlio (1540), who also introduced stage design to France. After 1550, Lescot (façade of the Louvre), Chambiges (Saint-Germain-en-Laye), Bullant (Ecouen, Chantilly) and Androuet du Cerceau no longer required Italian tutors, but their geometric, modular designs conformed to Renaissance canons. One harmoniously proportioned example was the Château d'Anet (1547), which survives today in a mutilated form: this was built by Delorme, who in 1564 designed a plan for the Tuileries. Religious architecture was less marked by innovation (Saint-Eustache in Paris, Saint-Michel in Dijon).

Right-hand page: **Androuet du Cerceau,** design for a façade: two bays of the gallery of the Château de Verneuil, 1565–75 (Musée du Louvre, Paris). Few buildings have survived to bear witness to the genius of this architect, one of the forerunners of Classicism in France. However, we do possess many drawings and his collection *The Most Excellent Buildings,* in which he also included his own designs. The style of this plan for the Château de Verneuil (since destroyed) successfully combines Mannerist decorative elements with a very well balanced structure, whose gracefulness elegantly conceals its solemnity. *Photo © RMN*

Nowhere else could a movement on this scale be observed. In Spain, following public consultation, Seville Cathedral was still built in the Gothic style in 1531–61, and civil architecture (Toledo) was more inspired by Flemish than by Italian idioms (1500) up until the advent of the Plateresque style, which was pre-Baroque in tenor (Burgos, 1540), the austerity of the Escorial being an exception. In Flanders, the palace of Margaret of Austria at Mechelen and the town halls of Bruges and Antwerp were simply a synthesis of Italian details (for example, rustic bosses) and the dominant vogue of the Flamboyant. In Britain, Tudor Gothic continued up until around 1550 in an undiluted form, and (with the exception of a few castles) it was only with Inigo Jones (d.1652) that Palladian architecture would begin to flourish.

In France painting quickly began to absorb the new influence: although Andrea del Sarto, summoned by the French monarch in 1519, left almost immediately, the building of Fontainebleau (*see page 122*) was to have profound consequences. In a different field, Jean and François Clouet took the art of portrait drawing and the sophistication of romantic mythological subjects to new heights of excellence, even if many anonymous pictures have been too hastily attributed to them. The two Jean Cousins (father and son) represent the Parisian urge to renew links with

Philibert Delorme, Chapel of the Château d'Anet, 1545–55. Set between two spires which still retain an air of medieval sobriety, the rotunda represents one of the first adaptations of the central plan in French architecture: an entrance drum and three chapels surround a space covered by a dome with a lantern. The interior decoration is a stunning variation – embellished with crescent-moon motifs (in homage to Diane de Poitiers) – on the 'coffers' of the Pantheon in Rome. *Photo © Dagli Orti*

François Clouet,
The Bath of Diana,
c.1555 (Musée des
Beaux-Arts, Rouen).
According to some, this
painting is not a veiled
homage to Diane de
Poitiers (who by this
time was in any case
too old to be
represented 'in the
flesh') but a
celebration of the
marriage of Francis II
and Mary, Queen of
Scots. Essentially it
should be seen as an
eclogue reminiscent of
the poetry of Ronsard:
eroticism, ritual, nature
and mythology merge
harmoniously under
the clear influence
of Primaticcio.
Photo © Jean Feuillie-
CNMH/T

Roman classicism. The father, who began as a draughtsman for glass and tapestry manufacturers (notably in Sens and Langres), was the painter of the first French nude, *Eva Prima Pandora* (1549), a precious mythological painting whose subject might well be the city of Rome itself. He was also the author of a *Livre de Perspective* and produced some very fine drawings. Many provincial workshops, not all of which were equally well known, developed at this time: a great variety of ornamentists and engravers emerged. Many were also painters, such as Pseudo-Félix Chrestien in the Auxerre region (*Cellar Scene*, 1537) or Simon de Châlons (in Avignon).

As early as 1508, the rhetorician Lemaire de Belges paid tribute to Perugino, Leonardo da Vinci and Giovanni Bellini by gallicizing their names. This was the period when the old Venetian master Bellini was saluted as 'the best' by a young and enthusiastic 24-year-old foreigner, Albrecht Dürer, who at 13 years of age had executed his first *Self-Portrait* (1484) in silverpoint. His exceptional precocity swiftly led him to explore the work produced in Late Gothic studios (Martin Schongauer, Stefan Lochner) with its echoes of the *quattrocento*. The greatest German Renaissance painter, a brilliant engraver and an inspired watercolourist, Dürer was also a visionary intellectual. Not content with simply recycling the decorative elements of Mantegna (already famous in northern Europe), he visited workshops, imitated Carpaccio, met Jacopo da Barbari (the inventor of still-life portrayed for its own sake) and, thanks to him, became familiar with the theories of Leonardo da Vinci. He was passionately interested in perspective.

Although after 1510 he concentrated more and more on engraving, Dürer's finest paintings show a preoccupation with geometrization of

Konrad Witz, *The Miraculous Draught of Fishes*, 1444 (Musée d'Art et d'Histoire, Geneva). This is a section of an altarpiece typical of German art at the time: the landscape, showing Lake Geneva and Mount Saleve, contrasts through its precise realism and nuanced colours with the massive red mantle worn by Christ, who is otherwise represented in a conventional pose. Similarly, the audacity with which certain forms are geometrized and the extreme transparency of the water contrast with the archaic treatment of Saint Peter, depicted both in the boat and swimming in the water. *Photo J Arland © Larbor/T*

Below: **Hans Memlinc**, *The Seven Joys of the Virgin*, undated altarpiece, detail (Alte Pinakothek, Munich). The horizon is raised to provide room for the unfolding of a complex 'sacred story', which takes place against a topographical vista where ancient classical architecture is interspersed with medieval details. The arrangement of episodes is both traditional and extremely tortuous. Memlinc manages to create relief effects in the soft iridescences of the distant horizon. *Photo © Joachim Blauel/T*

Albrecht Dürer

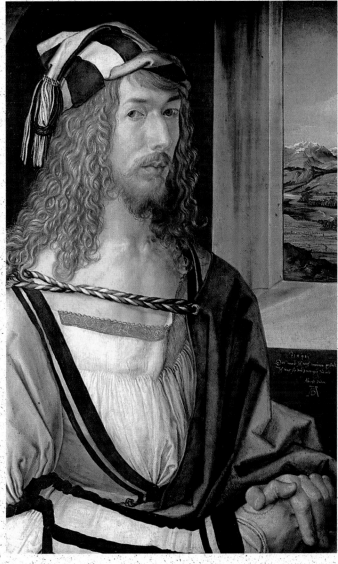

Self-Portrait, 1498 (Museo Nacional del Prado, Madrid). Of the various self-portraits of the young artist, this is the most lifelike and at the same time the one with the most effective setting. The first engraver to become famous throughout Europe, at only 26 years of age, Dürer here acknowledged (through his choice and arrangement of the landscape) his indebtedness to Italy, which also enabled him to present himself as a man of sophistication (a great novelty in Germany). Photo © Colorphoto Hinz/T.

Right-hand page, centre: The Willow Mill, 1496–7, watercolour and gouache (Cabinet des Estampes, Bibliothèque Nationale, Paris). Watercolours and gouache, outside of illumination work, had only been used by a few artists before Dürer. He employed them in a variety of ways, ranging from the evocation of a twilight scene, as shown here, to his extremely meticulous studies of plants and animals, before using wash drawing, for the first time in history, to convey a dream vision (in a picture with an accompanying text: Dream Vision, 1525, Kunsthistoriches Museum, Vienna). Photo © Bibliothèque Nationale/Larbor/T

1471. Albrecht Dürer is born in Nuremberg, the third son of a Hungarian goldsmith who had travelled extensively throughout northern Europe.

1483. He embarks on a career as a painter, and his brilliance is soon acknowledged, but (apart from a few drawings) little evidence of his work from this time has survived.

1491. At Colmar, in the workshops of the sons of Martin Schongauer, and later in Basel, the young Dürer makes his mark as a wood engraver.

1494. Gets married after returning to Nuremberg. First trip to Italy (Mantua, Padua and, most importantly, Venice).

1495. First watercolours. Opens his own studio in Nuremberg, and produces wood and copper engravings. First notable paintings (Haller Madonna, 1497).

1498. Publication of his Apocalypse (with wood engravings), which makes him famous throughout Europe.

1505–7. Second journey to Italy, staying mainly in Padua and, for a longer period, in Venice (where the Senate had issued a decree protecting his prints against forgers). He leads 'the life of a gentleman', buying objets d'art and editions of the classics for the humanist Pirckheimer, his friend and patron.

Left: *Hands in Prayer,* drawing, 1508 (Graphische Sammlung Albertina, Vienna). Study for an apostle for the Heller altarpiece, whose central theme is the Coronation of the Virgin. In the same way that the theme was modified by imitating a painting by Raphael, the treatment of the traditional motif of hands joined in prayer appears less austere than in the work of the Gothic draughtsmen. *Photo Ed A Schroll © Archives Larbor/T*

1507. Returns to Nuremberg (*Adam and Eve; The Martyrdom of the Ten Thousand*).

1512. Beginning of his acquaintance with Emperor Maximilian I, whose portrait he paints, and who commissions from him the largest wood engraving ever made (10 square metres), the *Triumphal Arch,* the complexity of which Dürer himself found tedious in the extreme.

1514. Produces two of his most famous independently executed engravings: *The Knight, Death and the Devil* and *Melancholia,* a woodcut with a plethora of cabbalistic symbols. He travels to the Netherlands; in his diary, he dwells less on the artists he meets than on his discoveries: shells, parrots, Aztec objets d'art, etc. He travels as far as Zeeland, in the vain hope of seeing a beached whale, and falls ill during this expedition.

1521. Having returned home, he plans to write a book on painting. He writes his treatises on fortifications, geometry and anatomy (published between 1525 and 1528).

1521–3. Last major paintings (*Saint Jerome*). Paints his last self-portrait in the *Man of Sorrows.*

1526. A convert to the ideals of the Reformation, he finishes his last great work, the *Four Apostles* (Munich).

1528. Dürer dies in Nuremberg.

A EUROPEAN-WIDE MOVEMENT

Albrecht Altdorfer, *Susannah at the Bath,* 1526 (Alte Pinakothek, Munich). Altdorfer often liked to present a story dwarfed beneath vast skies and great elaborate forests or, as is the case here, beneath extravagant edifices, with German town halls 'constructed' according to the aesthetic canons of the Renaissance. Susannah, whose feet are being washed (the nude was outlawed in biblical scenes in Germany) is also identified by the bouquet of lilies (an allusion to the Hebrew etymology of her name) that her handmaiden carries as she leaves the garden in the direction of an esplanade teeming with people.
Photo © Joachim Blauel/T

CROELLI SISTEER PONTORMO TITIAN UCCELLO VAN DER WEYDEN VAN EYCK VASARI VERONESE VERROCCHIO ZUCCARO ALBERTI ALCANIZ ALLORI ALTDORFER AMBROGIO L
BELCAELMI BELLANGE BELLINI BONILOGNONE BERNINI BERRUGUETE BOLDEMAER BONIFOL BOSCH BOTTICELLI BOTTICINI BOUTS BRAMANTE BROEDERLAM BRUEGEL BRONZE LE
ERA ACCIAIO COLLANTONIO COLYER IZAMBURDE FRENCH FERRUZERRO FARSA DEI GHIRANDES FABRIANO EL COLORADIO MOUS HANS JO FOSTANDES HITORS
POLLI CHIO ROLLOGNI BOUTS BRAMANTE BROEDERLAM HERACLE ANGEL DEL SCHOOL SIMONIA DE ISAMEI FLAMENCA LEONARDO BANDO ANGA VASCO AVELE FEBRA CA LEA LE
HBERTI GHIRLANDAIO GIORGIONE GIOTTO GIOVANNI PISANO GRUNEWALD HOLBEIN INGRES JEAN DE BOULOGNE LEONARDO DA VINCI LIMBOURG LIPPI LORENZETTI LOTI

Hans Holbein the Younger, *The Ambassadors*, 1533 (National Gallery, London). A double portrait of Francis I's envoy to London, Jean de Dinteville, and his confidant, Georges de Selve. Both highly cultured men, the nobleman and the bishop are surrounded by objects representing their intellectual interests. The painting, in its trompe l'œil magnificence, is based on a system of codes and symbols: the ambassadors' ages as well as various allusions to their life histories can be deduced from it. Holbein inserts an anamorphosis into this celebration of earthly glory: a human skull, both a symbol of vanity and a signature (*hohles Bein*: hollow bone), as well as a celebration of his mastery of perspective. *Photo E Tweedy © Bridgeman-Giraudon*

forms and chromatic grandeur and harmony, which give a humanist dimension to the expression of religious disquiet (*Adam and Eve*, 1507; *The Four Apostles*, 1526). His work had some influence on the amiable eclecticism of his friend and rival Lucas van Leyden (d.1533), the cosmic vision of Altdorfer (*Battle of Alexander*, 1529), and the amazing prints of Hercules Seghers, in which meticulously rendered landscapes acquire a metaphysical dimension. Deutsch (in Switzerland) and the Master ES (in Hungary) formed part of his school, but his essential spirit is to be found in the work of Baldung Grien, whose exceptionally pure style of drawing freed fantastical themes from conventional treatment.

It was the Flemish art of van der Weyden which, in Augsburg in around

Right-hand page:
Hieronymus Bosch,
The Garden of Earthly Delights, 1503–4, central panel (Museo Nacional del Prado, Madrid). This brilliant triptych shows Heaven on the left, a 'diablerie' on the right which interprets the theme of Hell in a bizarre manner, and in the centre (shown here) the disturbing vision of the earthly world where sin, in myriad forms, reigns supreme in a landscape of the most delicate, appealing, even innocent luminosity, where the figures appear like sleepwalkers. This complex masterpiece certainly contains allusions to contemporary Rhenish mysticism, but many details evoke the symbolism of alchemy, or even doctrines bordering on heresy. The technique is wonderfully inventive and subtle throughout, and the painting was an immediate and lasting success.
Photo © Dagli Orti

1500, inspired Hans Holbein, whose son Hans Holbein the Younger (1497/98–1543) was more than just one of the greatest portraitists of all time. The sheer scale of the artistic problems that he tackled and resolved, combined with the intimate psychology evident even in his ceremonial portraits, reflects his thorough knowledge of the major artists (Leonardo, but also Dürer and the Fontainebleau School), intellectuals and writers (Erasmus) of his era. Having been engaged by King Henry VIII in 1533, he paved the way for the school of English miniaturists (Hilliard, Oliver). The nomadic life of this artist, who moved in the same circles as the rich and powerful (and who died, still young, of the plague in London), shows the extent to which the Renaissance now permeated all of Europe.

Conversely, the Netherlands, which was to go through a terrible war of independence in the years 1566–79, turned away from the outside world to a certain extent: the work of Hieronymus Bosch (1453?–1516) is all the more intriguing for that reason. He never left his native town and experienced nothing of the intellectual turmoil of his times. However, if his *Temptations of Saint Anthony* (pre-1515) are compared with the memorable contemporaneous painting of the same subject by the Rhenish artist Matthias Grünewald (Issenheim altar, Colmar, 1511–17) a huge difference can be seen. In spite of a few fragments treated in trompe l'œil, Grünewald belongs totally to the world of the Middle Ages in his expressive violence, his crowded figural compositions, and his jarring colours. By contrast, Bosch's most grotesque demons are depicted in

Matthias Grünewald,
The Issenheim Altar, detail. The Temptation of Saint Anthony, c.1515 (Unterlinden Museum, Colmar).
Photo © Giraudon

BELLA CALLING BELLINI BERNINI BRUEGHEL GIOVANNI BERNINI PERUGINI LE BENTMARIA PURIANO POUPLET LUI BERNINI QUILLE DE MURANO LUCIO BUON BERGAMO LUI CELVINO RAPHAEL BUILIN
LA SETTIO SANSO DONATELLO DURER ANGELINO DANTE BUCCHI LE GHIRLANDA GABRIANI GUBERTI SGUIBENDAIO GIORGIONI BOSCH CELINI GRANSI TO BOTTICELLI ANSO BUILINI
PROCCHINO ZUCCARO GIOVANNI CARIANA SPIRIT HOMMER AMBER BRUICDE ESCHI REAMANCELLA DAMBO CLEMASNANI DUE TANSO DUSO CUERA AUTO CERRA DA BEVULE
HUBERTI GHIRLANDAIO GIORGIONI GIOTTO GIOVANNI PISANO GRÜNEWALD HOLBEIN INGRES JEAN DE BOULOGNE LEONARDO DA VINCI LIMBOURG LIPPI LORENZETTI PULSE

an orderly, even serene, setting, and his bizarre creatures are portrayed with a delicacy of brushwork and a quasi-Lombardian transparency of colour. He displays affinities with manuscript illumination, a receptive art, much more than with Late Gothic sculpture. Most importantly, he interiorized the most unrealistic religious motifs to such an extent that he anticipated psychoanalysis. In the 17th century, the Spanish monk Joseph de Siguenza, bearing the artist's sources in mind (popular devotional imagery, semi-burlesque scenes of the mysteries), made the curious observation that Bosch 'paints men not as they are on the outside, but as they are on the inside'. Bosch would have no artistic heirs, other than indirectly in the Brueghels – a dynasty of painters of whom the founder alone had genius.

Apprenticed in Antwerp in around 1540, Pieter Brueghel the Elder (1525/30?–69?) absorbed the cosmopolitan life of a port which was beginning to supplant both Genoa and Venice. He had humanist friends: the printer Plantin and the geographer Ortelius, for example. He was

Brueghel the Elder, *The Fall of Icarus*, c.1558 (Musées Royaux des Beaux-Arts, Brussels). Not so much visible in the illuminated sky as suggested by the gaze of the shepherd, Icarus falls into the sea on the right. His fall does not disturb everyday human activity, symbolized by the toiling labourer. It would be wrong, however, to conclude that this is a moral commentary derived from folk wisdom, denouncing the folly of reckless enterprises (alluded to by the vessels dotted along the hilly coastline): all of Brueghel's work is pervaded with a tension, often tinged with nostalgia, between the radicalism of the Renaissance pioneers and an austere, simple morality.
Photo Lou © Larbor/T

SELIGIGNANO DONATELLO DÜRER EL GRECO FILARETE FOUQUET LE FIULLI DA FABRIANO GHIBERTI GHIRLANDAIO GIORGIONE GIOTTO GIOVANNI PISANO GRÜNEWALD HOLB
ANGELO DI NICCOLO MABLITAGLIA CERTALDO PISANO ALSO MATEO FATENCO CHE FREDI EMMANALI ANDREA AFTER SAN FAGNI ANDRES PISANO UNGELLLO AN POLIALLO DA CRAVATA
ACELLI EDITICONI HERO BRAMANTE BRONZANO HENCRO CARAVAGELLO CHI PRIMA HINCLUSO INGAELO LAN BEY CAMBIO DE CARAQUI SAN PISA SOU CABOCIN GOLTZLICE GIO
ALI GHIRLANDAIO GIORGIONE GIOTTO GIOVANNI PISANO GRÜNEWALD HOLBEIN INGRES JEAN DE BOULOGNE LEONARDO DA VINCI LIMBOURG GIOTTO FIRENZE EL VAUTTI

Left-hand page, top:
Joachim Patinir, *The*
Flight into Egypt, c.1501
(Musée des Beaux-Arts,
Antwerp). In the course
of his brief life, about
which little is known,
Patinir painted only about
20 paintings, all except
one using religious
subjects as a pretext. The
subject here is nothing
but a pretext: Patinir, who
appreciated the subtle
presentation of back-
grounds in the work of
Gerard David and
perhaps Bosch, was
obsessed with landscape.
He does not yet treat it as
a more or less realistic
'genre' but as the arena
for an idealized recreation
of the world. The tiny
figures are dwarfed by the
magical depths of the
landscape, depicted in a
range of colours which
have the sparkle of
delicate gems and which
gradually fade into the
trio of shaded tones used
to render the background
– a technique Patinir did
not invent but to whose
development he greatly
contributed.
Photo © Giraudon/T

familiar with the work of Joachim Patinir, the creator of Flemish land-
scape, who brought to the genre in around 1510 a luminosity and seren-
ity rarely attained thereafter. In 1551, Brueghel travelled to Italy, where
he drew the mountains of the Alps and the ruins of Rome, which he was
to feature in some of his religious paintings. Even before this fervent
advocate of the Reformation was inspired by the repressive Spanish
Inquisition to execute biblical allegories, he revisited medieval themes in
a wholly new 'infinitist' vision (*The Tower of Babel,* c.1560; *The Triumph
of Death,* 1563) or combined realism with a mythological theme (*The Fall
of Icarus,* 1558). He executed these masterpieces in a spirit close to the
'pantheism' of the Renaissance philosophers: nature, even in movement
(*The Storm at Sea,* 1568), is in collusion with man (*The Four Seasons*).

The popularity of the large number of Brueghels who came after him
meant that art buyers soon favoured simple rustic or folkloric scenes, or
scenes of a stereotypically fantastical nature, over this intellectual art.
But engravings 'after' Brueghel the Elder had a huge success quite inde-
pendent of the family firm.

Diffusion and Decoration

The importance of engraving in the diffusion of the Renaissance cannot
be overemphasized, even before the development of the chiaroscuro
woodcut (xylography using several blocks of wood) by Ugo da Carpi
(Venice, 1516). The 'industrial' arts, as we call them today, contributed to
this diffusion. Again and again, Venice was at the centre of this process.
The city had long possessed an 'artistic' printworks, the Aldine Press: to
this we owe, for example, the *Dream of Poliphilus* or *Hypnerotomachia,*
the work of Francesco Colonna (1499), who exerted a huge influence for
several generations with his courtly Platonism and rich symbolism. His

Brueghel the Elder,
Haymaking, 1564
(National Gallery,
Prague). This is one of five
known paintings probably
belonging to a series
depicting the months of
the year (in this case July).
The breadth of the
landscape and the calm
evocation of country life
give a dimension of
serene grandeur to this
picture, transcending the
level of mere storytelling:
a quality that Breughel's
many disciples would
rarely achieve.
Gallery Photograph ©
Archives Larbor/T

A-WIDE MOVEMENT A EURO
MOVEMENT A EUROPEAN-WIDE
A-EUROPEAN-WIDE MOVEMENT
AN-WIDE MOVEMENT A EURO-
MOVEMENT A EUROPEAN-WIDE
AN-EUROPEAN-WIDE MOVEMENT
MOVEMENT A EUROPEAN-WIDE
A-EUROPEAN-WIDE MOVEMENT
AN-WIDE MOVEMENT A EURO-

A EUROPEAN-WIDE MOVEMENT

Lorenzo Lotto,
Maiden's Dream, c.1506
(Samuel H Kress
Collection, National
Gallery of Art,
Washington).
A versatile and eclectic
artist, Lotto here
seems to have been
influenced by Bellini
and even Giorgione.
Furthermore, it is rare
for him to tackle a
non-religious theme
(except in portraiture).
The Venetian quality of
the landscape and the
dreamy atmosphere are
tinged, in this rather
indecipherable allegory,
with a rather archaic
sense of fantasy, which
is not devoid of charm.
*Photo © the Museum-
Archives Larbor/T*

SCATTADI BELLINI BELLINI BORGOGNONE BRUSINI BERAUGUELE BILOTMAERT BOSCH BOTTICELLI BOTTICINI CARSAMANTE BRONDERLIA INTROBEBERDALLI IL ASCHILIANUO CONSTEO PACHER BARBIECO FILANTE LEOUQ BELLO FERRUTA CARDONE CORRI BELLO CUITISANDANI CHURCIONE GIOTTO IO GIOVANNI PISANO GROTH BARTATIAN ANCHO PAUGCINI AMBELI ALCANINI INDIORTER PATERNO CETELIAO BIZAUMALLASORIO CARTATIALLO COTTAGINO GRILO CIGLIO DA POLUGLIO DA ARGUITAN ERHIRLANDAIO GIORGIONE GIOTTO GIOVANNI PISANO GRONEWALD HOLBEIN INGRES JEAN DE BONLOGNE LEONARDO DA VINCI LIMBURG LIPPI LORENZI CAVITO

Tintoretto, *Crucifixion,* detail, 1565 (Scuola di San Rocco, Venice). Tintoretto executed 62 paintings 'telling the story' of the Old and New Testaments in his vast decorative scheme for a confraternity building. Each episode is treated with the pathos (less realistic than visionary) and the boldness (construction based on diagonals, and falling or hurtling figures) which are characteristic of the painter. The theatrical attitudes of the figures are bathed in contrasting light, adding to the illusion of movement. *Photo © Marzari, Schio/T*

Left-hand page, bottom: **Marcantonio Raimondi,** *The Massacre of the Innocents,* engraving after a composition by Raphael, c.1511 (Cabinet des Estampes, Bibliothèque Nationale, Paris). Developed in Florence before 1450, metal engraving immediately began to rival wood engraving. Due to the ease with which large quantities could be produced, as well as its greater accuracy, it became the best vehicle for the distribution of paintings and drawings. With the advent of Mannerism, engraving ensured that paintings were very popular throughout Europe. Among the projects Raphael never managed to carry out, this one (for which several sketches exist) has been preserved thanks to the development of engraving. *Photo © Bibliothèque Nationale/Larbor/T*

engravings were wrongly attributed to Mantegna.

Mosaic work went into decline after 1520, but in Urbino and elsewhere majolica (glazed enamelware) versions were produced of the compositions of Raphael and the painters of Lombardy and Emilia. The Renaissance stained-glass window had already featured in the Hôtel Jacques Cœur de Bourges, whose uniformly painted décor was the work of an anonymous painter (c.1445), and was now reproduced throughout Europe. Julius II summoned Guillaume de Marcillat, a native of Berry, to Rome, and although nothing remains today of the work he produced in Rome in collaboration with Raphael (it was destroyed in 1527), the stained-glass windows which he made for the Cathedral of Arezzo can still be seen.

Even in Florence, the painters Poccetti, Ligozzi and others worked in the Opificio delle Pietre Dure (Hard Stones Workshop), where, in 1588, engravers began to be trained in antique stone mosaic craftsmanship (the *commesso* technique). Marquetry continued to be produced throughout the century (Lotto at Bergamo). There was an unexpected revival of manuscript illumination work in Rome (Clovio). With regard to tapestry work, Raphael's *Acts of the Apostles* and Giulio Romano's *History of Scipio* challenged Gothic conventions, which still persisted at the beginning of the 16th century. The new studios of Florence (1545) and Brussels (1530–75: *The Hunts of Maximilian*) were strongly Mannerist.

In Venice, however, during the second half of the *cinquecento,* the predominance of Titian eclipsed the work of other artists. His rival, Tintoretto, who emerged in around 1540, was essentially local, although he began by succumbing to Mannerism (while drawing in the manner of Michelangelo). A fiercely determined painter, both a realist – at times even bordering on crudity in certain details – and obsessed with grandiose visions, he produced, with his great decorative cycles in the Scuola di San Marco and then in the Scuola di San Rocco (1562–4), the

A EUROPEAN-WIDE MOVEMENT

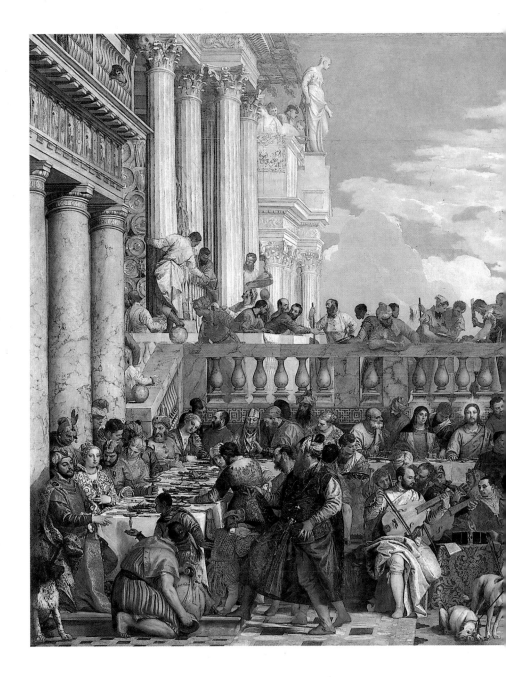

Veronese, *The Marriage at Cana*, c.1571 (Musée du Louvre, Paris). The Marriage at Cana is one of the two largest paintings in the world (along with the *Feast in the House of Levi* by the same artist). The biblical story is lost in the profusion of figures (132) and the splendour of the colours, which through a system of visual rhymes divert attention from the rather cavalier approach to perspective in parts of the painting. Traditionally, some of the musicians depicted have been identified as portraits of some of the most famous Venetian painters of the time: suffice it to say that the 'subject' is less important than the richness of aesthetic and formal harmonies that it suggested to the artist. *Photo © RMN*

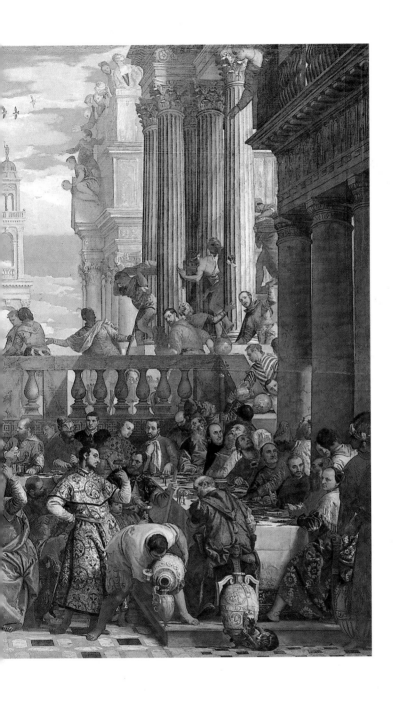

"-WIDE" MOVEMENT A EURO
MOVEMENT A EUROPEAN-WIDE
EUROPEAN-WIDE MOVEMENT
-WIDE MOVEMENT A EUROL
MOVEMENT A EUROPEAN-WIDE
EUROPEAN-WIDE MOVEMENT
-WIDE MOVEMENT A EUROL
EUROPEAN-WIDE MOVEMENT
MOVEMENT A EUROPEAN-WIDE
-WIDE MOVEMENT A EURO-

A EUROPEAN-WIDE MOVEMENT

Veronese, *The Creation of Eve*, 1570–2 (Art Institute, Chicago). This is one of the masterpieces of the painter's mature period. Freed here from the constraints of the sumptuous decorative work to which he so often applied himself, Veronese identifies himself in a way with God, shown delicately extracting a still numb Eve from Adam's side. The landscape seems entirely realistic, but its striking clarity, its reduction to its essential elements, its fullness and remarkable radiance all remind us that this is an Edenic, prelapsarian landscape. *Photo J Martin © Larbor/T*

only ceiling paintings capable of vying with those of the Sistine Chapel. After a short interlude, when he devoted himself to mythological themes in the Doges' Palace, he executed some huge compositions (*Paradise*, 1586; *The Last Supper*, 1594) and was still working when he died. In his oblique compositional layouts and his contrasts, which are not so much based on colour as on great avalanches of light and shade, he differs markedly from Veronese.

An eclectic who owed his taste for full, rather classical forms (such as those of Mantegna) to his place of origin, Veronese (1528–88) settled in Venice as a rival to Tintoretto, treating the same religious scenes in an entirely secular manner. Some maintain that his decorative masterpiece is to be found at the Villa Maser, built by his friend Andrea Palladio, who introduced an elegant, rational and yet warm and intimate architecture to the Veneto (1563). A master of trompe l'œil, Veronese was as happy painting action-packed allegories to the glory of Venice (1580) as he was producing mythological paintings, which were now highly fashionable. Venetian painting began to wane at the same time as Venetian politics, although it still had an influence on painters such as Scarsellino in Ferrara (1580), in whose work the Counter-Reformation artfully subverts Mannerism.

WIDE MOVEMENT A EURO-
OVEMENT A EUROPEAN-WIDE
EUROPEAN-WIDE MOVEMENT
OVEMENT A EUROPEAN-WIDE
EUROPEAN-WIDE MOVEMENT
WIDE MOVEMENT EUROPEAN-WIRO-
EUROPEAN-WIDE MOVEMENT
OVEMENT A EUROPEAN-WIDE
-WIDE MOVEMENT A EURO-

A EUROPEAN-WIDE MOVEMENT

MAGNITA CARAVAGGIO CARON CARRACCHI CARRACCI CAVALLINI CELLINI CIMABUE CLOUET LORRE GIO FRANACH DAVID DELACRO
LEONARDO DA VINCI DUBREUIL LIMBOURG LIPPI LORENZETTI LUINI LUCAS VAN LEYDEN MANTEGNA MANTINI MAN FORLI NANACCI MEMLINC
ALLEN MANODNALLI BARTO LOMMEO BASSANO RICCCI MALBERTANG FORTUNI BOROUGNONE IL GRECO IL GRECO MLAREI IL FOCQUET CRI
GIORGIO CARRACCHI BARTO DELACROIX DESIDERIO DA SETTIGNANO DUBREUIL DURER EL GRECO MIALREI FOCQUET GRI

Previous page: *The Story of Cupid and Psyche* (stained-glass window of the Château d'Ecouen), after 1542 (Musée Condé, Chantilly). From the end of the 15th century, and especially after 1530, a new style came to prominence in stained-glass window work which exploited certain technical innovations: acid etching of the clear layer in double-layered glass, the use of vitrifiable red chalk resulting in elaborately detailed draughtsman- ship, the use of yellow or silver stain and grisaille, and a reduction in the numbers of lead strips used. This was also the period when a large

Tapestry of The Hunts of Maximilian, known as the *Belles Chasses de Guise, July, the Stag Hunt,* from the cartoons of Van Orley, after 1520 (Musée du Louvre, Paris). The creator of the cartoons for this famous series of tapestries, the painter Van Orley, never went to Italy, but was well informed about artistic developments and works of art created during the Renaissance. He freely combined complex allegories of medieval origin with realistic scenes, without there being any real connection between a given month of the year and the hunt depicted. Similarly, the 'northern' and largely fantastical setting is enriched with 'southern' motifs in the treatment of the foliage.
Photo © RMN

number of stained-glass windows were introduced into civil buildings, most of which are now lost. The set of windows from the Château d'Ecouen (42 stained-glass windows grouped in seven panels) is therefore an extraordinary testament to this art. Its anony-mous elegance (per-haps derived from engravings attributable to Raphael's assistants) is based on a fable which was popular with the humanists.
Photo © Giraudon

FORMATION THE MANNERIST TRANS- PASTAGSO ANDREA PISANO ANTULIO ANTONELLO DA MESSINA ARCIMBOLDO ARTINO BALDUNG GRIEN BANDINELLI BARTOLOMO
ION MANNERIST TRANSFORM- PARMIGIA CARAVAGGIO CARON CARRA CORI SARRACCI CAVALLINI CHI CIMABUE CICQUT L'XBBECIGLIO GHADA DI DAVID DANO
HE MANNERIST TRANSFORMA- PHS GARO ROMANO DI CRISEGROROLI TI HILO AUSANSSOM DI MARI REGINA MARTINI ABRAM DELLA FRANCA ANTLA
IST TRANSFORMATION THE PEGGIO CRAVALCH SARTO DI SACROA DANIL RIO DA SMITIGNANO URNAHIO DORER EL GRECO FLARETTI FOLQUET GENTIL
FORMATION THE MANNERIST
HE MANNERIST TRANSFORMAT-
RMATION THE MAN-
FORMATION MANNERIST
HE MANNERIST TRANSFORMA-
ANNERIST TRANSFORMATION
IST TRANSFORMATION THE

THE MANNERIST TRANSFORMATION

Mannerism was not a new development which created an upheaval in the evolution of art; neither was it a recurrent phenomenon in the history of artistic styles, occurring in the Gothic era just as it would in the 20th century. It was, in fact, a complex transformation of the Renaissance, linked to an alteration in the mentality of the times. It did not so much mark a break with the spirit of previous years as develop certain potentialities of this spirit; it did this by elaborating a style which had already been formed, and by exploiting models which had been per-fected but not yet exhausted. It manifested itself essentially in painting: sculpture, unhampered by any kind of constraint, simply continued on its course, and there is almost no Mannerist architecture in the strict sense of the term. In response to the model of convulsive and pre-Baroque grandeur in the work of Giulio Romano, an initial readjustment took place in the work of Andrea del Sarto (1486–1531), among others. The pre-eminence of a certain luminosity (which did not in any way eclipse drawing) was accompanied by naturalistic or imaginary elements. At the end of the period, Taddeo Zuccaro (c.1600) identified three ways in

Andrea del Sarto, *Saint John the Baptist,* c.1525–30.(Palazzo Pitti, Florence). Far from being the sentimental artist beloved of a certain school of romantic imagery, this Florentine master – although sensitive to the undercurrents of disquiet present in Mannerism – emerged in his mature period as a robust but delicate Classicist. *Photo Scala © Larbor/T*

DELLA AZZARI BELL/INI E PERUGINO BURRI ANTONE BELLINI DEL KRUGUEILE BENEMALEN BONINE BOSCH BOTTICELLI BOTTICINI BOULTS BRAMANTE BROEDERHAM BRUEGEL BRUNEL HERACHTO CANOVA CARAVAGGIO ASTIER FABRIGIANINO ELENKUGEL CERRUEL NO OBERONH GUTBERLE CATTERO DI CONTRGIOVNI DIUCORGIO KANALI LOTPOU PIOLO PONTH ERLOCCHIO ZUCCARI ALBERTI DAVANZZABRO PEIDRI DORRER AMBROUGUE DE PRED R AMMANTI ANDREA DEL CASTAGNO ANDREA PISANO ANCHIRO ANTONERIO DA VISVA CANI SIBFLE GALANI RABEI GIULNAK GHI MANCINI GREGIIO CLARAANCI AGRRI DELLA CILVO MELAN HERRIT GHIRLANDAIO GIORGIONE GIOTTO GIOVANNI PISANO GRÜNEWALD HOLBEIN INGRES JEAN DE BOULOGNE LEONARDO DA VINCI LIMBOURG LIPPI LORENZETTI LOT

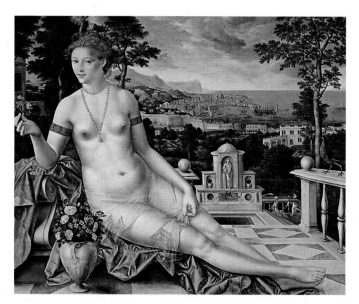

Jan Matsys, *Venus Cytherea*, 1561 (Nationalmuseum, Stockholm). The realism of the Antwerp painters is combined here with a Mannerism that is evident not only in the choice of themes, but also in the preciosity of pose and details. The landscape in the background has been identified as a view of Genoa, where Jan Matsys (son of Quentin) went into exile from 1544 to 1548 in order to escape an accusation of heresy.
Photo © the Museum/T

which the artistic 'idea' could be realized: art copying nature, the mind creating an artificial image of nature, and the *disegno fantastico*, made up of whims, eccentricities, 'unusual things' and inventions. Mannerism, while not disregarding the first form, assiduously cultivated the last two.

At first there was nothing pejorative about the term 'Mannerism'. It designated stylistic elegance and the infatuation of the people of the time with this elegance and with the 'manner' of such and such an artist. Subsequently it referred to their infatuation with the 'grand manner', which became the dominant style in Rome in around 1520: It was only at the end of the 17th century that the word was used to describe the degeneration of taste resulting from the predominance of the imagination over academic rules – rules which had been elaborated in the meantime.

With regard to the ideological aspect of this phenomenon, the effects of the 'catastrophe of 1527' (the Sack of Rome by Lutheran landsknects and the mercenary gangs of the Connétable de Bourbon, the unreliable ally of Charles V) should be neither downplayed nor exaggerated. Recent research has shown that, on the one hand, the dispersion of the artists working in Rome (of whom several would return to their homes after the departure of the imperial army) began as early as 1520 and, on the other, that the Papacy managed to transform the defeat into a celebration of the enduring permanence of the city. Furthermore, Charles V was to guarantee that the Medicis regained firm control of Florence shortly afterwards. It is nevertheless true that a new anxiety, linked to the dreams of a Catholic 'Reformation', pervaded the Italian courts and intellectual circles from about 1520 until the conclusion of the interminable Council of Trent (1563), which formulated the Church's response to Protestant propaganda. Mannerism therefore appears as the first reflection of this disquiet (the actual impact of the Counter-Reformation came slightly later): in Italy, it was expressed in the growing insularity of small

ON THE MANNERIST TRANS-
MANNERIST TRANSFORMA-
NNERIST TRANSFORMATION
NSFORMATION THE MAN-
FORMATION THE MANNERIST
ON THE MANNERIST TRANS-
E MANNERIST TRANSFORMA-
NNERIST TRANSFORMATION
ST TRANSFORMATION THE

THE MANNERIST TRANSFORMATION

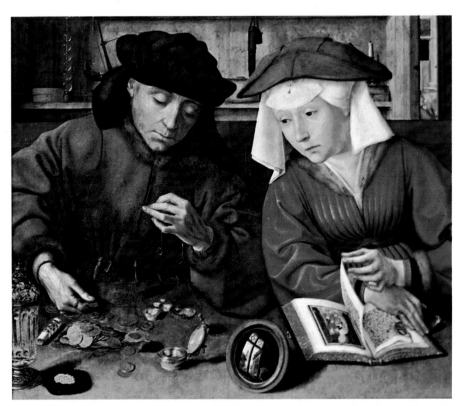

Quentin Matsys, *The Moneylender and His Wife*, 1514 (Musée du Louvre, Paris). This picture has become one of the most common allegories of the beginnings of capitalism. In fact, what this striking genre scene suggests is that a balance is desirable between worldly goods and religious faith (symbolized by the book) – which corresponds with the ideal of the Flemish humanists on the eve of the Reformation. Although the artist seems excessively attentive to materialistic detail, his friendship with Erasmus, of whom he left a fine portrait (Palazzo Barberini, Rome), indicates that he had a sense of the spiritual. *Photo Guiley-Lagache © Archives Larbor/T*

towns which were still independent, under more or less clear-cut Spanish control, although this socio-political insularity did not hinder the increasing homogeneity of artistic expression.

The formal origins of Mannerism can be found in certain daring innovations by Raphael towards the end of his life (and already evident in the *Foligno Madonna*, 1512) and, above all, in the work of the omnipresent Michelangelo. The dissemination of Germanic art (that of Dürer, for example) through engraving also played a role. But most importantly, a desire for greater virtuosity altered artists' relationship to the Renaissance ideal of beauty. A general vogue for sinuous forms led to an elongation of the human body as prescribed by Renaissance canons of beauty (its total height was no longer seven-and-a-half times the length of the head, but about nine-and-a-half times). In the work of a few artists, the tendency for treating sculptural forms like two-dimensional forms (Rosso) even took the form of cubist distortions (Luca Cambiaso, Giulio Campagnola). Light colours were used to depict rock-like figurations (Daniele da Volterra's *Deposition*, Church of Trinità dei Monti, Rome) or became pale, almost acid and cold (Pontormo). Often, the relation between the background and the principal figures was negated, with the pictorial space being completely filled by the figures except for an infinitesimal, almost vertiginous, perspective view. Sometimes, lighting from a single source was abandoned for contrasting effects of night and storm (Beccafumi, in *The Fall of the Rebellious Angels*, c.1530). The minds

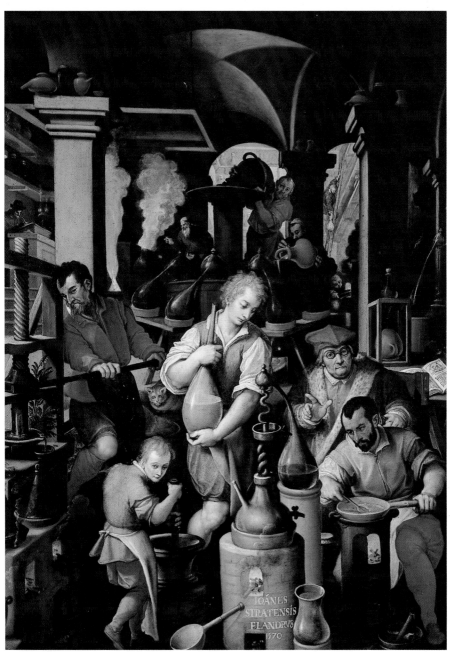

Giovanni Stradano, *The Alchemist's Laboratory*, 1570–5 (Studiolo of the Palazzo Vecchio, Florence). Many painters demonstrated their originality within the collective output of the *studiolo* coordinated by Giorgio Vasari (including Vasari himself). The originality of Stradano, a Flemish painter who worked in Florence for his entire career, consists in a realism in the treatment of details, reconciled with the prevailing style of Mannerism and combined with an emphasis on the bizarre. Alchemy was scarcely any different from chemistry at the time, and the 'laboratory' depicted here could be that of the Grand Duke Francesco himself. *Photo © Dagli Orti*

115

Jacopo da Pontormo (properly Jacopo Carrucci), *Deposition*, 1526 (Church of Santa Felicità, Florence). In this astonishing fresco, the cross is not depicted and the figures taking part in the holy drama seem to be in a state of levitation. All the movements and gestures form part of a rhythmic harmony of complicated arabesques, as the figures seem to gaze questioningly at the viewer. The coolness of the colours is subtly varied by the use of fiery shades of red.
Photo © Scala/T

Right-hand page: **Parmigianino** (properly Francesco Mazzola), *The Madonna with the Long Neck*, 1534–40 (Uffizi Gallery, Florence). Famous for the anatomical distortion of the sinuous body with its gracious little head and for the beauty of the faces, this painting is also important because of the daring, abrupt juxtaposition of the foreground with the deep background visible to the right of the column: the tiny 'allegorical' figure is accompanied by an inscription in which the painter makes fun of his own 'inability' to finish his picture.
Photo © Scala

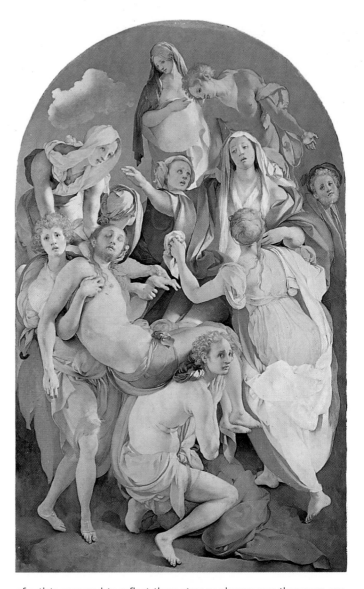

of artists appeared to reflect these strange phenomena: they were suspected (sometimes not without reason) of dabbling in magic, necromancy and alchemy. At the very least they seemed to be in thrall to misanthropy and melancholy. Along with the humanism which still lingered in art (Bacchiacca, Granacci), their work showed a curiosity about orientalism (for example, the *Circe* of Dosso Dossi, a Ferraran by adoption), an interest in science and, on top of that, a veiled but obvious eroticism expressed through complex symbols and present even in religious subjects.

Once more, it was Tuscany which provided the impetus: Pontormo (1494–1556), who ushered in Mannerism in its early form, trained with Andrea del Sarto. He knew Dürer, and even Schongauer, but there is no trace of any interest in the Reformation in the work of this cantankerous character, whose imaginative compositions were revealed in his diary,

116

BELLI SLUTER TINTORETTO TITIAN UCCELLO VAN DER WEYDEN VAN EYCK VASARI VERONESE VERROCCHIO ZUCCARO ALBERTI ALLANIZ ALTDORFER AMBROGIO DE
BALDUNG BRAMANTE BRUEGHEL ANGELICO BRONZINO BRUEGEL ER KNN ALBRECHT DUFY BRAMANTE BON DE BORGI
MEMLING MICHELANGELO PIETRO PONTORMO PRIMATICCIO RAPHAEL FRESCO DI RIBERA ROSSO TANPU CAMPAGNOLA CARAVAGIO CARON CARRACCI DO CARRACA CAS
RTI GHIRLANDAIO GIORGIONE GIOTTO GIOVANNI PISANO GRUNEWALD HOLBEIN INGRES JEAN DE BOULOGNE LEONARDO DA VINCI LIMBOURG LIPPI LORENZETTI LOTTO

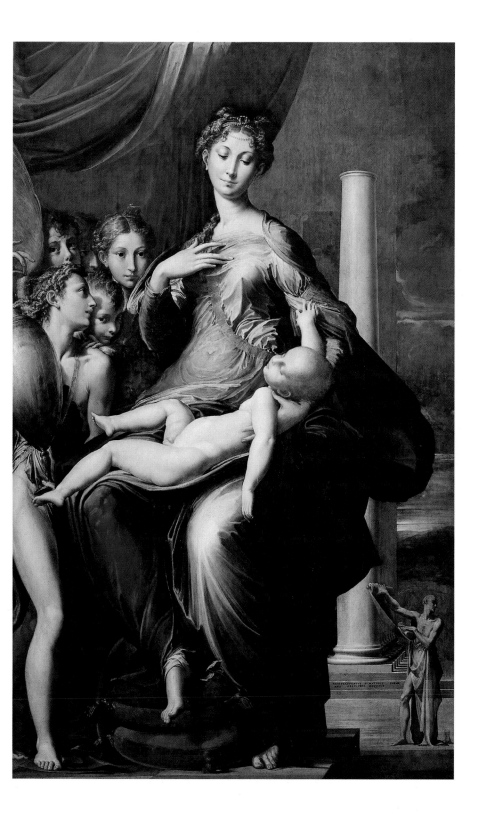

Domenico Beccafumi, *Continency of Scipio*, c.1530 (National Gallery of the Palazzo Mansi, Lucca). This evocation of an episode from Roman history is treated by Beccafumi in a style similar to that used in his strange frescoes in the Palazzo Pubblico in Siena: here again we find his idiosyncratic treatment of faces and his relative disdain for anatomy, which has been sacrificed to effects of posture and subtle contrasts (or 'fusions', in some cases) between the light, even cold, colours. *Photo © Alinari/Giraudon*

A SETTIGNANO DONATELLO DÜRER EL GRECO FILARETE FOUQUET GENTILE DA FABRIANO GHIBERTI GHIRLANDAIO GIORGIONE GIOTTO GIOVANNI PISANI GRÜNEWALD HOL
THEO NICCOLO NICCOLO DA TOLENTINO PARMIGIANINO PERUGINO PIERO DELLA FRANCESCA PIERO DI COSIMO PONTERMO CHICASSANO POUSSIN PRIMATICCIO RAPHAEL DA VINCI SAN
FICELLI BARTOLINI BOTTICELLI BRAMANTE BRUEGHEL CARAVAGGIO CAMELO CAMPAGNOLA CANOVA CARON CARRACCI TIEPOLO TINTORETTO UCCELLO VAN EYCK
THETI GHIRLANDAIO GIORGIONE GIOTTO GIOVANNI PISANO GRÜNEWALD HOLBEIN JEAN DE BOULOGNE LEONARDO DA VINCI

one of the first of its kind. His paintings integrate anatomical distortions and some precious effects of colour into fine rhythmic compositions inspired by Michelangelo, whom he strove to emulate in frescoes that are now destroyed (Church of San Lorenzo in Florence). However, he did almost equal him, though in a different style, in his decoration of the Charterhouse of Galuzzo and at the Church of Santa Felicità. Rosso (1494–1540) – another painter who had broken away from Sarto's studio – was already famous for his lurid effects of light and his semi-abstract constructions (*Marriage of the Virgin* in San Lorenzo; *Deposition* at Volterra, 1521) when he was recommended to Francis I of France and appointed director of works at the Palace of Fontainebleau. The third innovator did not share the same intense style of drawing: this was Beccafumi (c.1486–1551), a Sienese artist (frescoes in the Palazzo Pubblico). Despite his trips to Rome, he developed his own wholly individual style of craftsmanship. He demonstrated his Mannerist credentials by his use of unnatural colours and his inventions, which bordered on the fantastical. Mention must also be made of Bronzino (1503–72), the

ATION THE MANNERIST TRANS-
ATION THE MANNERIST TRANSFORMA-
MANNERIST TRANSFORMATION
ERIST TRANSFORMATION THE MAN
NSFORMATION THE MANNERIST
ATION THE MANNERIST TRANS-
THE MANNERIST TRANSFORMATION
MANNERIST TRANSFORMATION
ERIST TRANSFORMATION THE

THE MANNERIST TRANSFORMATION

Domenico Beccafumi,
Birth of the Virgin, c.1540
(National Gallery,
Siena). Beccafumi
occupies a singular
place in Sienese art: he
was very strongly influ-
enced by Raphael and
Michelangelo, during
two trips that he made
to Rome. This painting,
one of his most famous,
has several contrasting
light sources and a soft
chiaroscuro, another
distinctive feature of
Beccafumi's night
scenes. The extreme
stylization of the
domestic details of the
scene is also worth
noting. *Photo ©
Alinari/Giraudon*

Right-hand page,
bottom: **François
Clouet (?)**, *Woman at
Her Toilette*, c.1559
(Worcester Art Museum,
Worcester). There exist
several paintings on this
theme, which was
inspired by Italian
paintings – now lost,
but known in France at
the time – and by
mythological allusions.
The jewel which the
lady is holding round
her neck and the ring
supposedly symbolize
an illicit but faithful
union, thus inviting
comparisons with the
'portraits' of Diane de
Poitiers. The oblique
mirror suggests perhaps
the awareness of a
doubt or a lovers'
conflict. The light,
meticulous execution
and the atmosphere of
sophisticated luxury are
typical of the art of the
Fontainebleau School.
Photo © Archives ERL/T

ancestor (in both senses of the word) of a family of Florentine court painters. He managed to accommodate his crystalline style and penchant for complicated allegories in his imposing fashionable portraits and mythological nudes. In the work of Parmigianino (1503–40), a brilliant master of contrasts of scale who painted a famous self-portrait in a con-vex mirror, Mannerism became infused with alchemical symbols and numerous erotic allusions (*The Madonna of the Rose*). Finally, in the work of Primaticcio (1504–70) – a decorative artist and draughtsman as pro-lific as he was fascinating, and sent by Giulio Romano to Francis I – Mannerism reproduced the elegance of Raphael in a wholly original way.

The colourful figure of Benvenuto Cellini (1500–71) also belonged to the first generation of Mannerist artists: a first-rate sculptor (Perseus, Piazza Signoria, Florence) and an even more eminent goldsmith, he was also an adventurer, an assassin and a swindler. In his racy memoirs he is

CARLIM BELLANGE BELLINI BOREA A NONE BERNINI BERRUGUETE BOLTRAFFIO BONSIM BOSCH PHILIBELLA IVANUCINI BOUTS BRONZINO LEBRAREN FRANCO GHIVASILITIM JANSEN SANSOVINO PISANELLO DURER TRANSNI SCHUNGAUER PERUGINO PARAGNATI LETSKI SCHUMERO NELTOSINO ANTONELLO GIANNI CRIOILLION LORIPIZM ROCCHIO POLLICRO ALBERTI POLLAIUOLO DEGHESCERI AMOROSOS FELTI PREVIDAM SANTI ANDREA DEL CASTAGNO CLOUFTIO CORONEFRAMI ANTONIO MISTRO CA MUNVIN PERIT GHIRLANDAIO GIORGIONE GIOTTO GIOVANNI PISANO GRUNEWALD HOLBEIN INGRES JEAN DE BOULOGNE LEONARDO DA VINCI LIMBOURG LIPPI LORENZI ETTI LOT

Above: **Jean Goujon**, *Nymph and Putto*, bas-relief sculpture (from the Fountain of the Innocents), 1549 (Musée du Louvre, Paris). A great connoisseur of antique art and an admirer of Raphael, Goujon accepted the sinuous lines of Mannerism, but made his own mark through his individual style: fine texture, refined modelling and balanced and fluid composition. He decorated the Louvre of Pierre Lescot (1549– 64).
Photo H Josse © Larbor/T

a boastful but fascinating witness of his times. The state funeral of Michelangelo in Florence (1564) was the occasion of a quarrel between Cellini and Vasari, the official organizer. The issue at stake was serious: which was pre-eminent in the Mannerist world, painting or sculpture? Vasari won the argument, but by ultimately granting primacy to drawing, the father of the three visual arts, for which he created the first Academy at around this time. Michelangelo had lived to be old enough to see this ascendancy of drawing reflected in the work of young artists. In sculpture, Mannerism had appeared in the work of the Florentine Montorsoli and the Venetian Girolamo Campagnola, but it was an already ageing rival of Michelangelo, Bandinelli (1493–1560), who established it definitively by transposing the flat masses of Rosso's paintings into his colossal statues. Ammanati, whose work was less heavy, was nevertheless also haunted by the influence of Michelangelo. The vigorous grace of Giambologna, a sculptor and architect appointed by the Medicis after 1560, is more affecting: he was the great creator of decorative schemes which blended rocaille, water and vegetation with statuary. His disciple Buontalenti (d.1608), a famous designer of Medici court festivities and pageants, was one of the rare architects whose style was wholly Mannerist (Villa Petraia).

All of these artists were engaged in the prolific production of ornamental or functional objects whose design required as much talent as public or private buildings. Far from feeling humiliated by these small tasks, Mannerist artists saw them as an opportunity to display their skill, demonstrating dazzling 'inventiveness' in small-scale, meticulously executed and innovative pieces. Cellini executed large-scale designs for tiny objects. In around 1560, a change occurred within Mannerism. The concern with form did not disappear, but it

Fontainebleau

1526. Francis I decides to transform his modest royal manor into a palace. He enlists mainly Italian artists; some French architects (such as Gilles Le Breton) are also involved.

1530. Arrival of Rosso, director of works for ten years, who decorates the Francis I Gallery (paintings and stucco work).

1540. Rosso commits suicide (?); Primaticcio, already in Fontainebleau since 1532, takes his place. He decorates the Gallery of Ulysses (1540-70, now destroyed) and the Ballroom (much altered since then). Among his assistants are Niccolò dell'Abbate (1552), Luca Penni and Antoine Caron. Gradually, the stucco work is abandoned.

1540-5. Brilliant but stormy period of Cellini's stay: he executes The Nymph of Fontainebleau and the salt cellar of Francis I. He is accused of stealing. Creation of the bedroom of the Duchess of Étampes and the Vestibule de la Porte Dorée.

1540-50. Serlio, already used to working in France (Ancy-le-Franc), becomes, in theory, the palace architect: but the French builders dislike having to follow his instructions.

1545-60. A workshop is set up

Right: Benvenuto Cellini, salt cellar of Francis I, 1540-3 (Kunsthistorisches Museum, Vienna). This object, which is only 33.5 cm long, was designed and cast by Cellini with the same meticulous care that he would have lavished on a monumental statue. Salt, considered a luxury item, was always extracted from the sea; hence the gold motifs, some of them enamelled, on the ebony base, evoking Neptune and Amphitrite. Photo K G Meyer © the Museum/Archives Larbor/T

Left: Rosso Fiorentino, *The Unity of the State*, 1536–8 (Francis I Gallery, Musée National du Château de Fontainebleau). The monarch is surrounded by magistrates, soldiers, artisans and peasants: he holds a pomegranate in his hand, a symbol of the monarchy. Restoration work on the frescoes has shown that this one was executed under the direction of Rosso by assistants with varying degrees of skill. *Photo Jeanbor © Archives Larbor/T*

Benevenuto Cellini, *The Nymph of Fontainebleau*, before 1544 (Musée du Louvre, Paris). Designed for a door that was never built, this bronze sculpture – for which Cellini said he had used a 'marvellously beautiful' real-life nude model – exerted a considerable and continuous influence thanks to its reproduction in engravings. It shows that the goldsmith Cellini was also extremely talented when it came to large-scale sculpture: the elongated body and idealized face blend in with the pagan sensuality of the model. *Photo © Jean/RMN*

which produces a large number of engravings, thereby keeping alive the memory of lost paintings by artists such as Fantuzzi, Boyvin and Dumoustier.

1547. Death of Francis I.

1550. Relative eclipse of Primaticcio, who is supplanted by Philibert Delorme, favourite of Henri II. Reappointed superintendent of works (1558), he undertakes numerous building projects for the château, but also works in Paris (the Valois rotunda at Saint-Denis, 1560). In Fontainebleau, Niccolò dell'Abbate plays an increasingly important role.

1570. Death of Primaticcio. Work is suspended for a while due to the Wars of Religion. Intermediate 'School' (Carlo Giulio dell'Abbate, son of Niccolò, Ruggiero di Ruggieri) continuing the Mannerist tradition (Pavillon des Poêles, now destroyed).

c.1590. 'Second' Fontainebleau School. French and Flemish influences are more evident in this. Many anonymous works, often erotic (*Master of Flora*). Many works are now lost (Toussaint Dubreuil, whose *Lady at her Toilette*, from before 1600, has survived).

1599. Death of Antoine Caron, probably the French artist who best conveyed the sophisticated atmosphere and erudition linked with imagination that were typical of the

Fontainebleau court (*Triumphs of Winter, Spring*, etc; *The Tiburtine Sibyl*) while also including allusions to politics in his work (*Massacres under the Triumvirate*, 1566). He was also an active designer of cartoons for tapestries and an architect-decorator until about 1580.

1602. Ambroise Dubois takes over as director of works (*Theagenes and Chariclea*).

1614. Martin Fréminet (Chapel of the Trinity; *Four Evangelists* and *Four Fathers of the Church*, Musée d'Orléans: a majestic, violent style) becomes director. His death in 1619 coincides more or less with the abandonment of the works.

The Fontainebleau style had an immediate impact on the decorative schemes, now often lost or ruined, of other châteaux or chapels: Primaticcio's *Pietà*; the paintings and stained-glass windows of Ecouen; paintings inspired by the *Aeneid* at Oiron (Deux-Sèvres); paintings at Ancy-le-Franc, attributable in part to the entourage of Primaticcio and Niccolò dell'Abbate; and paintings at Tanlay (Yonne) and at Blois (the galleried Hôtel Sardini and other mansions), Villesavin, Beauregard and other places along the Loire, where Italians and mainly regional artists attached to the court – notably the Bunels – worked.

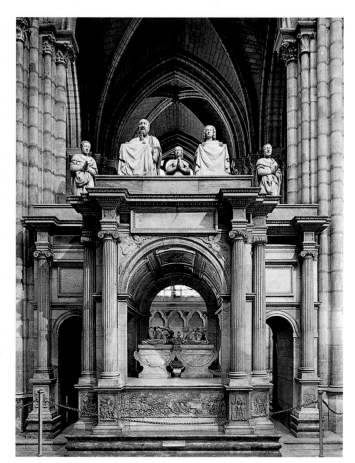

Philibert Delorme, tomb of Francis I and Claude de France, 1548–57 (Basilica of Saint-Denis). A triumphal arch flanked by Ionic columns encloses effigies of the royal couple. A compromise between traditional Gothic and the architect's desire for innovation, and incorporating elements derived from the Roman style, the tomb is surmounted by statues of the king and queen and their children. These statues were executed by Pierre Bontemps, who also created the bas-relief sculptures on the pedestal, most notably the remarkable *Battle of Marignan*, which can be seen here. *Photo © Phédon-Salou, Artephot/T*

was amalgamated with the recommendations of the Council of Trent with regard to religion in art. These recommendations came late in the day, and were messy, tentative and sometimes contested or circumvented. It did not matter: the piety of the Counter-Reformation was sometimes severe, exalted and almost mystical, and sometimes (indeed most of the time) attractive, but always rhetorical: opera was about to be born. At the same time, the popularity of theoretical debates, which had been initiated in the preceding generation, increased. Vasari's *Lives of the Artists* was a bestseller: the author worked on the second edition for years on end, updating it to include himself and his contemporaries, and giving rise to a whole range of quasi-polemical, quasi-historical literature.

The Medicis' return to Florence brought artists, whether connected or not to their 'clan', to the city: Salviati, the elegant and imaginative Allori (Bronzino's nephew) and basically the whole group of decorators of the Palazzo Vecchio (the *Studiolo of the Grand Duke Francesco*, 1575) – of whom Maso di San Friano, Santi di Tito and Poppi stand out – under the supervision of Vasari. In addition to being an esteemed biographer, Vasari, a painter of frescoes of questionable talent but otherwise a gifted artist (*Perseus and Andromeda*), was a skilled master of works as well as a fine draughtsman.

124

DA SETTIGNANO DONATELLO DÜRER EL GRECO FILARETE FOUQUET GENTILE DA FABRIANO GHIBERTI GHIRLANDAIO GIORGIONE GIOTTO GIOVANNI PISANI MÜNCH MANTEGNA
DI NANELLO NICOLA PISANO LA TOUR ARMIGIANINO BRONTINO ARBRECHT ALTDORFER BRAMANTE BROEDERLAM ANDREA DEL SARTO ANGELICO ANTONELLO DA MESSINA
BELLINI ALTICHIERO BRUEGEL BRAMANTE BROEDERLAM ANDREA BRUNELLESCHI BUFFALMACCO CANALETTO CAMPAGNOLA CARAVAGGIO CAROTO MERCACCI TREVI BRACCI LI VOLTE
BERTI GHIRLANDAIO GIORGIONE GIOTTO GIOVANNI PISANO GRÜNEWALD HOLBEIN INGRES JEANNEO COMPAGNOLA

Giambologna
(Giovanni Bologna), *Mercury*, 1564 (Museo Nazionale del Bargello, Florence). This bronze sculpture manages to suggest the soaring flight of the god in the frozen immobility of a moment. There is a marvellous balance between the elegance of the body and the significance of the gesture, the raised forefinger serving as a reminder that this is the messenger of Olympus. *Photo © Scala/T*

Bernard Palissy, *Fecundity*, c.1560–70 (Musée du Louvre, Paris). Palissy's earthenware pieces, decorated with figures in relief, were produced in large quantities at this period by the royal workshop of which he was in charge. Self-trained, Palissy had spent many years trying to rediscover the secret of enamelling work, which he developed to a rare degree of transparency. *Photo © Giraudon/T*

These artists endorsed the ideology of the Counter-Reformation only to varying degrees.

It was through Mannerism that the Renaissance was really disseminated throughout northern Europe: Dürer had barely gone further than Venice in his travels, and Jean Provost (c.1520) and the Bruges dynasty of the Pourbus knew Italy only at second hand. However, Jan Gossaert (c.1509), known as Mabuse, made the pilgrimage to Rome. He returned a keen convert to classical perspective. His disciple Lambert Lombard, from Liège (c.1538), attached paramount importance to Italianism. Along with Frans Floris (d.1570), a prolific author and specialist in pagan nudes, the 'Romanists' (Van Scorel, Van Heemskerck, etc) dominated Dutch painting – a trend which culminated in the work of Abraham Bloemaert (1564-1651) and the Haarlem School.

Religious wars and internal strife largely destroyed the evidence (statues and stained glass) of artistic life in the Netherlands in the 16th century, as well as a large number of paintings: the realist Mannerism of Pieter Aertsen (c.1550) suffered as a direct result of this. But the engraver Goltzius popularized Italian works of art as well as his own. A very refined form of Mannerism developed in the small court of Lorraine (Deruet, Bellange). The same thing happened in the Holy Roman Empire, with local centres such as Munich (Sustris), the court of Maximilian (Peter de Witte) and especially the Prague School, where Emperor Rudolf II engaged Hans von Aachen, Josef Heintz, Bartholomeus Spranger (d.1611) – a native of Antwerp who had spent some time in Rome – and Giuseppe Arcimboldo (d.1593), an artist with an idiosyncratic, inventive style. This central European Mannerism – exuberant, sometimes awkward, full of cabbalistic or epicurean allusions – indirectly paved the way for a specific version of the Baroque.

125

THE MANNERIST TRANSFORMATION

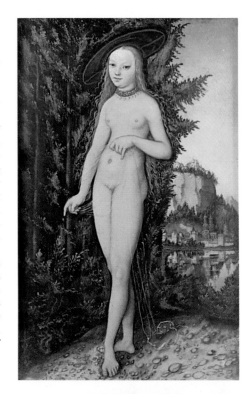

Lucas Cranach the Elder, *Venus*, c.1529 (Musée du Louvre, Paris). Probably taking some inspiration here from Ferraran art, Cranach was not very receptive to the spirit, let alone the letter, of the Renaissance: in this work the alluring female nude retains something of the perversity, bitter rather than naive, lent to Eve by medieval painters. There is a feigned awkwardness in the execution here, absent from both his landscape backgrounds and his portraits, which are nevertheless characterized by the same coldness.
Photo H Josse © Larbor/T

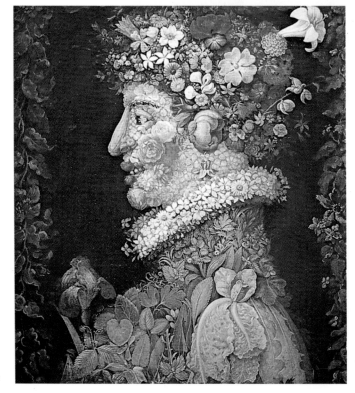

Giuseppe Arcimboldo, *Spring*, c.1573 (Musée du Louvre, Paris). Arcimboldo's portraits incorporate, in a systematic and comprehensive way, elements derived from nature in all its variety.
Photo © Bulloz/T

ABERTI BELLANGE BELLINI BORGOGNONE BELLINI BERRI LILLE BEGHMALN BONINU BOSCH RHULHELU BUZI CHIN PUUIS BRONIM LE BRYXRIEMAN BOCHISAWN IN BII FLIANDUANO DOSSO DAVID FLEUR ELRRECUANO JASHI ENISINOKUKI CLERIGUNA FABRO NFI LA FRANCGU GABRIEL ALLOSRENOUNSI CRUCCHI GHIANFOU POGLIOH IS ONIRRIU ROUCCHIO ZOLCARO MARTAL AOANZA RROELBOROUMER AMERINGHNOR FI AMUONAT ANDRO CASTAGNO ANDRO CONTAL ANDRO CASTAGNO ANDRAGHINO IN HAXOANONTBLO DA MUMIN BERTI GHIRLANDAIO GIORGIONE GIOTTO GIOVANNI PISANO GRUNEWALD HOLBEIN INGRES JEAN DE BOULOGNE LEONARDO DA VINCI LIMBOURG LIPPI LORENZETTI LOTTO

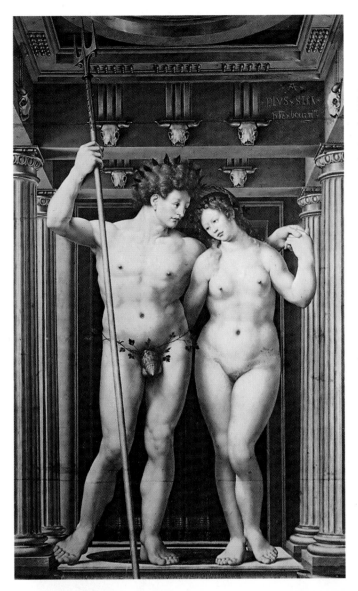

Jan Gossaert, known as **Mabuse**, *Neptune and Amphitrite*, 1516 (Staatliches Museum, Berlin-Dahlem). A later work than the *Adam and Eve* of Dürer (whose compositions Mabuse sometimes adopted), this picture, with its detailed but unsophisticated rendering of anatomy, is particularly striking for its setting, which is reminiscent of Mantegna. Despite their realistic appearance, the two pagan gods are portrayed here essentially as archaeological idols. *Photo © the Museum/T*

Maerten van Heemskerck, *Antique Arena*, 1552 (Musée des Beaux-Arts, Lille). In a coliseum, a bullfight or some kind of torture is taking place. Memories of various journeys made by the artist are united in one fantastical ruin. *Photo © the Museum/T*

LEGACY TWILIGHT AND LEGACY
AND LEGACY TWILIGHT AND
TWILIGHT AND LEGACY TWILIGHT
LEGACY TWILIGHT AND LEGACY
AND LEGACY TWILIGHT AND
TWILIGHT AND LEGACY TWI-

TWILIGHT
AND LEGACY

In 1564, the Pope yielded to pressure from certain cardinals and ordered that the nude figures in *The Last Judgement* should be covered up. Mischievously, the task was entrusted to Daniele da Volterra, a pupil of Michelangelo, who had a reputation for painting slowly, and who added the 'underwear' in such a way that it could in many cases be easily removed. When Veronese was summoned to appear before the Venetian Inquisition in 1573 to answer the charge of having depicted *The*

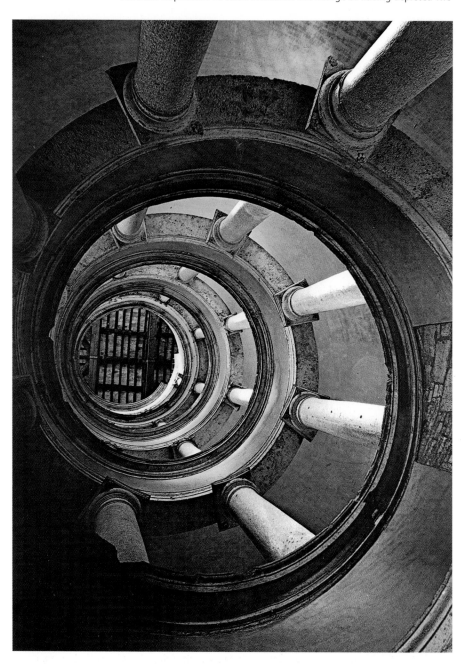

EX ALDIM BELLS ANE BELLINI BURRY ONLINE BERNINI BERRUGUETE BILTEMALEI BONDOL BOSCH BOTH FULL BOTTIN INI RUDOLF BRAMANTE BRU JEHAM BRUEGEL ARNHELD
REABELLI SANI CONTSTI LO DURER CANDEE FERRARI FENYOUS CORELLE DA GABRIAND GHIBELI GHITMAND AIO DISORGONE GIOTTI JHO GYANNI PISANO GRUNAWEL HO
SLOBELLI AL CARO ALBERTO GAINZ A NOGLI OZORIEN ANDREOCHE FRAN E VERANATO LO ANDREOCHE GALCANTO ANDIVA PISANO ANGHERO ANTONELFO DA MENALI
SUCCHIO ALCARO ALBERTO GAINZ ANOGLI OZORIEN AMER BRUGLHE FRAN E AMMANAT ANDREOCHE CALCANTO ANDIVA PISANO ANGHERO ANTONELFO DA MENALI
BRAMANTE BRUEGEL BRONZINO JHO RULLES RAPH ARNHELD AMER HEALDHI HAIM KARDIAL HAIM KARDIN HAIM KARDIAL LOTI
RERITI GHIRLANDAIO GIORGIONE GIOTTO GIOVANNI PISANO GRUNEWALD HOLBEIN INGRES JEAN DE BOULOGNE LEONARDO DA VINCI LIMBOURG LIPPI LORENZETTI LOTI

Caravaggio (properly Michelangelo Merisi da Caravaggio), *Young Bacchus*, c.1596 (Uffizi Gallery, Florence). Before undertaking his 'Caravaggiesque revolution', the painter was the pupil in Rome of a Mannerist, the Cavaliere d'Arpino, whose influence can be discerned here in the pale colours of the fruit. However, the stark contrast between the background and the foreground, as well as the provocative vulgarity of the model, mark a deliberate break with the Renaissance. *Photo Scala © Archives Larbor/T*

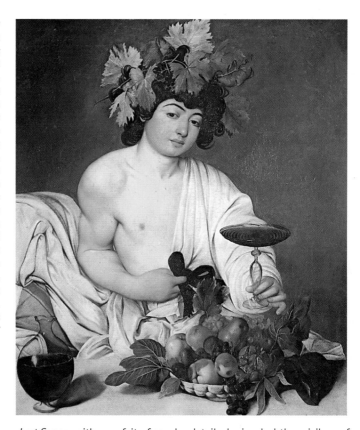

Last Supper with a surfeit of secular details, he invoked the privilege of 'poets and lunatics' on behalf of painters and escaped punishment by altering the title of his painting to *The Feast in the House of Levi*. When, in around 1610, the Late Mannerist Cigoli painted an *Assumption* for the church of Santa Maria Maggiore depicting the moon at the feet of the Virgin (a traditional motif) but including – in homage to his friend Galileo – the 'spots' on the moon that Galileo had recently discovered, he did not meet with any censure, while the equivalence between the earth and the moon implied by these craters or 'islands' became the subject of theological controversy. Soon afterwards, the first biographer of Galileo falsified the date of his birth by a few days so as to make it coincide with the date of Michelangelo's death, as if to claim that the artist had been reincarnated in a genius of equal stature.

The Renaissance mentality was not therefore a victim of the Counter-Reformation reaction, to which art adapted as best it could. Mannerist practices gradually died out, first by a process of degeneration, and then through dispersion. Even in northern European countries, the Wars of Religion led to the destruction of many works of art rather than to the decline of artistic techniques of Mediterranean origin which had been assimilated to a greater or lesser degree, especially through the collec-tions of ornamentists (Vredeman de Vries, 1527?–1604). Due to its

Right-hand page: **Bramante** (originally Donato di Angelo), spiral staircase, after 1515 (Belvedere of the Vatican). This imposing staircase gives an indication of the original plan for Saint Peter's in Rome by the man who first designed it. It contains references to ancient Classical architecture, but also incorporates all the technological advances of Bramante's time. *Photo Scala © Larbor/T*

GACY TWILIGHT AND LEGACY
LEGACY TWILIGHT AND LEGA
AND LEGACY TWILIGHT AND
TWILIGHT AND LEGACY TWI-
LEGACY TWILIGHT AND LEGA
GACY TWILIGHT AND LEGACY
AND LEGACY TWILIGHT AND
TWILIGHT AND LEGACY TWI-

TWILIGHT AND LEGACY

Veronese (real name Paolo Caliari), *Portrait of a Hunter*, detail of a fresco, c.1550–60 (Villa Barbaro, Maser). This is one of the famous trompe l'œil images that Veronese executed in this villa, which belonged to a patron of his: they seem to pierce the walls painted with fake architecture. A taste for the most diverse pleasures (this elegant figure may well be a self-portrait) combines with an increasing sophistication with regard to artistic experimentation. *Photo © Giraudon*

dynamic of constantly adding to stylistic forms and carrying them to extremes, Baroque art could not but continue, in some ways, the Mannerist tradition.

Thus, in painting, Ludovico Carracci (1555–1619) – the first of three Carraccis who were to have such an influence on 17th-century art – still belongs to the Mannerist tradition, while Annibale Carracci (1560–1609) asked to be buried beside Raphael. Without the latter, we can understand neither Guido Reni nor Domenichino, nor their French imitators, nor even Poussin.

It is true that the *quattrocento* (if we do not go back as far as Giotto) was scarcely better understood or known about in the Classical period. However, from the 1770s onwards, the general vogue for archaeology led (not without a certain amount of confusion, which continued in the Romantic movement) to the architectural remains of both the Middle Ages and the Renaissance being lumped together. No matter how much some disciples of David and, later, Ingres challenged each other one after another, they all demonstrated at times the alleged 'primitivism' of the *quattrocento*.

ECCLESIUM BELLINUS BELLINI BORGOGNONE BERNINI BERRUGUETE BLOEMAERT BONIFINI BOSCH BOTTICELLI BOULOGNE BOUTS BRAMANTE BROEDERLAM BRUNELLESCHI
DE ANGELICO CANO CANOVA CARPACCIO CASTAGNO CHASTEL CIMA DI CONEGLIANO CLOUET CORREGGIO COUSTOU COZZOLI CHIUSANI FRANCHI FRANCIA GRECO
PACIFICO BUCCARI AUBERT AUDRAN ZANZ ALTDORFER CAMBIASO DI PIERO DI ARMANATI ANDREA DEL CASTAGNO ANDREA PISANO VINCI PIERO ANTONELLO DA MESSINA
BOTICELLI BUCCANI ROGER CARRAND RORIO BOUDIGGIE PRUDGE ECH DU HERNAU DI MANANTI MANTEGNA ANDREA MANTEGNA ANDREA MANTEGNA MANTEGNA
HERRI GHIRLANDAIO GIORGIONE GIOTTO GIOVANNI PISANO GRÜNEWALD HOLBEIN INGRES JEAN DE BOULOGNE LEONARDO DA VINCI LIMBOURG LIPPI LORENZETTI LOTT

Frans Pourbus the Elder, *Ball at the Court of Charles IX*, c.1571 (Musée Baron-Gérard, Bayeux). The masks of Italian theatre are here intermingled with the personages of the royal court: their familiarity and freedom of movement reflect the development of social manners in France at this period. The pleasures of existence are also evoked, beyond the Roman architectural background reminiscent of the Louvre, by the vision of a garden with bowers, adorned with statues. The art of garden design was another Renaissance rediscovery. *Photo Studio le Monnier, Bayeux © Larbor/T*

In sculpture, the inheritance of the 'rupture' achieved by Michelangelo was to be the subject of debate for three centuries, between the tendency towards monumental severity and the tendency towards expressionism: the sculptor Bernini continued the Renaissance tradition (this was to be one of the reasons for his lack of success at Versailles). Architecture was nurtured on a similar inheritance, up to the mongrel styles that were contemporaneous with the industrial revolution, and through all the formal vacillations of Baroque and Rococo: one of the strangest revivals was the vogue for neo-Palladian architecture in the 1760s almost everywhere in Europe.

It is also possible that the true legacy of the Renaissance lies elsewhere: in the transformation of the very concept of the artist. We have mentioned the ambiguities inherent in the system of artistic patronage: this was an irreversible development – witness the (apocryphal) anecdote about Charles V picking up one of Titian's paintbrushes from the floor, and the (true) declaration of Cardinal Herculo Gonzaga, the regent of Mantua, that Giulio Romano was 'the true head of state, and that he deserved to have a statue at every crossroads of the city which he had enlarged, fortified and embellished so much'. The dignity of the artist – whose at times volatile personality became with Mannerism (if not before) a subject of curiosity, indeed of esteem – did not necessarily

A ARTIUS OSMA INU PEETLUO BVRG ET CAGEL SCHIARI TE BOUCOUET GENTIUM DA FABRIANO VOGHERTS GHIRLANDAIO GIORGIONE GIOTTO GIOVANNI PISANO GRUNEWALD HOL
TANCRED IN THE CAMP OF THE CRUSADERS C.1605 MUSEE NATIONAL DU CHATEAU DE FONTAINEBLEAU DESPITE THE LATE DATE OF THIS
LUCCHETTI POLLAIUO DE RASELLO ACTHER ZARABURIAN CON PATENTE MESSEGENTIUM DA FABRIANO VOGHERTS GHIRLANDAIO GIORGIONE GIOTTO GIOVANNI PISANO PONTORMO
PLUCCHETTI POLLAIUO POUSSIN BRAMANTE BROEDERLAM DER GELDER ANOUELLES SCHIARI AMMANATI ANVERO CIMABUE DEL MESSINA VERROCCHIO CARONI CARACCIO ODERO CRANATH
FRUI GHIRLANDAIO GIORGIONE GIOTTO GIOVANNI PISANO GRUNEWALD HOLBEIN INGRES JEAN DE BOULOGNE LEONARDO DA VINCI LIMBOURG LIPPI LORENZO LE

Ambroise Dubois, *Tancred in the Camp of the Crusaders*, c.1605 (Musée National du Château de Fontainebleau). Despite the late date of this painting, Dubois remained very much influenced by the first Fontainebleau School, especially in the way his compositions were arranged on different levels. However, the tonalities of his colours and the sculptural appearance of his figures anticipate Baroque art.
Photo © Jean Feuillie-CNMH/T

El Greco (properly Domenikos Theotokopoulos), *The Agony in the Garden*, c.1590–8 (Museum of Art, Toledo). Trained in Venice and Rome, the Spanish master shows links with Mannerism only in the luridness of his colours. The complete rejection of perspective, the fantastical arrangement of the figures and the elongated mystical poses are far more reminiscent of Byzantine painting, with which he had been familiar during his youth in Crete, and even of the Gothic style (the angel): there is no trace here of the spirit of the Renaissance.
Photo © the Museum/T

imply the (relative) solitude of a Da Vinci. There is evidence that distinct associations of painters (breakaway groups from the medieval corporations or guilds, which were less specialized) existed in Rome as early as 1478, in France as early as 1495 and in Bohemia and Poland around the same period. Artists' involvement in humanist circles, even if they were not 'members' as such, paved the way for the emergence of the academies, which were also initially intended to promote the skilled over the unskilled and to provide apprentices with a thorough training.

Renaissance artists eagerly invoked Prometheus as a symbol of their ambition. For Da Vinci, to 'make oneself the master of the secrets of nature' – to cite the phrase which would be used right up to the time of Descartes – was not simply the expression of an encyclopedic appetite: it attributed to the painter the faculty of 'being able to summon before one', at will, the entire universe. When Botticelli painted *The Birth of Venus* for a circle of initiates, he had absolutely no need to 'Christianize' the nudity of the goddess (as has been claimed) by an allusion to the pilgrimage to Santiago de Compostela. The shell upon which Venus floats was simply a product of literary tradition and Greek statuettes which he was reinterpreting. Painters and sculptors 'alluded to' philological sources quite unpedantically. Although Mannerism, in its complexity, seems more artificial, the era of the first modern engineers was also that of poetry in the visual arts.

This new status of the artist went hand in hand with the first instances of the democratization of works of art. Where public life was already well developed (Tuscany, for example), many artistic and building projects were submitted to a process of consultation, with the risk that works (especially church façades) remained unfinished.

Art collections – many of which form the basis of modern museums – were not displayed to the friends and acquaintances of the owner solely for reasons of ostentation: early theoreticians also sought evidence for their theories in these collections. While they did not yet constitute permanent museums, the gallery of the Medicis (1587) and the collections of some owners (possibly dealers), especially in the Low Countries, provided foreign travellers with examples of an increasingly liberal engagement with the world. The 'curiosity' which had been a constant stimulus to Renaissance man passed from the 'creator' to the 'consumer'.

Thus, the Renaissance saw the emergence of both the artist (as a relatively autonomous entity) and the work of art (as a specific product of the artist's activity): they had only been regarded as such exceptionally in Classical times (as far as we can judge), but now this became the rule. It was no accident that this period witnessed the rebirth of art history (forgotten since the days of Pliny the Elder) and the birth of that intangible phenomenon which we call 'aesthetic judgement'. Together, the critical mind and the creative mind inaugurated a major development. If we just confine ourselves to the most illustrious phases of this develop-

The Building of
Saint Peter's in Rome

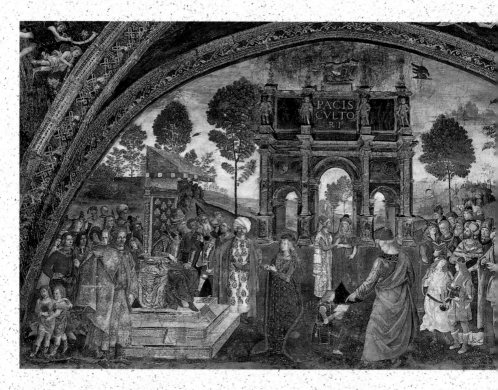

Pinturicchio (properly Bernardino di Betto), Saint Catherine's Disputation with the Pagan Philosophers, fresco, 1492–4 (Borgia Apartments, Vatican City). Summoned in 1481 to help with the frescoes for the walls of the Sistine Chapel, Pinturicchio seems to have been the subject of constant admiration in Rome. Here, in a dense, story-based composition, the use of ancient Classical architecture and even grotesques can be observed, brightened up by an Umbrian-style landscape.
Photo Scala © Archives Larbor/T

AD324. Constantine has a basilica built on the supposed site of Saint Peter's tomb.
c. 1150. First phase of work to connect the Palace of the Popes to the basilica, and to enlarge the basilica itself.
1278–1300. Contributions of Arnolfo di Cambio (sculptures) and Giotto (who drew the cartoon for the Navicella, a mosaic now replaced by a copy above the portico entrance).
1439–45. Averulino Filarete executes the bronze doors (central entrance) which commemorate Eugenius IV.
1455. Nicholas V undertakes the first large-scale alterations (probably inspired by his friend Alberti). Rossellino builds a new apse behind the one built by Constantine.
1493–8. Tomb of Sixtus IV by Pollaiuolo, and Michelangelo's Pietà. The palace is considerably extended.
1506. Pope Julius II entrusts the direction of the works to Bramante. The Belvedere Court is created by joining together the residences of Nicholas V and Innocent VIII (the latter building dating from 1492). The old basilica is demolished, and a central plan with a dome is proposed for

the new basilica. The connecting extension to the Vatican is finished shortly afterwards.
1514. Raphael becomes director of works following the death of Bramante. He proposes a Latin Cross plan for the basilica.
1520. Peruzzi reinstates the Greek Cross plan.
1543. The idea of reinstating the Latin Cross plan (Antonio Sangallo the Younger) is quickly dismissed by Michelangelo, who goes back to a modified version of Bramante's plan. He is inspired by Brunelleschi's dome in Florence. Michelangelo directs the works up until his death in 1564 in a turbulent atmosphere (his site manager is said to have been assassinated by a killer hired by the Sangallo clan).
1565. On the death of Michelangelo, Vignola continues with his plan; Giacomo Della Porta and Fontana work on the dome and the lantern as designed by Michelangelo.
1585–90. Demolition of Rossellino's apse. The dome is completed.
1586. Fontana erects the Egyptian obelisk from Nero's Circus on the square (in accordance with a suggestion made to Julius II).

Right: Domenico Passignano, *Michelangelo Presents the Model of Saint Peter's to the Pope*, 1618–19 (Casa Buonarroti, Florence). A ceremonial painting by a late Mannerist, which idealizes a historical scene, especially in endowing Michelangelo with eternal youth, as expressed in his profile and pose.
Photo Scala © Larbor/T

1605. Paul V returns to the Latin Cross plan: Maderno is given responsibility for extending the nave towards the square and builds the existing façade (based on a design by Michelangelo, but on a larger scale). 1626. The building is consecrated by Urban VIII.

Later, Bernini creates the baldachin (1633), Saint Peter's Chair and, finally, the quadruple colonnade of the square with its balustrade bearing 140 statues, executed in a 'Roman' style which perpetuates the ideas of the Christian humanists of the Renaissance.

ment, for two centuries an extraordinary symbiosis existed both between art and philosophy, indeed between art and science, and between art and everyday life. The latter was transfigured and appreciated for its own sake: the Renaissance also introduced the idea of a certain 'enjoyment of life'. Here was a marvellous interrelationship whose components were thereafter separated and only came together at very rare intervals in the future – never again in such a close union, but subterraneously or in a context fraught with insoluble contradictions. Hence there remains a nostalgia for the Renaissance which has never disappeared and which the modern age, so often seen as dating from the Renaissance itself, continues to express in so many museums that are destined to become for each individual an 'imaginary museum'. For the Renaissance offers us today what we seems to lack most cruelly: space and splendour.

Raphael, *The School of Athens*, 1509–10 (Stanza della Segnatura, Vatican City). Located directly opposite the *Dispute Over the Holy Sacrament*, which exalts revealed truth, this fresco gathers together the witnesses of truth discovered through reason. Its solemnity evokes the 'temple of philosophy' once dreamed of by Marsilio Ficino. The ancient sages are represented in the guise of friends and contemporaries of Raphael. In the centre, Aristotle, his hand outstretched, suggests the organization of the world through politics and ethics; Plato, his finger raised, points out that this world must be based on its ideal principle. In this regard, it is striking that Plato, who is given 'the last word', is depicted as the conventional Aristotle figure of the Middle Ages, but transfigured by an allusion to Da Vinci's famous self-portrait. This is the apotheosis of a whole revolution in thought: in its supreme harmony, *The School of Athens* embodies the Renaissance.
Photo © Marzari, Schio/T

Fecundity (Bernard Palissy), 125
Ferrari Gaudenzio (c.1480–1546), 83
Filarete Antonio Averlino (1400–after 1465), 55, 134
Flight into Egypt (The) (Joachim Patinir), 103
Floris Frans (1516–70), 125
Fontainebleau 122–3
Fontana Domenico (1543–1607), 79, 134
Foppa Vincenzo (c.1427–1515), 67
Fouquet Jean (c.1420–77/81), 46
Fra Angelico see Angelico
Francesco di Giorgio see Martini
Francken Jérôme II (1540–1610), 16
Fréminet Martin (1567–1619), 123
Froment Nicolas (c.1435–84), 42
Funeral of Saint Francis (The) (Domenico Ghirlandaio), 61

G

Gaddi Taddeo (c.1300–66), 25, 30
Garden of Earthly Delights (The) (Hieronymus Bosch), 101
Geertgen tot Sint Jans (c.1460–before 1495), 42, 46
Gentile da Fabriano (c.1370–1427), 34, 37, 41, 65, 67
Ghiberti Lorenzo (1378–1455), 37, 38–9, 55
Ghirlandaio Domenico (1449–94), 61
Giambologna (Giovanni Bologna) (1529–1608), 8, 121, 125
Giocondo Fra (real name Giovanni da Verona) (c.1433–1515), 91
Giorgione (Giorgio Barbarelli) (1477–1510), 11, 84, 85, 86, 89
Giotto (di Bondone) (1266/67–1337), 7, 8, 18, 19, 20, 22–26, 30, 31, 35, 39, 54, 130, 134
Giovanetti Matteo (fl. Avignon 1346–67) 30, 31-2
Giovanni da Milano (fl. Florence 1346–69), 25
Giovanni da Udine (1487–1564), 71, 83
Giovanni da Verona (1457–1525), 61
Giovanni di Paolo (c.1399–1482), 32, 33
Giovanni di Ser Giovanni, 51
Giovanni Pisano (c.1245–after 1314), 22
Girard d'Orléans (d.1361), 35
Girolamo da Fiesole, 90
Girolamo di Benvenuto, 64
Girolamo di Cremona (fl.1460–83), 53
Goltzius Hendrick (1558–1617), 125
Gossaert Jan (known as Mabuse) (c.1478–1532), 125, 127
Goujon Jean (c.1510–c.1564/9), 121
Gozzoli Benozzo (c.1442–97), 58
Grassi Giovannino de, 30
Greco El (properly Domenikos Theotokopoulos) (c.1540–1624), 132
Group of Nude Men Fighting (Raphael), 79
Grünewald Matthias (1460/70–1528)100

H

Hands in Prayer (Albrecht Dürer), 97
Haymaking (Brueghel the Elder), 103
Head of an Old Man (Lorenzo di Credi), 70
Heintz Josef (known as the Elder) (1546–1609), 125
Holbein Hans (c.1465–1524), 100
Holbein the Younger Hans (1497–1543), 99, 100
Holy Family (The) or the Tondi Doni (Michelangelo), 76

Holy Women at the Sepulchre (The) (Duccio di Buoninsegna), 19
Hunts of Maximilian (The) (tapestry), 110–11

I, J

Ideal City (The), 14
Ingres Jean Auguste Dominique (1780–1867), 130
Invention of the True Cross: the Queen of Sheba (The) (Piero della Francesca), 56
Jacobello del Fiore (fl.1394–1439), 67
Jacopo de Barbari see Barbari
Jacopo della Quercia (c.1367–1438), 41
Jacquemart de Hesdin (fl.1384–1409), 29
Jones Inigo (1573–1652), 92
Joos van Gent (fl. Urbino 1473–5), 70

L

Laurana Francesco (died after 1500), 90
Laurana Luciano (c.1420–79), 14, 53, 70
Leonardo da Vinci (1452–1519), 14, 17, 32, 54, 59, 67, 70, 72–74, 75, 79, 83, 91, 99, 100, 133
Lescot Pierre (1515–78), 91
Liberale da Verona (1445–1529), 53
Lieferinxe Josse (fl. Marseilles and Aix 1493–1505), 20
Limbourg (brothers), 29, 46
Limosin Léonard (c.1505–c.1577), 11
Lippi Filippino (1457–1504), 50, 52, 61, 68
Lippi Filippo (c.1406–69), 49, 52, 57, 58, 59, 61
Lochner Stephan (c.1405/15–51), 46
Lombard Lambert (1506–66), 125
Lorenzetti Pietro (c.1280–1348?), Ambrogio (d.1348) (brothers), 20, 21, 23, 25, 26, 54
Lorenzo di Credi (c.1459–1537), 59, 70
Lorenzo Monaco (c.1370–after 1422), 34
Lorenzo Veneziani (1336–73), 67
Lotto Lorenzo (c.1480–1556), 87, 104, 105
Lucas van Leyden (1489 or 1494–1533), 99

M

Mabuse see Gossaert
Maderno Carlo (1556–1629), 135
Madonna of Humility (The) (Giovanni di Paolo), 33
Madonna of the Pear (Giovanni Bellini), 84
Madonna with the Long Neck (The) (Parmigianino), 117
Maiden's Dream (Lorenzo Lotti), 104
Mantegna Andrea (1431–1506), 11, 38, 46, 56, 59, 61, 65, 66, 67, 94, 108
Man with the Glove (The) (Titian), 89
Marcillat Guillaume de (1467–1529), 105
Marriage at Cana (The) (Veronese), 106–7
Marriage of Alexander and Roxana (Il Sodoma), 78
Marriage of the Virgin (The) (Raphael) 80, 82
Mars and Venus Surprised by Vulcan (Tintoretto), 88
Martini Francesco di Giorgio (1439–1502), 14, 64, 70
Martini Simone (c.1284–1344), 12, 23, 26, 31-2, 35

Martorell Bernardo (fl.1427–52), 31, 32
Masaccio (Tommaso di Ser Giovanni) (1401–28), 39, 41, 43, 52, 56, 57, 83
Maso di Banco (first half of the 14th century), 25
Masolino da Panicale (1383–1447), 39, 41
Massacre of the Innocents (The) (Marcantonio Raimondi), 105
Master of the Cueur d'Amour Espris, 41, 42
Matsys Jan (1509–c.1573), 113
Matsys Quentin (c.1466–1530), 114
Matteo di Giovanni (known as Matteo da Siena) (c.1435–95), 64
Meeting between Aeneas and Latinus on the Banks of the Tiber (The) (Giovanni di Ser Giovanni), 51
Memlinc Hans (c.1433–94), 95
Memmi Lippo (attested 1317–47), 26
Mercury (Giambologna), 125
Michelangelo (more fully Michelangelo Buonarroti) (1475–1564), 7, 59, 63, 65, 70, 73, 74, 75, 76–7, 78–9, 83, 87, 105, 119, 121, 128, 129, 131, 134, 135
Michelangelo Presents the Model of St Peter's to the Pope (Domenico Passignano), 135
Michelino da Besozzo (fl.1388–1445), 30, 32
Michelozzo (1396–1472), 38, 49, 53
Mino da Fiesole (c.1430–84), 40
Miraculous Draught of Fishes (The), (Konrad Witz), 45
Mona Lisa (Leonardo da Vinci), 17, 73, 74
Moneylender and His Wife (The) (Quentin Matsys), 114
Montorsoli Giovanni Angelo (c.1507–63), 121
Moses (detail of the Charterhouse of Champmol) (Claus Sluter), 27, 28
Murano (glass), 11

N

Neptune and Amphitrite (Jan Gossaert, know as Mabuse), 127
Nicola Pisano (c.1220–c.1287), 21
Night (Michelangelo), 77
Nymph and Putto (Jean Goujon), 121
Nymph of Fontainebleau (The) (Benvenuto Cellini), 123

O, P

Orcagna Andrea (fl.1343–68), 23, 26
Pacher Michael (d.1498), 46, 48
Palazzo del Te (Mantua), 9
Palazzo Medici-Riccardi (Florence), 53
Palazzo Piccolomini (Pienza), 52
Palissy Bernard (c.1510–89/90), 125
Palladio Andrea (1508–80), 54, 92, 108
Palma the Elder (c.1480–1528), 87, 89
Parmigianino (properly Francesco Mazzola) (1503–40), 116, 117, 120
Passignano Domenico (c.1560–1636), 135
Patinir Joachim (c.1480–1524), 102, 103
Pazzi Chapel (Florence), 40
Penni Gianfranco (c.1488–1528), Luca (1500–56), 83, 122
Perugino (real name Pietro Vannucci) (1445–1523), 15, 57, 59, 63, 68, 69, 70, 80, 94
Peruzzi Baldassare (1481–1536), 83, 134

Pesellino Francesco di Stefano (c.1422–57), 53
Picture Shop of Jan Snellinck (The) (Jérôme II Francken), 16
Pierino del Vaga, 83
Piero della Francesca (c.1416–92), 52, 54, 56, 57, 61, 64, 65, 67, 68
Piero di Cosimo (c.1462–1521), 53, 68, 69
Pietà (Cosmè Tura), 64
Pietà (Enguerrand Quarton), 25
Pinturicchio (properly Bernardino di Betto) (1454?–1513), 68, 83, 134
Pisanello (real name Antonio di Puccio di Cerreto) (c.1395–c.1450), 32, 35, 41
Polidoro da Caravaggio (properly Polidoro Caldara) (c.1490–1546), 83
Pollaiuolo Antonio (1431?–1498), 52, 54, 58, 65, 78, 134
Pontormo Jacopo da (properly Jacopo Carrucci) (1494–1556), 114, 116, 116
Pope Leo X with Cardinals Luigi de Rossi and Giulio de' Medici (Raphael), 80
Portinari Triptych: The Adoration of the Shepherds (Hugo van der Goes), 67
Portrait of a Hunter (Veronese), 130
Portrait of a Princess of the d'Este Family (Pisanello), 32
Portrait of a Young Woman (Palma the Elder), 87
Portrait of Fra Luca Pacioli (Jacopo de Barbari), 54
Pourbus the Elder Frans (1545–81), 125, 131
Poussin Nicolas (1594–1665), 130
Presentation at the Temple (The) (Ambrogio Lorenzetti), 21
Primaticcio Francesco (1504/5–70), 13, 14, 120, 122, 123
Primavera ('Spring') (Botticelli), 60, 62
Profile of Man and Studies of Riders (Leonardo da Vinci), 73
Prophet Habakkuk (The), (Donatello), 37
Provost Jean, 125
Pucelle Jean, 29

Q, R

Quarton Enguerrand (fl. Aix, Arles, then Avignon 1444–66), 25, 41
Quercia see Jacopo della Quercia
Raimondi Marcantonio (c.1480–1534), 83, 104
Raphael (properly Raffaello Santi) (1483–1520), 8, 57, 70, 74, 78, 79–83, 79, 80, 81, 82, 83, 87, 91, 105, 114, 130, 134, 136
Reni Guido (1575–1642), 130
Roberti see Ercole de' Roberti
Romano Giulio (1492–1546), 9, 83, 105, 112, 120, 131
Rosselli Cosimo (1439–1507), 63, 69, 70
Rossellini (Brothers), 41
Rossellino Bernardo (1409–64), 52
Rosso (Fiorentino) (real name Giovanni Battista de Rossi) (1494–1540), 114, 119, 121, 122
Ruggiero di Ruggieri, 123

S

Saint Catherine's Disputation with the Pagan Philosophers (Pinturicchio), 134
Saint George Killing the Dragon (Bernardo Martorell), 31
Saint John the Baptist (Andrea del Sarto), 112
Saint John the Baptist and the Sinners (Andrea Pisano), 22
Saint Martial Resurrecting the Son of Nerva (Matteo Giovanetti), 30
Saint Michael Slaying the Dragon (Josse Lieferinxe), 26
Saint Peter Distributing Alms and the Death of Ananias (Masaccio), 43
Saint Peter's in Rome, 134–5
Saint Wolfgang Altarpiece: the Circumcision of Christ (Michael Pacher), 48
Salt cellar of Francis I (Cellini), 122
Salviati Cecchino (originally Francesco de' Rossi) (1510–63), 124
Sangallo Antonio da (c.1455–c.1535), 78, 134
Sangallo Giuliano da (1445–1516), 55, 78
Santa Maria del Fiore (Florence), 15
Sassetta (originally Stefano di Giovanni) (1392–1451), 32
Schongauer Martin (known as Beautiful Martin) (c.1445–91), 116
School of Athens (The) (Raphael), 136
Seghers Hercules (c.1590–c.1638), 99
Self-Portrait (Albrecht Dürer), 96
Sellaio Jacopo del (1442–93), 60
Serlio Sebastiano (1475–1554), 79, 91, 122
Sermon to the Birds (Giotto), 18
Seven Joys of the Virgin (The) (Hans Memlinc), 95
Signorelli Luca (c.1445/50–1523), 52, 65, 66
Simonetta Vespucci (Piero di Cosimo), 68
Sluter Claus (c.1340 or 1350–1405/6), 27, 28
Sodoma II (name given to Giovanni Antonio Bazzi) (1477–1549), 78, 83
Solomon and the Queen of Sheba (Lorenzo Ghiberti), 39
Spranger Bartholomeus (1546–1627), 125
Spring (Giuseppe Arcimboldo), 126
Stefano da Verona (c.1374–after 1438), 32
Story of Cupid and Psyche (The) (stained glass window at Ecouen), 110
Stradano Giovanni (name given to Jan van der Straeten) (1523–1695), 115
Study of a Lapwing (Pisanello), 35
Susannah at the Bath (Albrecht Altdorfer), 98

T

Tancred in the Camp of the Crusaders (Ambroise Dubois), 132
Tempest (The) (Giorgione), 85, 86
Tempietto (Rome), 75
Thebaid: Scenes from the Lives of the Hermits (The) (Paolo Uccello), 13
Three Philosophers (The) (Giorgione), 86
Three Scenes from the Story of Esther (Filippino Lippi), 50
Tintoretto (name given to Jacopo Robusti) (1518–94), 87, 88, 105
Titian (properly Tiziano Vecellio) (1488/9–1576), 85, 89, 105, 131
Tomb of Francis I and Claude de France (Saint-Denis), 124
Tomb of Sixtus IV (Vatican), 58
Tommaso da Modena (c.1325–79), 25
Tower of Belem (Lisbon), 91
Traini Francesco (fl.1321–64), 26
Très Riches Heures du Duc de Berry:

August (Pol de Limbourg), 29
Tura Cosmè (c.1425–95), 64, 66

U, V

Uccello Paolo (1397–1475), 13, 37, 38, 49, 53, 54, 55, 56
Ulysses and Penelope (Primaticcio), 13
Unity of the State (The) (Rosso), 122
Van der Goes Hugo (c.1440–82), 67
Van der Weyden Rogier (real name Rogier de la Pasture) (d.1464), 14, 44, 46, 66, 99
Van Eyck Jan (1390/1400–41), 42, 46, 47, 48
Van Heemskerck Maerten (1498–1574), 125, 127
Van Scorel Jan (1495–1562), 125
Vasari Giorgio (1511–74), 8, 17, 24, 40, 89, 121, 124
Venus (Lucas Cranach the Elder), 126
Venus Cytherea (Jan Matsys), 113
Venus of Urbino (Titian), 89
Veronese (pseudonym of Paolo Caliari) (1528–88), 11, 106, 108, 130
Verrocchio Andrea (1435–88), 52, 59, 68, 73, 74, 78
Vignola Giacomo Barozzi da (1507–73), 79, 134
Virgin and Child with Angels (Filippo Lippi), 57
Virgin and Child with John the Baptist (The) (Botticelli), 63
Virgin and Child with Saint Anne (Leonardo da Vinci), 73
Virgin and Child with Saint John the Baptist (The) (Raphael), 81
Virgin with Saints (Fra Bartolommeo), 71
Visconti Gian Galeazzo (1351–1402), 30
Vision of Saint Augustine (Vittore Carpaccio), 85
Vivarini Antonio and Bartolommeo, 67, 84
Volterra Daniele da (1509–66), 128

W, Y, Z

Willow Mill (The) (Albrecht Dürer), 97
Witz Konrad (c.1400–45), 46, 95
Woman at Her Toilette (François Clouet), 121
Young Bacchus (Caravaggio), 129
Zacharias in the Temple (Jacopo della Quercia), 2
Zoppo Marco (1433–78), 67
Zuccaro Taddeo (1529–66), 112

Bibliography

Sources

Alberti, L B, *Della pittura*, Florence, 1435

Alberti, L B, *De re aedificatoria libri X*, Florence, 1485

Cennini, C, *The Craftsman's Handbook: Il Libro dell'arte*, (2 vols), translated by D V Thompson Jnr, Yale University Press, New Haven; Oxford University Press, London, 1933

Ghiberti, L, *Lorenzo Ghiberti's Second Commentary: the translation and interpretation of a fundamental Renaissance treatise on art*, translated by C K Fengler, University of Michigan, Ann Arbor, 1974

Ghiberti, L, *Lorenzo Ghiberti's Treatise on Sculpture: The Second Commentary*, translated by J H Hurd, University of Michigan, Ann Arbor, 1978

Gilbert, C, *Italian Art 1400-1500: Sources and Documents*, Prentice Hall, London, 1980

Holt, E G, *A Documentary History of Art: Volume 1. The Middle Ages and Renaissance*, Princeton University Press, Princeton, 1981

Piero della Francesca, *De prospective pingendi*, (2 vols), edited by G Nicco Fasola, Casa Editrice le Lettere, Florence, 1984.

Vasari, G, *Lives of the Artists*, translated by George Bull, Penguin, Harmondsworth, 1965

Vasari, G, *Lives of the Painters, Sculptors and Architects*, (2 vols), translated by Gaston du C de Vere, David Campbell, London, 1996

General

Antal, F, *Florentine Painting and its Social Background*, Harvard University Press, Cambridge, 1987

Brown, G B (ed), *Vasari on Technique*, Dover Publications, New York, 1980

Blunt, A, *Artistic Theory in Italy 1450-1600*, Oxford Paperbacks, Oxford, 1962

Borsook, E, *The Mural Painters of Tuscany*, 2nd edn, Oxford University Press, Oxford, 1980

Burckhardt, J, *Civilization of the Renaissance in Italy*, translated by S G C Middlemore, with a new introduction by Peter Burke and notes by Peter Murray, Penguin Books, Harmondsworth, 1990

Burckhardt, J, *Cicerone: an art guide to painting in Italy for the use of travellers and students*, translated by Mrs A H Clough, with a preface by P G Konody, T Werner Laurie, London, 1908

Burckhardt, J, *The Altarpiece in Renaissance Italy*, translated by Peter Humfrey, Phaidon, London, 1988

Burckhardt, J, *The Architecture of the Italian Renaissance*, translated by Peter Murray, Penguin Books, Harmondsworth, 1987

Burke, P, *Tradition and Innovation in Renaissance Italy*, Fontana, London, 1974

Cole, B, *Sienese painting from its origins to the 15th century*, Harper and Row, New York, 1980

Freedberg, S, *Painting of the High Renaissance in Rome and Florence*, (2 vols), Harvard University Press, Cambridge, 1961

Gombrich, E, *Norm and Form: Studies in the Art of the Renaissance*, 4th edn, Phaidon, Oxford, 1985

Hills, P, *The Light of Early Italian Painting*, Yale University Press, New Haven, 1987

Holmes, G, *Florence, Rome and the Origins of the Renaissance*, Clarendon, Oxford, 1986

Huizinga, J, *The Waning of the Middle Ages*, Dover Publications, London, 1980

Larner, J, *Italy in the Age of Dante and Petrarch, 1216-1380*, Longman, London, 1980

Maginnis, H, *Painting in the Age of Giotto: A Historical Re-evaluation*, Penn State University Press, State College, 2000

Millon, H, and Lampugnani, V M, eds, *The Renaissance from Brunelleschi to Michelangelo: the Representation of Architecture*, Rizzoli International Publications, New York, 1997

Muller, T, *Sculpture in the Netherlands, Germany, France and Spain*, Yale University Press/Pelican History of Art, New Haven, 1992

Murray, P, *The Architecture of the Italian Renaissance*, revised edn, Thames and Hudson, London, 1986

Panofsky, E, *Early Netherlandish Painting: Its Origins and Character*, (2 vols), Harvard University Press, Cambridge, MA, 1953

Panofsky, E, *Studies in Iconology: Humanistic Themes in the Art of the Renaissance*, Westview Press, Boulder, 1972

Panofsky, E, *Renaissance and Renascences in Western Art*, Westview Press, Boulder, 1972

Panofsky, E, *The Renaissance and Mannerism: Studies in Western Art*, Acts of the 20th International Congress of the History of Art: Princeton, 1963

Pope-Hennessy, J, *Italian Renaissance Sculpture*, Phaidon, London, 2000

Ring, G, *A Century of French Painting, 1400-1500*, Phaidon, London, 1949

Seymour, C Jr., *Sculpture in Italy, 1400-1500*, Penguin Books, Harmondsworth, 1966

Smart, A, *The Dawn of Italian Painting, 1250-1400*, Phaidon, Oxford, 1978

Stubblebine, J, *Assisi and the Rise of Vernacular Art*, Harper and Row, New York, 1985

White, J, *The Birth and Rebirth of Pictorial Space*, 3rd edn, Faber, London, 1987

Wittkower, R, *Architectural Principles in the Age of Humanism*, 4th edn, Academy Editions, London, 1988

Wolfflin, H, *Renaissance and Baroque*, translated by Kathrin Simon, Collins, London, 1964